BETWEEN
THE BYLINES

BETWEEN THE BYLINES

THE LIFE, LOVE AND LOSS OF LOS ANGELES'S MOST COLORFUL SPORTS JOURNALIST

DOUG KRIKORIAN

FOREWORD BY JERRY WEST

Charleston London

THE
History
PRESS

Published by The History Press
Charleston, SC 29403
www.historypress.net

First published 2013

Manufactured in the United States

978.1.62619.004.7

Library of Congress CIP data applied for.

This book is dedicated to the memory of
Gillian Mary Howgego Krikorian.

Contents

Contents

CONTENTS

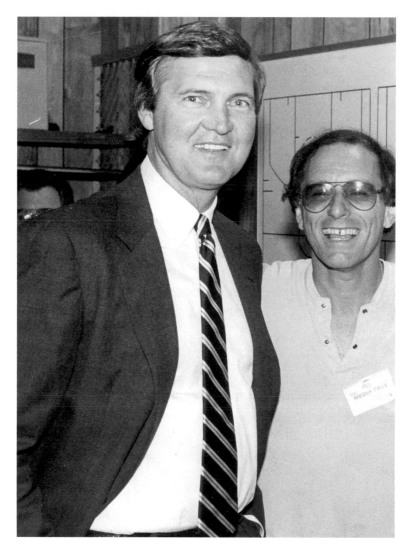

The Los Angeles Lakers' legendary former player and general manager Jerry West shares a laugh with Doug.

Foreword

I have known Doug since 1968 as a sportswriter and, more importantly, as a friend. Our friendship was built out of a mutual respect for each other's craft. My many years with the Lakers were filled with frustrations and disappointments. Doug was such a Lakers fan and always seemed to take the disappointments as personally as our team. He could be a tough critic but always was a fair one.

Doug has lived a life in the media business as a traveling reporter, a columnist and a radio announcer. During the traveling years, Doug led a rather carefree and somewhat wild life, especially after he and his first wife split up. He gambled, drank heavily and chased around, and although that might sound exciting, at the end of the day he had no one to bring stability to his life.

Then Gillian unexpectedly entered his life, and the spark was back. She was everything that Doug needed, and although he was guarded at first, perhaps because of the carefree bachelor life he had been leading, he eventually fell in love. They soon married, but not long after that another unexpected event took place: Gillian was diagnosed with cancer. Though Gillian fought hard and courageously, she lost the battle, and Doug's heart was broken. The love of his life was taken so quickly, and Doug spiraled into deep despair for a few years.

Perhaps therapeutically, Doug began writing this book—a book filled with candor and honesty about his turbulent life and the love of his life. Although this book was a difficult task, Doug has written with courage and honesty and has shared his demons and secrets with us all.

Congratulations to you, my friend.

Jerry West

Special Acknowledgement

U nlike writing a newspaper column, which can be done in a few hours, the creation of a book is a totally different challenge. I equate it to what major-league players go through in their professions. Their toil is like a grueling marathon rather than a brief sprint, as they compete day after day with joyful moments and despairing ones from April until October, with only a few off days. I found writing a book to be comparable, as the editing, the research, the composition, the endless fact-checking and the attempt to set down the prose in an orderly fashion turned out to be a daily, weekly, monthly grind for almost a year. A lot of dormant memories were revived, many glad ones, many sad ones and many that, frankly, I now find astonishing since some of those memories brought back a person—me—I described who doesn't faintly resemble the person I am today.

I doubt I could have written this book without the stellar support and constant encouragement of my fiancée, Kathy Heddy-Drum, who selflessly goaded me to write on a sensitive subject—the tragic saga of my late wife, Gillian—that I had kept hidden in the attic of my senses for a decade. Like Gillian, Kathy is also a kind, giving, sweet person. She also is a doting mother, and her daughter, Lolo Silver, is a member of the USA Water Polo team; her son, Matt Drum, is a star water polo player and swimmer at Los Alamitos High. It's not surprising that Kathy's children have excelled in aquatics, since Kathy herself was a swimmer extraordinaire who won four gold medals in the 1975 Pan-American Games and also was a participant in the 1976 Montreal Olympics.

Prologue

It is 4:00 a.m. on September 11, 2001, and my wife, in a desperate, pleading voice of sadness, awakens me from a fitful sleep and says, "Please call the hospice nurse. I can't take the pain any longer."

I turn to her in the darkness of the bedroom and know at that instant the end is near, that her horrific year-and-a-half struggle soon will be over, that all the surgeries and treatments and consolations and prayers won't contain her deadly disease.

I never had heard her during this agonizing period complain about her plight and the terrible physical and mental torment she had been enduring.

Within an hour, the hospice nurse makes an appearance at our home, injects her with a shot that instantly brings her relief from the harrowing pain and induces sleep.

We are awakened a couple hours later by the loud ringing of a phone perched on a nightstand near me, and I drowsily answer it.

I hear the voice of a friend named Mark Emerzian and chide him before he even starts speaking.

"You know better than to call this early in the morning," I say as I blearily gaze at a digital clock that informs me it's 6:45 a.m.

"I'm so sorry, but, well, America is being attacked," says Emerzian somberly. "They've struck the Twin Towers in New York and the Pentagon in Washington, D.C."

"What?" I reply, quickly forgetting my irritation.

"Turn on the TV. We're under attack. It's Pearl Harbor all over again," says Emerzian.

I quietly get up and go to the front room, where I click on the TV and begin watching in horror the images coming out of New York and Washington, D.C.

I walk back into the bedroom after awhile and inform my wife of the chilling events.

Her eyes remain shut, and she doesn't respond.

The strong dosage of morphine the hospice nurse has injected has her in a comatose state in which she will remain for the rest of her life, which will come to a blessed end four days later.

But as far as I'm concerned, my wife, my Gillian, my dear Brit, ceases living on September 11, 2001, as nearly 10,000 others do around the country on that infamous day, a total inflated by the 2,996 who perished from the terrorist attacks.

I am stunned by the tragedy unfolding on the other side of the country, as well as numbed by the one unfolding in my midst.

My thoughts are a tangle of despairing emotions.

The international romance Gillian and I had that was so implausible, so defiant of convention, so joyful, so plagued, ultimately, by misfortune is drawing to a dark finish.

The chances of our hooking up in the first place, much less even meeting each other on that rain-soaked afternoon in a railway station in the south London district of Crystal Palace in the spring of 1992, were roughly tantamount to a person being struck by a meteorite in the middle of the Sahara Desert.

"A 50 trillion to 1 proposition our ever coming across each other," I often said to Gillian, who always nodded in agreement. "And a 100 trillion to 1 proposition our ever marrying each other."

It was a quirk of incomprehensible fate that I was even in England when I met Gillian. It was a country I had not previously visited and hadn't planned to visit until I suffered what I felt was an injustice that inspired my making an intemperately impromptu decision: boarding a Virgin Atlantic flight to Heathrow a mere three hours after I decided to make such a trip.

Our lives, our backgrounds, our professions, our beliefs, our ages were such a disparate mixture that I often wonder how we were able to create the magical alchemy that resulted in a fiercely devoted and loving relationship.

Still, in retrospect, there were forebodings in our brief marriage, going back to the first year of it when her impending, passionately desired

motherhood was cruelly denied on the same day we were set to buy a crib for the child that was expected in less than four and a half months.

The trajectory of life is rife with gladness and sadness, triumph and failure. The random fickleness of it conspires against certainties, and one never knows what lurks around the corner except the taxman always waits at the gate to collect his due.

"You too often take life for granted and don't realize how special it is until you know it's nearing an end," Gillian once said during her sickness. "You come to realize the beauty of it all—the chirping birds, the barking dogs, the beautiful flowers and trees, the mountains, the lakes, the cathedrals, the art museums, the great cities, the tender relationships you make with people, the different cultures you're able to experience in different countries. I'm just glad I was able to experience what I did. I'm glad we were able to experience together what we did."

We experienced a lot during the time we were together, the aging sportswriter from America who finally settled down after years of hedonistic wanderings and the young woman from Great Britain who was responsible for such a dramatic transformation.

We watched the new millennium arrive in the Middle East on the seventh-story balcony of our Le Meridian Hotel room in downtown Damascus. We had celebrated the previous New Year amid loud, garish fireworks at the Brandenburg Gate in Berlin. We were among the shrieking multitudes a couple years earlier watching the ball drop at Times Square in New York. We saw the grisly, sordid rematch between Mike Tyson and Evander Holyfield at the MGM Grand Arena in Las Vegas, the one in which Tyson was disqualified for chewing off a portion of Holyfield's ear.

And we jogged everywhere—Circus Maximus in Rome, Englischer Garten in Munich, Tiergarten in Berlin, Alster Lake in Hamburg, Grosser Garten in Dresden, Promenade de la Crosiette in Cannes, Tuileries in Paris, Regent Park and Hyde Park in London, Phoenix Park in Dublin, Prater in Vienna, Central Park in New York, Grand Tetons in Wyoming, Sun Valley in Idaho and El Dorado Park in Long Beach, as well as Banff, Vancouver and Victoria Island in Canada.

We never had a serious argument and never retired for the evening angered at each other, but the romantic idyll was too fleeting.

Why, I kept asking myself that horrifying September morning of apocalyptic happenings, is this woman who assisted so many ailing elderly folk in her duties as a physical therapist with the National Health Service in London, who had a tenderness and kindness that bordered on the divine, having her life cut so prematurely short?

Why is there no sense of proportion, of justice, of equity in this world that can be so enchantingly pleasant and yet so wickedly mean?

Why, oh why?

It's a question posed by everyone who has lost a loved one in tragic circumstances, and there's no logical explanation except the ones tendered by those with sanctioned affiliations with the Almighty.

Chapter 1

I don't believe in serendipity and view as mountebanks those who claim to have powers of clairvoyancy. But what occurred that long-ago day that brought Gillian into my life does make one idly wonder about unexplainable phenomena.

It was the middle of a Friday afternoon, and I had walked to the Crystal Palace railway station from a nearby athletic facility where I had just finished interviewing an American football player. There were two benches on the station's platform, and I noticed one was crowded with young students, while another had only one person on it, a woman engrossed in a newspaper. I decided to sit by her.

My hair, clothes and shoes were damp from the rain that had been relentlessly persistent during the three days I had been in London.

I sat quietly, looked straight ahead and waited for the train that would take me back to Victoria Station. It was due in fifteen minutes, and one did arrive at the designated time but zoomed past without stopping.

In frustration, I turned to the woman next to me and asked, "What happened?"

"The train that was supposed to stop was canceled, and the next one won't come for another forty-five minutes," she said in a thick English accent as she peered up at the overhead board that displayed the train schedules.

The woman was adorned in an overcoat, and she had long, thick brown hair that hung to her shoulders and framed a youthful face that I immediately noticed was without makeup.

She returned to reading the paper—I believe it was *The Guardian*—and I cast a sidelong glance in her direction, instinctively curious about the shape of the anatomy that was camouflaged by her overcoat.

Then I noticed a revealing characteristic. Her fingers were long, thin and delicate, even elegant. Piano fingers. Angelic fingers. Fingers that indicated to me that perhaps I should engage her in a conversation.

Not that I had any ulterior motives toward this stranger who still was seated beside me only because of a train foul-up. A long, deteriorating relationship I had been in had just ended, and the last thing on my mind that dreary day was pursuing a woman, which actually is quite ironic since pursuing women had been such a dominant part of my life since the breakup of my first marriage more than a decade earlier.

"You from London?" I asked in commencing a dialogue.

There was no hesitation in her answer, which indicated to me she was willing to be sociable.

"Oh, I've lived here a few years, but originally I'm from Hartlepool," she said.

"Where in tarnation is Hartlepool?" I wondered.

"It's up in the northeast near Newcastle," she replied.

"I thought Newcastle was a beer, not a city," I said, trying to be humorous. She smiled amiably.

I asked her what she did for a living, and she told me she was a physical therapist with the National Health Service.

"That's why I'm here in Crystal Palace today because I worked with some senior citizens in the swimming pool," she said. "What do you do?"

"I'm a newspaperman from Los Angeles," I replied.

"That's interesting. What brought you to Crystal Palace?'"

I paused momentarily in reflection and peered vacantly ahead, retracing the factors that had led to my coming to this faraway land, to my being at this spot at this moment in what was pure happenstance.

It was inconceivable earlier in the week that I would have been present. It was a mere three days ago that I was having lunch at a popular restaurant, Phil Trani's, in the California beach city of Long Beach with a couple of pals, Van Barbieri and Don Kramer, and hadn't the faintest notion at the start of it that later that afternoon I would be on a flight to London.

I was in a downcast mood that day because of my recent peripheral involvement in radio that had ended badly. At the time, I was naïve about the industry, was unaware of its maddening unpredictability, its ephemeral nature, its rampant personnel upheavals.

Doug is flanked by Los Angeles Clippers owner Donald Sterling (left) and UCLA's legendary basketball coach John Wooden.

I long had been in the newspaper business, which in those pre-Internet, pre-iPad, pre-Twitter, pre-Facebook, pre-iPhone days was a thriving entity and not in the moribund state it is today.

I had been active in chronicling sports on the Southern California landscape for several decades, first for the Hearst-owned *Los Angeles Herald Examiner*, where I worked from May 1968 until it ceased publication on November 2, 1989, and then with the *Long Beach Press-Telegram*.

I never even had actively sought employment in radio and savored my job as a sports columnist covering Olympic Games, Super Bowls, World Series, Rose Bowls, NBA Finals, world championship fights and all the high-profile athletic events in the Los Angeles area.

I had become known for expressing strong, irreverent opinions in print—I had rows across the years with such American sports figures as Wilt Chamberlain, John Wooden, Joe Namath, Al Davis, Carroll Rosenbloom,

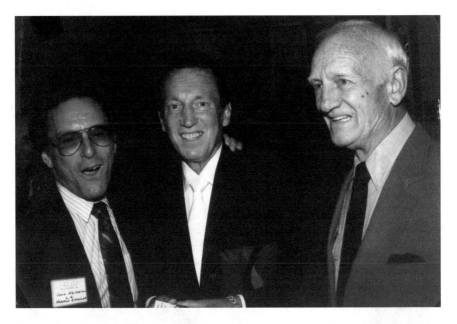

Doug poses with two gridiron legends, Al Davis (center), late managing general partner of the Oakland and Los Angeles Raiders, and Tom Harmon (right), the 1940 Heisman Trophy winner at the University of Michigan who became a longtime sports broadcaster.

Howard Cosell and countless others—and was a frequent guest on many of the Los Angeles radio and TV sports shows.

One of the radio stations I often was on was 710-AM, KMPC, which then was owned by the one-time cowboy film star Gene Autry. It long had been carrying the games of the Angels—Autry also owned that Major League Baseball team—and the Los Angeles Rams, but it was a station geared mostly to music.

I guess I had made a favorable impression with the KMPC management because it offered me a job when the station was set to change its format and become the first twenty-four-hour sports talk outlet in LA.

I was set to become a co-host with an outspoken local radio voice, Joe McDonnell, and we were going to work the midday shift, followed in drive time by Jim Lampley, the HBO fight announcer.

I actually was looking forward to the opportunity, not only for the increased visibility it would bring me in the LA media market, but also for the increased financial benefits.

But the week before our show was to debut, KMPC management suddenly decided to replace me as McDonnell's partner with the former Los Angeles Raider star tight end Todd Christensen.

"I hold the distinction of being the first person ever fired in radio before even going on the air," I had told Barbieri and Kramer.

Which, of course, was not true.

In the many years I would go on to be active in radio, I'd see a lot of people offered jobs—only for the offers to be withdrawn at the last moment for various reasons, most of them nonsensical.

"Don't be too down…You still have your job with the newspaper, which is your real job," said Barbieri, a former fight publicist for Aileen Eaton at the old Olympic Auditorium in downtown Los Angeles who also had once served as an aide-de-camp for the Hall of Fame football coach George Allen, who long had been a close friend of mine.

"Working two jobs takes too much time anyway," said Kramer, a Runyonesque character and lifelong ticket scalper known by the sobriquet "Donnie No Win" for his peerless knack for making unsuccessful sporting wagers.

Then Kramer, given to mindless pronouncements, said, "Why don't you go fly to London to cool off?"

For once, Donnie No Win made sense.

Why not? I thought to myself.

"For the first time in your life, Kramer, you said something that isn't outlandish," I responded, even though what Donnie No Win said was typically outlandish. "Good idea. I think I am going to take your advice and go to London later this afternoon. Why not? I've never been there even though I've visited Europe many times. I think I could use a week off to clear my head. I know there will be no problem from the paper getting the time off since I have a lot of vacation time saved up. And I already have a round-trip ticket."

"How's that?'" wondered Barbieri.

"I have one of those buddy passes, a non-revenue ticket in which I only have to pay for the tax, which is usually less than $200," I replied. "Airline employees get them, and mine came from a friend who works for Delta. The guy's allotted sixteen a year, and I always wind up buying five or six for travel in this country and abroad. And I always kept one in hand in case I want to fly somewhere quickly like I'm now going to do today."

I checked my watch. It was 1:30 p.m. Van Barbieri gave me a puzzled look.

"You're kidding, aren't you…You're really not going to go to London today?" he said.

"Yeah, I am," I said.

And within four hours on that fateful Tuesday in early April, I was on a Virgin Atlantic flight to London and even wound up being seated in business

class because the buddy pass allowed for such an upgrade (Delta Airlines had a co-share with VA in those days).

I checked into the Park Lane Hilton across from Hyde Park late the following morning, and the first couple of days I visited the Tower of London, Buckingham Palace, Westminster Abbey, Madame Tussauds, Harrods and a lot of pubs. I also went on jogs at Hyde Park and Regent Park and found myself wildly amused by the salacious London tabloids.

On my third day in the city, I noted an item in one of the sports sections that a former Long Beach State receiver, Sean Foster, was a member of the London Monarchs. The Monarchs were in the World League of American Football, which now is extinct but then had teams in several major European cities and was being subsidized by the National Football League.

I already had become slightly bored and figured I'd mix in some work—Foster would make for a nice Long Beach story—on a day I had nothing planned until the evening. I reached a person in the Monarchs' public relations office, found out the team trained at the Crystal Palace Athletic Fitness Center and had the fellow set up an interview for me with Foster at 1:00 p.m. I had no idea how to get to Crystal Palace, but the PR guy told me what train to take, and I made it there without any trouble.

After the session with Sean Foster had ended, I trudged back to the railway station to return to the hotel. I was set to be picked up at 6:00 p.m. by the prominent boxing and track writer of the *London Sun*, Colin Hart, who was going to drive me to his home for dinner.

And now I was seated next to this young lady who had just asked me the reason for my being at this south London location at three o'clock on a Friday afternoon.

"I just got finished interviewing an American football player who went to college in the city where I work," I finally responded.

She nodded, and we continued to talk about various trivial matters until our train arrived, whereupon we both got on the same carriage and sat in seats across the aisle from each other.

We resumed our conversation as the train made a couple of stops, and then, as it slowed for Streatham Hill, she said, "Well, it was nice talking to you, but I'll be getting off here."

"Oh yes, nice talking to you also," I said.

We both looked at each other warmly, and then she started to rise.

And strangely, I felt like rising also and accompanying her off the train. But that was absurd because I didn't even know her name, and anyway, she couldn't have been more than twenty-two or twenty-three (I'd find out later

she was twenty-five); and anyway, I was too old at forty-eight; and anyway, I'd be back in LA in a couple days; and anyway, for a pleasant change, I hadn't been seeking any female companionship on this trip and had been determined to keep it that way.

But my instincts took over, and suddenly, I found myself saying, "Gosh, I don't even know your name."

"Gillian," she answered.

"I'm Doug," I said.

The train was braking to a stop, but I didn't want to stop my interaction with Gillian, and I simply said, "Listen, I'm going to be here in London until Tuesday. Maybe we can get together for lunch or dinner."

"Sure."

"Can I have your phone number?"

"Sure."

The train came to a stop, and I hurriedly pulled out my pen and notepad as she gave me the number.

"I'll call you tomorrow."

"OK."

We shook hands softly, she disembarked and I figured it would be the final time I'd see Gillian.

I was wrong.

Chapter 2

I had an enjoyable time that evening with Colin Hart and his wife, Cindy. She cooked a superb dinner that featured boiled beef, and Hart, a Fleet Street veteran I had come across many times in Las Vegas at major title fights, proved to be a superb raconteur.

But what made that evening even more pleasurable was the unexpected experience I had earlier in the day at the Crystal Palace train station. I told Colin and his wife about it, and I remember Colin saying to me, "Looks like you met your future wife." We all laughed at such a ridiculous statement.

I knew nothing about Gillian except that she had flawlessly textured fingers and worked for the NHS and resided in Streatham Hill and came from some place called Hartlepool. Yet I found myself that night thinking about our unlikely meeting and wondering, even hoping, we'd meet again over the weekend.

I called Gillian late the next morning and asked her to have dinner with me that evening.

"Oh, I can't because I'm going to a friend's birthday party tonight," she said.

I figured such a response was her gentle way of letting me know she wasn't interested in getting together and that she had simply been courteous the previous day when she had given me her phone number without hesitation.

But just as I was set to quickly end the conversation to spare her, as well as myself, any further discomfort, I heard her say, "But I'm free on Sunday."

I was startled. Maybe she really did have a birthday party to attend. Maybe she wasn't brushing me off.

"Sure, anytime would do," I responded quickly.

"I'll meet you in front of the National Gallery at Trafalgar Square. Would 10:00 a.m. be all right?"

"Certainly."

After going on a lengthy run at Hyde Park, traipsing around Piccadilly Circus, visiting a couple of pubs and taking a leisurely afternoon nap, I had an early dinner that Saturday evening at a Chinese restaurant and went to sleep by 11:00 p.m. so I'd be well rested for whatever was on the agenda Sunday.

Not that I was even certain Gillian would actually show up to meet me at the National Gallery. I had been single long enough to know the vexing capriciousness of these types of first-time dates and that being stood up was always a distinct possibility.

So when the phone rang in my hotel room at eight o'clock that Sunday morning and I heard Gillian's voice at the other end when I answered it, I figured she was calling to tell me she was canceling for one illegitimate reason or another.

"I'm sorry, Douglas," she began, and I knew what was coming next. "But I can't be there at 10:00 a.m. I didn't get home from the birthday party until three o'clock in the morning…"

My heart sank. The gleeful anticipation I had felt since meeting Gillian had instantly disappeared and been replaced by disappointment.

But then, to my surprise, I could hear her saying, "I just woke up. Do you mind if we push it back to twelve o'clock?"

"No problem at all," I said coolly in an attempt to disguise my relief. "I'll be there at noon in front of the National Gallery. Looking forward to it."

I hung up, sighed deeply and shrieked in ecstasy, "Yeah, baby!'"

Unbelievable!

This young lady I didn't even know calls to apologize for coming late when I figured she was calling to tell me she wasn't even coming.

I arrived at Trafalgar Square at 11:15 a.m., and naturally, it was drizzling. I walked slowly around the crowded area gazing vacantly at the Nelson Column and statues of other dead English war heroes and began thinking about the absurdity of the situation.

Here I was, on an impulsive whim, in a foreign country thousands of miles away from home waiting for a young woman I had known for barely an hour. What would we do for the remainder of the day? Why did I arrive forty-five minutes early? Would she still even show up?

Noon came, and there was no Gillian. Ten minutes passed and still no sign of her. I began to get slightly agitated. Remember, those were the pre-cellphone days when plausible explanations for tardiness could not easily be communicated.

But then, at around 12:15 p.m., I spotted her walking briskly across the square toward the National Gallery and hurriedly went over to meet her.

"Oh, I'm so sorry I'm late...the train was delayed," she said.

"No problem whatsoever...We already know about train delays," I said, as I clasped her right hand gently and looked into her expressive brown eyes that I found unusually captivating.

I noticed once again that her face was unmarred by makeup and also noticed that her lips were full and that she had a perfectly formed chin below teeth that were in need of braces, which she would be fitted with shortly after we got married.

There was no flash allure about Gillian, but I realized as I surveyed her for the first time in a more discerning manner that she was one of those women whose lack of name-brand apparel and upscale accoutrements and garish cosmetic enhancements belied a natural beauty oftentimes not easily detected by casual observance.

There was a momentary silence after our opening greeting before she said, "I'll show you a few places around London. Do you mind starting off visiting the National Gallery? Do you like art?"

"Yes, that would be great, and I love art," I said, even though I was fibbing and knew nothing about it.

And so we spent the next couple hours roaming through the maze of rooms at the National Gallery, and Gillian astounded me with her knowledge as we viewed some of the 2,300 works that hung on its walls.

The first painter who caught my attention that afternoon was John Constable, whom I'd never heard of before entering the National Gallery. I found myself being drawn to his evocative paintings, including the *Hay Wain*, which I later would learn was his most acclaimed one.

"Who is this Constable?" I asked Gillian, and she told me he was a Suffolk romantic artist known for his landscape renditions.

As we strolled the premises, I'd ask her similar questions about men with surnames like Turner, Botticelli, Bruegel, Caravaggio, Poussin, Vermeer, Titian, Reynolds, Degas, Renoir, Chardin, Delacroix, Rubens, Ingres and others whose work caught my attention.

I previously had been to only two other European museums—the Louvre in Paris and the Alte Pinakothek in Munich—and had walked briskly through both with a bored indifference.

But not this time, as we paused at paintings we found interesting, with Gillian providing insightful commentary. I always point to that day as being the one I was seized by an epiphany that resulted in my becoming

a passionate devotee of art. During the next decade, I would wind up buying more than one hundred books on the subject, stocking my home with countless prints I would have framed and visiting many of Europe's most renowned museums.

After departing the National Gallery, we had lunch at a nearby café, and my inquisitive nature resulted in my pressing Gillian about her cultural tastes and background.

I found out that she enjoyed attending plays and films, relished the literary offerings of Shakespeare, Auden, Kundera and Murdoch and, of course, liked art.

I found out she grew up in Dalton-Piercy, a small township (population ninety) three miles from Hartlepool, had an older brother and sister and was a rebellious teenager who had been a poor student until a derogatory comment from one of her instructors altered her life.

I found out she had a close relationship with her parents and that her father had been a manager in an engineering firm and that her mother had been a business studies instructor.

I found out she graduated from the University of Newcastle with a degree in physiotherapy and that she went to work at the oldest hospital in London, St. Bartholomew's—the Barts—at age twenty-one.

I later would find out a lot more about Gillian from both her and her sister, Katharine Elliott, and what she told me that day was a mere threadbare glimpse of the fascinating maturation she underwent in her late teens and the struggles she faced in her early days in London.

We must have walked at least ten miles that first day together, amid the ceaseless stream of double-decker red buses and black taxicabs that clogged the thoroughfares. As we headed to Greenwich, which is almost six miles from central London, Gillian turned out to be a stellar tour guide, as she kept pointing out historic sites along the way.

It was during this period I found myself warming to her thick accent with its strong enunciation on heavy consonant words that often were indecipherable. I would find out it was sort of a hybrid Teeside-Geordie dialect, although I later would discover that you risk being verbally accosted if you dare tell people from Hartlepool that they sound like a Geordie, which is what the good burghers of Newcastle are called.

As we navigated the streets, I suddenly found myself having to stifle the urge to hold Gillian's hand. She still hadn't given me an indication that this was anything more than a platonic engagement in which she was simply being kind to a foreigner with no knowledge of the great city.

As the afternoon grew late and darkness neared, I braced myself for her farewell and figured we'd go on with our lives without further contact. But I was surprised when this soft-spoken lady with a sweet disposition said, "Would you like to see where I live?"

"Yes, for sure," I said, barely able to contain my excitement. "And then we'll have dinner."

"That would be nice," she responded, and suddenly I began viewing her differently. Why would she invite me to see her living quarters and then agree to have dinner with me if she had no interest in me?

It turned out Gillian resided in a second-floor, two-bedroom walk-up at 85 Salford Road in the south London district of Sreatham Hill that she shared with a male roommate—she owned 50 percent of it—in an ethnically diverse neighborhood. It was small but comfortable and had a front room with a couch and desk in it.

We stayed there about fifteen minutes and then walked to a nearby Italian restaurant that was crowded. We sat at the bar for the next three hours, during which we ate and drank and never stopped talking.

Although there were moments when I could have used an interpreter to translate what Gillian was saying—I swear I only understood her half the time that night—I found her severe accent to be enchanting. I never tired of listening to Gillian throughout our relationship, and it turned out she felt the same way about me.

I don't know for sure how many screwdrivers I consumed that evening, but I know it was enough to keep me chatting excitedly away, not only with Gillian, but also with the bartenders, waitresses, busboys, customers and owner of the restaurant. Gabbing with strangers in such an environment long had become a playful habit of mine.

Fortunately, Gillian always found such antics entertaining since she said English men were notoriously reticent and that none came even faintly close to being as outgoing and friendly as I was in public venues.

I must have had three drinks after dinner—she had actually been pacing herself and turned to water after two glasses of wine—and remember asking her if she had ever before been out with an American.

"Oh, no, you're the first one," she answered quickly. "And I've had a wonderful time today."

"So have I," I said, and I put my right arm around her shoulders in a sign of affection.

She looked at me shyly, and suddenly I felt an urge to go a step further to display the growing fondness I was feeling for this demure lady whom I already realized was cut from a different raiment.

Should I, I thought to myself? Should I risk alienating her? Should I set myself up for a humbling rejection? Or should I go ahead and attempt to kiss her?

Emboldened by alcohol, I chose the latter. I bent over and put my lips firmly against hers in what would be the first of several ardent kisses we'd exchange at that restaurant on that glad evening.

We stayed until the place closed and straggled back to her flat as I resumed grilling her lightly.

Among other things, I found out that she was devoted to fitness, a dedicated jogger and swimmer.

I wasn't surprised, since the frame that had been concealed by her overcoat at the Crystal Palace railway station was trim and firm.

"I run as much as I can," she said. "In college, I was into judo. I actually wound up earning a black belt."

She then related a story that I found humorous at the time without realizing the deep insight it revealed about her character.

"A couple of years ago we were at a party here in London, and there were some British Royal Marines present," she said. "Well, one was pretty drunk, and he pinched my bun as I walked past him. I reacted instinctively and body-slammed him. Other partygoers immediately came over and warned me that there might be serious trouble and that the embarrassed Royal Marine and his friends might seek revenge against me and the friends I was with. We were advised to leave, and so we reluctantly did."

I couldn't imagine a lady who didn't weigh more than 115 pounds—Gillian was five-foot-five—roughing up a Royal Marine, but I would discover in time that Gillian's gentleness and sweetness obscured a resilient toughness that she displayed so admiringly throughout her most formidable ordeal.

"I also like working out," I offered. "Lifted weights most my life. In my younger days, weightlifting dominated my life. Boxed a little. Grown to love jogging in recent years."

I suddenly realized a most embarrassing oversight on my part.

"You know, I don't even know your surname," I said.

"Howgego," she said. "What's yours?"

"Krikorian. Howgego? What ethnic origin is that? That doesn't sound British."

"The origin supposedly is Huguenot. I know about 200,000 Huguenots had been driven out of France in religious persecutions by the end of the seventeenth century. I guess my distant family was one of them."

"Well, Gillian Howgego, do you mind if I stay at your place tonight? I have no idea how to get back to central London. I'll sleep on the couch."

I was taken slightly aback by her response.

"That won't be necessary," she said softly.

Chapter 3

It didn't take me long to realize that Gillian was devoted to her profession, and that made a favorable impression on me. She rose early the next day for a treatment session with an elderly gentleman who had suffered a stroke, driving over to his residence that I recall as being in Whitechapel, the east London district where Jack the Ripper committed his notorious murders.

She would meet with four other patients that day and not return to her flat until eight o'clock in the evening. I later would discover from her co-workers how much she was revered by those she treated and that she often would provide assistance to those in need of it even on her off days.

I took the train back to central London later that morning, got off at Victoria Station, checked out of the Park Lane Hilton and returned to Gillian's flat by noon. I was going back to Los Angeles the next day and decided to take an afternoon stroll around Streatham Hill.

There was a foggy mist—I still hadn't seen sunshine since arriving in London—hanging over what turned out to be an eclectic area in which there were myriad small shops, a large bowling alley, an indoor public swimming plunge, a couple historic movie theaters and many cafés and pubs.

But my favorite place turned out to be a pint-sized establishment I found around the corner from Gillian's residence operated by two spinster sisters who related to me their experiences during the London Blitz when they hid in an underground railway station bunker as the German bombs fell. Despite its small dimensions, the place was stocked with a lot of merchandise and reading materials, including all the London newspapers, of which I purchased six.

Gillian was exhausted when she finally arrived home that evening, and I would later find out she routinely put in twelve-hour days. We went out for an Indian dinner—it turned out to be her favorite cuisine—and I soon discovered that Gillian was a strong advocate of women's rights, that she served as a union rep, that she hadn't been fond of Margaret Thatcher and that she wasn't a monarchist.

I listened attentively and didn't react to anything she was saying even though I was more conventional on political matters. After all, it was too early in our brief time together to engage in a debate over subjects that weren't exactly high on my priority list.

She also informed me she had recently had a relationship come to an end—much like myself—and I found a refreshing innocence in her sincere, transparent manner in which there wasn't a hint of opaqueness.

At this early juncture, I made a concerted effort not to volunteer information about myself unless asked, and I continually, slyly maneuvered the discourse toward Gillian. I noticed long ago that guys in such circumstances who babble on about themselves in the first person often send yawning women scurrying to the exits.

Finally, after a while, Gillian said, "Douglas, I'm tired of talking about myself. What about you? I don't know anything about you."

Despite my reluctance, I knew I had to reveal a few tidbits.

"Well, ask me a question," I responded.

"What led you to becoming a newspaperman?" she asked.

"Yes, well, it all goes back to the first Major League Baseball game I ever attended between the San Francisco Giants and Los Angeles Dodgers at Seals Stadium in San Francisco when I was fourteen years old," I responded, purposely leaving out the year—it was 1958—so she couldn't figure out my age. "I was with my father, and we arrived at the stadium early and watched the players go through their hitting and fielding drills. And I saw a group of men on the field in suits and sports coats holding pens and notepads and asked my dad who they were. And he said, 'They're sportswriters. They cover the teams for their newspapers.' And I said, 'You mean they get to travel with the teams?' And my dad said, 'Yes.' And from that moment on, I wanted to become a sportswriter because I knew even at that age that I'd never realize my passionate desire to become a Major League Baseball player. So I figured the next best thing was to become a sportswriter and get the opportunity to travel with a major-league team.

"And that's precisely what happened a few months after I joined the *Los Angeles Herald Examiner* [of course, I didn't mention the date]. I was given

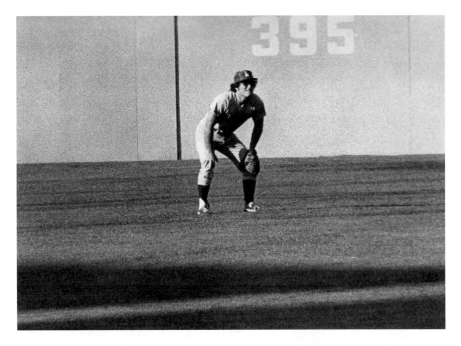

Doug patrols center field at Dodger Stadium in 1974 during a celebrity baseball game.

the opportunity to take a road trip with the Los Angeles Dodgers, and it was a surreal experience as I visited places like New York, Pittsburgh and Houston for the first time. And then that fall, my boss at the *Herald Examiner*, a legendary, larger-than-life character named Bud Furillo, assigned me to cover the Los Angeles Lakers. And they had three of the most famous basketball players in the world on the team in Wilt Chamberlain, Elgin Baylor and Jerry West. And the next two seasons, I had to be one of the happiest persons in America, as I was traveling first class around the country with the Lakers and visiting all the big cities and staying in top hotels and being friends with most of the Lakers players. I even served as Wilt Chamberlain's chauffeur one afternoon in Atlanta as we drove around checking out women, a fact Bud Furillo later would report in his column in the *Herald Examiner.*

"Now I'm sure you don't even know who Wilt Chamberlain was, but he was a seven-foot-one superstar center who once scored one hundred points in a game and once averaged more than fifty points a game for an entire season. He and I didn't get off to a good start with the Lakers. Early in that first season I covered the team, Wilt had played poorly in a game, and my lead paragraph in the *Herald Examiner* the next day was, 'Wilt

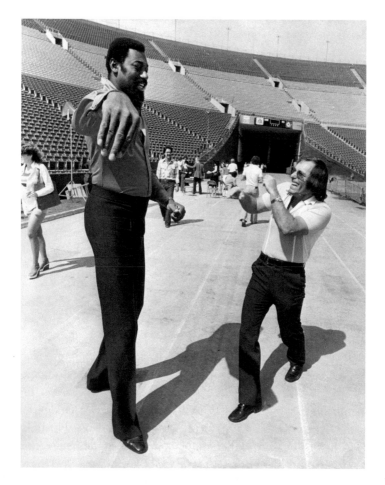

Wilt Chamberlain waves off the potential cameraman's evidence on the track at Los Angeles Memorial Coliseum as he and Doug prepare for mock fisticuffs.

Chamberlain was the tallest spectator at The Forum last night…' And a couple of nights later at The Forum, a few hours before the game, he saw me in the team's offices, came up to me and said angrily, 'Hey, my man, who in the fuck do you think you are saying I was the tallest spectator at The Forum the other night?' And I said, 'Well, Wilt, you were.' And he gave me a look of utter contempt and said, 'I should kick your ass for that.' And I said, pointing to my chin, 'Go ahead and take your best shot. I need the money.' I was scared to death, but I was young and dumb and had a lot of nerve in those days. Well, Wilt suddenly broke out in a laugh, extended his

right hand and we became friends until years later when he got mad at me again at another story I had written about him. He hasn't spoken to me for the past five years."

Gillian smiled softly and said, "That must have been some experience."

"It was a dream come true, and I kept pinching myself to make sure it wasn't all a dream during my early days at the *Herald Examiner*," I said. "I was being paid to do a job I gladly would have done for nothing. Here I was, a young guy who came from a small, sleepy farming community of fewer than two thousand called Fowler—it was located in the middle of California near a place called Fresno in the San Joaquin Valley—and meeting all these famous people. Never forget that first holiday season at the *Herald Examiner* receiving a Christmas card from the actor Cliff Robertson and his wife, Dina Merrill. I must have proudly shown that card to everyone I knew. I was too naïve at the time to realize that their PR agency had sent out Christmas cards to all the members of the Los Angeles media."

There was so much more to tell Gillian, but it all could wait. I didn't want her yawning and scurrying to the exit.

I paused a moment and then said, "That's enough talk about me. I think you're much more interesting."

"No, Douglas, I think you are," she said.

She drove me to Heathrow early the next morning, and I remember during the flight back to Los Angeles how different I felt than I had the previous week when I arrived in London upset about the failed radio opportunity and not exactly cheered by the breakup with my girlfriend.

Now I felt that joyful giddiness endemic to a new romance in which the principals haven't been together long enough to have those long bored silences, or to know each other's faults or to have built up resentments.

Chapter 4

It seemed as though my chance meeting of Gillian Howgego altered my fortunes. Within a month after my return to LA, KMPC management sought my services again after Todd Christensen's pairing with Joe McDonnell had turned sour.

Joe and I, finally, were on the air together by June, and it turned out we had a natural chemistry that resulted in our show becoming an immediate hit on the Southern California airways.

We argued heatedly; never couched our views in euphemistic, PC claptrap; and had first-rate guests from our long list of contacts and an aggressive producer named Nick Zaccagnio. We became known as the *McDonnell-Douglas Show*—a former sportswriter turned fight publicist, John Beyrooty, gave us the nickname in honor of the Long Beach aerospace giant—and we soon took over the prestigious drive-time shift from Jim Lampley, who moved to mornings to replace the departing Robert W. Morgan, a Los Angeles disc jockey institution.

We became so popular—and controversial—that Lampley felt compelled one morning to stage a three-hour referendum on our show. He polled his listeners, and happily, more folk liked us than detested us, though there were plenty of dissenters.

I was now holding down two full-time jobs, and what made such duty especially hard was the daily seventy-mile round-trip commute from Long Beach to Hollywood, where the KMPC station was located on Sunset Boulevard on the one-time Warner Brothers lot where the first talking movie,

The Jazz Singer, with Al Jolson, was shot in 1927. I found myself spending two to three hours a day on the congested freeways.

But I didn't mind such a grind because my monthly income had more than doubled, and the increased recognition—suddenly, people were asking me (me!) for an autograph—certainly wasn't harmful to my vanity. Joe McDonnell and I were continually being mentioned in the local newspapers—it seemed like the *Los Angeles Times*'s radio-TV columnist Larry Stewart, an old friend from college, had a weekly obsession with us—and in July I even was offered a position on an upcoming new football show that would be shown on the local CBS television affiliate. "Krikorian Is the King of All Media," wrote another radio-TV columnist, Tom Hoffarth, in the *Los Angeles Daily News*, affixing shock jock Howard Stern's self-proclaimed moniker on me.

Hoffarth was dripping in sarcasm—he routinely demeaned my radio work—but such a description wasn't that far off the mark. The following year, I even got a speaking role in the Ron Shelton film *Cobb*, based on Hall of Fame baseball player Ty Cobb, which starred Tommy Lee Jones and Robert Wuhl and, ironically, wound up costing me my job at KMPC.

Oh, was I busy then. I was not only doing four columns a week for the *Press-Telegram* and doing five radio shows a week for KMPC but also that fall could be seen on Sunday mornings on Channel 2 with local sportscaster Jim Hill on the *L.A. Football Company*, providing pertinent information and analysis on the two National Football League teams that were then in Los Angeles, the Rams and Raiders.

I had been calling Gillian on a regular basis since our spring meeting and invited her to come and see me even though my time was limited by my hectic schedule. I had had previous dalliances in Europe and even had flown a couple ladies over to visit me, which I regretted both times. Despite the fact I had known Gillian for only a few days, I had a different feeling about her than I did about the others and just knew I'd have no regrets if she came, which she did at the end of the summer.

On a Friday in late September, Gillian arrived at LAX, where I picked her up late in the morning and took her for lunch at Musso & Frank's, Hollywood's oldest restaurant where F. Scott Fitzgerald and Ernest Hemingway once ate lightly and drank seriously, according to lore. We then went to the radio station, where she patiently sat in the studio and listened to Joe McDonnell and me do our four hours of wicked repartee, acerbic putdowns, goofy anecdotes and insightful, albeit at times hilarious, interviews.

I'm sure she was worn out by the long flight and inhumanly bored by our show, but she would say later, "I have no idea what you guys were talking

Rams running back Eric Dickerson (second from the right) became the second player to rush for more than 2,000 yards in a single season, with 2,105 in 1984. He poses here with (from left) Donald Sterling and Doug and (on the far right) former Pepperdine University chancellor M. Norvel Young.

about and who you guys were talking to, but it all seemed so interesting." I thought she was only being diplomatic but found out later it wasn't in Gillian's nature to tell fabrications, even small ones.

I remember her being astounded by the maze of freeways—there are none in London—that crisscrossed the area and her saying, "We have railways and you have freeways."

"There are eight freeways within the LA boundaries covering more than 650 miles," I said, and the only reason I knew such numbers is that I had recently read a magazine story on the subject.

After the show, we flew to Las Vegas, where we checked into Caesars Palace, site of a scheduled middleweight title match the following night between champion Terry Norris and Simon Brown. We freshened up in our room and then headed across the street to the Barbary Coast, a small hotel at the corner of Las Vegas Boulevard and Flamingo that at the time had the

most acclaimed restaurant in Las Vegas, Michael's (it now is located at the South Point Hotel and hasn't lost its stellar gourmet luster).

Dining at Michael's had become a pre-fight ritual for me for more than a decade. It started as a result of the friendship my closest newspaper pal, Allan Malamud, had with Kenny Epstein, who then ran the Barbary Coast for its owner, Jackie Gaughan, a Las Vegas casino pioneer. Epstein always would comp the Michael's dinner because of Malamud, who worked with me at the *Herald Examiner* before joining the *Los Angeles Times* after the *Herald Examiner* folded and long had been a close friend of Epstein.

Allan was a colorful fellow who appeared in bit roles in many movies—director Ron Shelton of *Bull Durham* and *White Men Can't Jump* fame was one of his closest friends—and wrote a popular column of miscellaneous sporting items. He was a ravenous consumer of steaks and pies and cakes and also was a high-stakes blackjack player who would die of a heart attack at the too-young age of fifty-four on September 15, 1996, ironically preceding Gillian's death by exactly five years.

Anyway, as Gillian and I were walking out the front entrance of Caesars that evening on the way to Michael's, the rambunctious fight promoter Don King was coming in flanked by his usual entourage of diamond-bejeweled hangers-on.

I knew King well since I had covered so many of his shows, including most of the title matches of Larry Holmes and Mike Tyson when they were heavyweight champions and the classic Sugar Ray Leonard–Robert Duran fight in Montreal and the infamous "No Mas" rematch in New Orleans.

"Krikorian! Oh, what a delight! What a magnificent, gorgeous, breathtaking young lady you have with you! Indubitably!" he roared, as Gillian shyly looked up at this huge African American gentleman with his trademark hair that resembled a silver-hued bushel of cotton candy.

I heartily shook King's hand and said, "Don, this is Gillian...She's from England."

"Oh, she's royalty! A princess! Wow! So happy to met you, your royal highness!" jested King, in prime hyperbolic form.

Gillian's face reddened, and she nodded in obvious embarrassment.

She had no idea who Don King was, and King would be the first of many sporting personalities she'd meet during our time together, most of whom were unknown to her.

But a few minutes later, after we arrived at Michael's, Gillian did actually meet a person whose name she did recognize: the former heavyweight champion George Foreman. He was at the time in the midst of his remarkable comeback and was a couple years away from stunning the fistic

Roberto Duran, here with Doug, was one of the most enduring fighters of all time across five decades and four weight divisions.

orbit by becoming the world champion again with a tenth-round knockout of Michael Moorer.

George joined us at Michael's that evening because of his long friendship with the zany fight publicist Bill (Bozo) Caplan, a close friend of Malamud who had been working with Foreman since Foreman was an amateur winning a gold medal in the 1968 Mexico City Olympics.

Ironically, it was at Michael's almost six years earlier that I sat next to Foreman, who announced that evening to his dining companions that he was planning to return to the sweet science even though he had been retired from it for almost a decade.

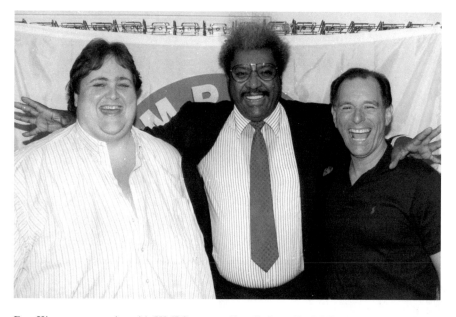

Don King gets expansive with KMPC sports talk radio hosts Joe McDonnell (left) and Doug.

I remember telling George such an idea was absurd—he insisted he wasn't broke even though others felt there was a financial motivation behind his decision—and I repeated my feelings early the next morning when we jogged together around Las Vegas for more than an hour and a half.

Fortunately for Foreman, he ignored my advice, and his comeback would turn out to be a stirring success that would climax with his impalement of Moorer when he was forty-four. It's estimated that his fistic sequel resulted in his earning more than $250 million, and that doesn't even include the $100 million he made outside the ring from selling his share of the George Foreman Grill.

There were ten people in our group that Friday night at Michael's, and what I remember most about that dinner was Gillian taking issue with the way I addressed her during the ordering of drinks.

"Honey, what would you like to have?" I asked. Saying honey and sweetheart and sweetie pie had long been part of my outmoded vernacular.

"My name is Gillian," she responded, loud enough for everyone at the table to hear.

There was a momentarily tense silence, and then Bozo Caplan, ever the jokester, piped up, "C'mon, Doug, how could you not know Gillian's name?"

Laughter broke out, and I said, "Sorry, Gillian, what would you like to drink?"

Privately, I was bothered by Gillian's rather brusque reaction that seemed so out of character for someone I had found to be so soft and sweet, but I let it pass—for the moment.

We had, as always at Michael's, a superlative dinner, and the service was exemplary. Afterward, we watched Allan Malamud play blackjack at the Barbary, and he did well, as he was up over $20,000 when we walked back to Caesars.

Gillian and I went on an hour-long run the next morning, and after we got back, as she showered, I went to the gift shop and bought her a Caesars sweatshirt and T-shirt so she'd have mementoes of her Las Vegas trip.

But when I presented them to her, she shook her head in dissent and said, "I can't accept these unless I pay you for them. I just won't accept them."

Now I had come to realize that Gillian Howgego was a strongly independent lady with feminist leanings. But I had had enough of it and decided to voice my disapproval, which I hadn't done the previous evening at dinner after her chiding of me for my addressing her with an eponymous word.

"First off, Gillian, I'm not trying to buy you with these gifts," I said firmly. "I got these because I like you and because I want you to have something to take back to London as a remembrance of your stay in Las Vegas. You know, last night you seemed terribly offended when I referred to you as 'honey.' Well, it was certainly not my intent to disparage you by using the word. I've long used the word in normal conversation, and if it offends you, I'll try not to use it anymore. But its intent was not to degrade you, as you obviously thought it was. It's just part of the way I speak. I'm sorry that you were so offended."

Gillian bowed her head, and I noticed rivulets of tears suddenly streaming down her cheeks. She rubbed her eyes, glanced up at me sheepishly and said in a low voice, "I'm also sorry. I spoke out of turn, and I'll never do it again. I know you didn't mean anything bad by what you said. Sometimes I guess I get a little carried away, and I'm sure my being up for so long and being very tired didn't help matters. And thank you for the shirts. It's very thoughtful of you."

Never again would Gillian take umbrage with my antiquated terms of endearment, even though they didn't fit within the feminist parameters of her zeitgeist.

Chapter 5

We spent the following afternoon lounging at the Caesars pool, reading, swimming, frolicking and laughing, much of the latter caused by Bill Caplan, whom I long ago had nicknamed "Bozo" for his wacky disposition.

To say I had built up a bizarre collection of pals and acquaintances over the decades would be an understatement of staggering magnitude. Not many were establishment figures, and most were bookmakers, ticket touts, dreamers, gamblers, boozers, skirt chasers, bartenders and guys like Caplan who eat too much and traverse the obstacle course of life with their guiles, smiles, laughter and charm.

Ol' Bozo worked for a lot of famed fight promoters—Don King, Bob Arum, Dan Goossen, Aileen Eaton, George Parnassus—and has been endowed with a God-given skill of being able to schmooze with members of the media and get many to write favorably about his clients' shows even when those shows have been preordained farces.

He was terrific at PR—actually, still is now for Oscar De La Hoya's Golden Boy Promotions—but no one ever made me laugh more than Caplan did on those rare occasions he handled public address chores at boxing matches. Certainly, he wasn't as smooth as the most renowned practitioner of the art, Michael "Let's Get Ready to Rumble" Buffer, but Caplan left the aficionados rolling in the aisles in guffaws with his loud, piercing, melodramatic voice and his humorous introductions like the one he made one memorable night at a small fight show in Anaheim in the pre-politically correct days when he introduced a long-forgotten preliminary

fighter thusly: "And in this corner, he's big, he's bad and he's black." No one giggled more animatedly than the fighter himself, but Caplan, sadly, didn't seriously pursue such an endeavor, even though I think he would have been as successful as Buffer had he done so.

The fight crowd was out en masse at the Caesars pool that scorching late September afternoon, and Caplan cut a most comical figure in his ill-fitting bathing suit with the 315 pounds that amply filled his five-foot-seven frame, giving him an unmistakably noticeable presence.

He never stopped prattling and joking, and Gillian turned to me on one occasion and said, "Are all your friends this wildly amusing?"

"Well, there is only one Bozo, but almost all of them have their own unique personas," I said.

"What do you think of America so far?" I wondered.

"Definitely different," she said. "It seems the people are so much friendlier here. And that was the best meal I've ever had last night. I never had a steak [New York sirloin] like that. Never. And that dessert was incredible. What do you call it again?"

"Bananas Foster," I said.

"Never had anything close to that."

"Neither have I."

"And I've noticed the helpings here are huge, much larger than in England."

When Gillian departed for the restroom, I asked Caplan, "What do you think of her?"

"Sweet girl," he replied. "As long as you don't call her honey."

We laughed.

"No big thing," I said. "She was tired last night. She'd been up for more than twenty-four hours. I told her that's just the way I talk. I think she now understands."

Caplan nodded.

"I've always liked British people, and I'm sure I'll like Gillian," he said. "We'll have fun at the fight tonight. You're not even working it, right?"

"You're right."

Alas, the Norris-Brown fight would be canceled later that day when Brown had to be hospitalized for dizziness, and Gillian and I had an uneventful Chinese dinner at Caesars that evening and then walked around the Strip, where we gazed at the neon sights and had lengthy discussions on various subjects.

I remember her telling me about how she became skilled in judo.

"I got interested in it when I was going to the University of Newcastle and wasn't very good at it at the beginning," she related. "I wasn't really

into it—I was doing it just to keep in shape—but somehow wound up participating in a competition. I faced a woman who was well experienced, and she beat me badly. I thought she was unnecessarily rough with me. Actually, I think she tried to humiliate me. I was not only embarrassed but mad.

"Well, for a whole year, I took judo seriously. Very seriously. Trained about three hours every day. And when I met that woman again in a competition, I was ready for her. And I beat her pretty easily. She was absolutely stunned."

That was my first hint of Gillian's fierce competitive nature. She would go on to display it often when jogging, lifting weights, studying and battling her illness. She betrayed such a side when discussing her early days in London when she was working in the pediatric ward at St. Bartholomew's and residing in a cramped one-room apartment on the premises.

"I didn't know anyone in the city, and there were times when I didn't have enough money for food," she said. "I went to bed hungry many times."

"Why didn't you ask your parents for help?" I wondered.

"Oh, I'd never do that," she said. "I was twenty-one. I was an adult. I was determined to take care of myself. It was a struggle. But I somehow made my way through it."

I liked what I was hearing from this woman whom I knew only on a superficial level. Clearly, she had a strong inner drive and didn't let adverse circumstances unravel her. Who would have guessed that in less than eight years she would be tested beyond human comprehension in this area?

We flew back to LAX the next day, dined that evening at Phil Trani's and went back to my home in east Long Beach, where Gillian took a swim in the backyard pool before going to bed.

That week, I returned to my busy schedule, and I had Gillian wait for me during the afternoons at the Studio City apartment of my close friend Johnny Ortiz while I did the radio show in Hollywood.

Ortiz was a Cuban gentleman storied for his nimbleness at courting women, as well as being known for his lengthy involvement in boxing as a manager, a co-owner of the legendary Main Street Gym in downtown Los Angeles and a longtime host of a popular radio fight show.

At the time, he was residing with his five-year-old daughter, Johnna, who wound up adoring Gillian. Gillian taught her how to swim in the apartment pool and also took Johnna one afternoon to Universal Studios.

I took Gillian with me to the CBS Studio on Sunset on Thursday night, and she watched the taping of the *L.A. Football Company* show and even met a couple Raiders players who were guests on it.

Raiders managing general partner Al Davis holds court with the media. Doug (right center) listens intently.

We got along well, and the twenty-three-year age difference never became an issue, never was even mentioned. I did find it strange that she never inquired about my age, but I certainly wasn't going to volunteer it since I figured such a revelation might frighten her away.

She flew back to London on Saturday morning amid tender embraces and sweet words. I told her I'd be returning to England in late December, which I did.

But I didn't see her and wouldn't for more than three years.

April 1998 [A Dark Omen]

W e were so happy, so blessed, as a fervent desire of both of us soon was to become a reality. I never was filled with greater joy than during the almost five months of Gillian's pregnancy. Finally, at fifty-four, I was going to become a father, much to the relief of my parents, who had yearned for such a wondrous development for many years.

I never had desired to have a family before I married Gillian. I never wanted such a burdensome responsibility, although twice previously I had seemed destined for fatherhood, only for early miscarriages to prevent it.

After Gillian and I exchanged matrimonial vows on September 27, 1997, at the Portofino Hotel in Redondo Beach before a small gathering, we delayed our honeymoon until December, when we took a twenty-six-day trip to Europe.

We started it off in Rome, then went to Cannes and Paris before flying to Newcastle for Christmas at Gillian's parents home in a village near Hartlepool and then continued the journey to Munich, Vienna and Berlin before returning to Long Beach.

I remember one morning in Munich when we were in our Park Hilton hotel room and, as the maid was cleaning it, Gillian was complaining of being nauseous. The maid, who was from the Philippines and spoke English, overheard Gillian. "I think you might be pregnant," the woman interjected.

Both of us ignored what she said—I don't even think we commented on it—but it came to mind a week later on a Friday morning after we had returned to Long Beach when Gillian admitted she was still having occasional periods of nausea, as well as not having her normal menstrual cycle.

I immediately phoned Dr. Narciso Azurin, whose office was in nearby South Gate, and he told me to bring Gillian in for a pregnancy test. Dr. Azurin wasn't my regular physician, but I had come to know him well because his parents lived next door to me.

There are times in one's life when something momentously blissful occurs that is forever etched in one's consciousness—and forever remains a glad remembrance.

For me, that came later on that day of January 9, 1998, when Dr. Azurin called to notify us that Gillian's test was positive and that she was indeed pregnant.

I immediately called my parents, called Gillian's parents, called all my friends and was beside myself with joy, as was Gillian.

How beautifully symmetrical was the life now unfolding for us. We couldn't have asked for a more heavenly blessing.

I recall that evening celebrating the great event at several taverns around Long Beach, buying a lot of drinks and consuming a lot of them—much to my regret the next day when I endured a horrific hangover.

The next couple of months went seamlessly, as regular visits to Gillian's obstetrician resulted in only positive reports, including a ultrasound that showed the fetus in her womb to be male.

I enjoyed those visits, especially when the nurse would rub the ultrasound against Gillian's stomach and I could see a squirming outline of something I had helped create. How proud and exhilarated I felt. I had changed so much since falling in love with Gillian. I had always been so self-absorbed in my job and in my carefree lifestyle and never cared one bit about propagating the human species.

But now I just couldn't wait for my son to be born, couldn't wait to take him to ballgames, to teach him how to hit a baseball, shoot a basketball, kick a soccer ball. I was in a constant state of euphoria, as was Gillian. She had given up so much to join me in America—a job she cherished, a group of loyal friends she cherished, a close-knit family she cherished. It was a daring move on her part, and it was all working out fabulously.

Gillian had been so healthy during her pregnancy that we never missed a workout, either at Frog's, a fitness center on the campus of Long Beach State, or 24-Hour Fitness, which was nearer to our home.

"Douglas," she used to say with such earnestness, "I think this country is my good luck charm. Ever since I came, everything has been perfect for me. I couldn't have asked for more."

On April 1, as I drove to the Aquarium of the Pacific in downtown Long Beach for the Toyota Grand Prix of Long Beach media gathering—the annual open-wheel race was to be held four days later—I kept thinking to myself how I had been bestowed with so much good fortune in my life.

Gillian is captured in a happy moment early in the marriage.

I had overcome a California zip code pedigree of rural bleakness to wind up working for a major daily in the movie capital of the world and covering, even becoming friends with, many sporting personages; becoming a radio personality; and even making TV and film appearances.

While my private life often had been turbulent—the bad first marriage, the constant pursuit of women after it, the anguish of romantic breakups, the drugs, the drinking, the frenetic years of excessive gambling—I finally had settled into a stable existence with a bright lady with a good heart and with a son looming on the incandescent horizon.

The Aquarium of the Pacific wouldn't be open to the public for another two and a half months, and the huge tanks that soon would be filled with 350,000 gallons of water and thousands of marine life were empty.

But the place that day was brimming with civic leaders, race officials, media members and Indy race car drivers like Alex Zanardi, Dario Franchitti, Al Unser Jr., Bobby Rahal and many others.

As I was speaking to Zanardi, who would go on a few days later to win the race, my cellphone rang.

"Oh, it's my wife…Pardon me for the interruption," I said to Zanardi, who nodded amiably.

The words I heard at the other end left me shaken.

"Honey, I'm bleeding badly…Please come home," Gillian was saying somberly. "I called the doctor, and he wants me to come to the hospital as soon as possible."

"I'm coming right home," I said.

"Is something wrong?" asked Zanardi, guessing by my solemn reaction to the call that there was.

"Yes, there is," I said, excusing myself and hurriedly heading for the exit.

When I got home, Gillian was lying in bed, and my devoted neighbor, Esther Fawcett, who had become sort of my surrogate mother with mine residing 230 miles away in Fowler, was seated next to her.

Gillian had tears in her eyes when she saw me, and I could only shake my head in despair.

"It's not good," is all she said. "I'm afraid I've miscarried."

We drove to Long Beach Memorial Medical Center, where it was discovered the fetus no longer had a heartbeat. Gillian soon underwent a procedure performed by her doctor, and later a nurse brought the fetus wrapped in a blanket into her hospital room.

"Would you like to hold him?" she asked me.

I did and looked down at the fetus that was to be my son, was to be my most precious legacy, was to bring so much joy to Gillian and me.

I held him for a couple of minutes and was overwhelmed with a sad emptiness that I would feel often in the coming years. I wept.

It had all happened so suddenly, so unexpectedly, so shockingly.

We were set to order a crib that day, and the previous day we had been discussing what to name our son.

And now we were steeped in grief.

That was the first agonizing day that Gillian and I experienced in our marriage, but unfortunately, it would not be the last.

In retrospect, it's almost ghoulishly ironic that the only driver I talked to that day at the Long Beach Grand Prix press conference was Alex Zanardi, whose career would come to a tragic end on September 15, 2001, the day Gillian passed away, when he was involved in a frightening crash at the Euro-Speeway Lausitz in Germany that resulted in his having both legs amputated.

Chapter 6

After Gillian's first trip to America in late September 1992, I continued to juggle my trio of jobs—newspaper, radio, TV—and she continued to work her therapeutic skills on physically challenged elderly folk in London.

While I certainly had a fondness for Gillian at the time and remained in regular telephone contact, old habits don't magically disappear. I had been single for a long time and had become accustomed to its liberating sovereignty. I liked being able to do what I wanted to do when I wanted to do it without restraint from another party.

I had become satisfied with my life the way it was, and I wanted to keep it that way—or at least I thought I did. And anyway, at that time, there remained in me vestiges of emotion for the lady I had just split from when I met Gillian. Her name was Karin R., and we actually had lived together for a year until she decided to return to her hometown—the California resort hamlet of Pebble Beach—to get an MBA degree at the Monterey Institute of International Studies.

Karin and I maintained cordial relations, and she continued to make periodic visits to Southern California to see old friends, as well as her Beverly Hills hairstylist, a gentleman who went by the name of Christophe and who later gained international fame for styling the locks of the forty-second president of the United States, Bill Clinton. She would stay with me during those visits.

We once had almost a maniacal affection for each other, but our relationship became complicated and eventually dissolved—as did the only

Karin R. and Doug during gleeful times.

other serious one I had after my 1981 divorce—because of my skittishness about marriage, for which I developed almost a pathological fear.

I had become terribly disillusioned with the institution after trying it for eight years with a lady I shall call M. I don't know if it's a reflection of just how disillusioned I was, but to this moment, I have no idea the day or month when M and I got married. I know it happened sometime in 1973, when I was still too young and frisky at twenty-nine to endure its constraints, which I too often found discomforting and too often simply ignored.

I do remember with horror what happened when I violated the nocturnal deadlines M imposed on me. I would be showered with a stream of high-pitched invectives as well as thrown articles.

In those days, I sparred a lot at the Westminster Boxing Gym and became adept at ducking punches, a skill I'm sure was honed by my having to duck the various flying objects that M aimed at me when she lost her temper.

M's anger was understandable late in our marriage when I'm sure by then she knew I no longer was serious about upholding the sacredness of monogamy.

But early in the marriage, when for the most part I actually did, she alienated me continually with what I deemed her unreasonably stringent clock management.

There are so many episodes that I can relate, but one can serve as a microcosm of my grievances with M. It came in the summer of 1973, shortly after we moved into an apartment in the Long Beach seaside community of Belmont Shore. I was invited one evening to have dinner with several members of the Rams organization, including the team's general manager, Don (Duke) Klosterman, and new coach, Chuck Knox.

Klosterman was a superb raconteur who knew a lot of people in high places and was a close friend of Ethel Kennedy, widow of the slain Massachusetts senator Robert F. Kennedy, and also Edward (Ted) Kennedy, who served in the U.S. Senate for forty-seven years and would attend Klosterman's funeral in June 2000.

We ate at the Palmer House in Culver City and had a convivial time, as the drinks and stories flowed liberally in the male-only gathering. I called M at about ten o'clock and informed her that I might not be home until midnight—an hour later than she expected—and that this get-together was vital to my work. Remember, I was just in my second season of covering the Rams for the *Herald Examiner* and still building sources.

You would have thought I had informed M that I was spending the evening with Raquel Welch, then the reigning sex goddess of film. She exploded in anger and hung up on me. She remained mad for almost a week, refusing to even talk to me. It would be a reaction often repeated throughout our troubled marriage.

M was a thin, loyal, supportive, obsessively neat blond lady of German heritage—she was born in Munich—who was an exceptional cook, but I always felt I was ensnared in shackles during our time together. When I was away from home at night for one reason or another, I always found myself nervously checking my watch so I wouldn't miss M's curfew, which I often did anyway. As a symbolic act of defiance, I threw that old Longine into a garbage bin the day I left M.

Still, while M's excessive possessiveness led to many prolonged conflicts that created serious fissures in our marriage—as did my carefree attitude toward the institution at the time—it was another development that probably finished it.

And, ironically, M had nothing to do with it.

You must understand that for almost a year of the marriage—throughout a good portion of 1977—I actually lived a monastic existence. That was the

Doug covered the Rams teams coached by Chuck Knox (center). A veteran head coach of five NFL teams, Knox's stints with the Rams were from 1973 to 1977 and 1992 to 1994. Jimmy Torosian is on the right.

Don Klosterman (center), pictured here with Doug, was general manager of the Los Angeles Rams in the 1970s. Donnie Srabian is on the left.

most tranquil period of it because I spent almost all my spare time at home, to the delight of M. I didn't drink, didn't do much of anything except write my articles for the *Herald Examiner* and work on a project in which I had become totally absorbed.

I began writing the Great American Novel—or at least the Great American Sports Novel. I noticed the incredible success novelists like Harold Robbins and Sidney Sheldon were having at the time—I devotedly read all their latest renderings—and figured I could do the same with an athletic twist to the prose.

I had been covering the Rams on a regular basis since the 1972 season and decided to take advantage of the knowledge I had built up about the underbelly of pro football: the widespread gambling, the Super Bowl ticket scalping, the back-biting locker room bickering among the players and coaches, the excessive drinking and drug usage and marital infidelities of the players, etc.

The fictional tale I created had all these ingredients in it and was centered on a star quarterback who owed bookmakers a lot of money and wound up paying off his immense debt by agreeing to dump the Super Bowl. I tried to make it a fast-paced read with a lot of sex, romance and subplots.

The person I initially enlisted to help me find a publisher was the high-powered Beverly Hills entertainment attorney E. Gregory Hookstratten, who had a lot of big contacts and whose clients included the likes of Johnny Carson, Tom Snyder, Tom Brokaw, Vin Scully and, at the time, Rams owner Carroll Rosenbloom.

I'll never forget the late December Friday afternoon that my wife and I met with Hookstratten in his Beverly Hills office and I presented him with a manuscript of my book, which I called *Super Scandal*. I even had a celebratory drink with Hookstratten and M, breaking my lengthy abstinence.

"We'll get it placed somewhere," promised Hookstratten.

A few days later, he called me from Hawaii, where he had been vacationing with his first wife, the actress Pat Crowley, and said, "Love your book. Can't put it down, read it in one day."

But before I could savor those joyful words, he quickly added, "I'm afraid I can't help you get it placed. It would be a conflict of interest for me. I'm not sure Carroll Rosenbloom or Pete Rozelle [the NFL commissioner] would want this book in print, especially with the revelations in it about the Super Bowl ticket scalping and some other sensitive things that wouldn't exactly shed a positive light on the NFL. I know it's a novel, but a lot of the stuff you write about is not exactly nonfiction."

Doug is pictured with Carroll Rosenbloom, owner of the Los Angeles Rams from 1972 to 1979. Rosenbloom drowned at Golden Beach, Florida, in April 1979, and his wife, Georgia Frontiere, inherited 70 percent control of the Rams.

I was crestfallen. I had spent so much time and energy on the book. Even when I was on road trips with the Rams that season, I had declined dinner invitations from the team's PR people and sportswriting friends and remained secluded in my hotel room feverishly working on it. I routinely stayed up until midnight at home and had even stopped going to the fitness gym, which was the ultimate sacrifice for me.

Where would I turn now?

Well, there was a person I had befriended at the *Herald Examiner* named Arelo Sederberg—he was the newspaper's business editor—who had written several novels that had sold well, like *The Power Players* and *60 Hours of Darkness.*

I gave him a copy of *Super Scandal,* and after he read it, he told me he liked it so much he had given it to his literary agent.

"I don't see any reason why this won't be published," said Sederberg, who once was a public relations spokesman for Howard Hughes.

It turned out the literary agent liked it, too, and he told me a well-known publishing house—it was Simon & Schuster—was interested in it,

but nothing ever happened. The literary agent planned to take it to other publishing houses but soon died of cancer.

I also thought *Super Scandal* would make a good movie, and so did an actor acquaintance, Michael Dante, who gave the manuscript to the powerful film producer Howard Koch Jr.

"This will take some time…The movie people move at a tortoise pace," warned Dante.

Dante was right, but I was too impatient in those days, and after waiting only a month, I told Dante I wanted my manuscript returned, which he reluctantly did before Koch even had an opportunity to read it.

After that, in bitter frustration, I stuck the manuscript in the bottom drawer of the nightstand next to my bed, and it languished there untouched until I moved out of the house in the fall of 2009.

There's no doubt in my mind now that the deep disappointment I felt about the fate of my novel had a calamitous effect on my marriage.

For a year, I had been the model husband. With the book no longer an obsessive priority with me, that changed quickly. During the next few years, much to the displeasure of my wife, I began staying out too late and drinking too much and routinely breaking vows of fidelity. M, now more than ever, had become an insufferably intrusive nuisance that I knew I had to escape, and I never will forget what I told her one early Friday evening in May 1981 when I headed out the front door.

"Where are you going?" she asked.

"I'm going down to the end of the block," I answered.

I came back six days later, and a month later M and I were done.

Chapter 7

I should have known better than to get hooked up with a lady inclined to possessiveness.

A few years before marrying M, I was involved with one who was responsible for the most embarrassing, shocking, stunning, bewildering, astonishing moment of my life.

Nothing since has come close to matching it. In fact, more than forty years later, I still find the incident in a downtown Los Angeles motel so implausibly unreal that it's difficult to believe it actually happened.

But it did, and I still cringe at the thought of it. In the spring of 1969, when I was covering the Lakers for the *Herald Examiner*—that was the spring they would lose a storied seven-game series to the Boston Celtics in the NBA finals in the farewell appearance of the Celtics' sainted center Bill Russell—I began dating a lady I shall call X. Actually, it was she who began dating me, since she was the one who lured me into her boudoir.

Now you must understand that at the time I was only a few years removed from Fowler and wasn't exactly a seasoned performer with the opposite sex, seldom going out with women during my years at Fresno State when weightlifting commanded so much of my attention and when my sexual appetites were mostly sated by curvaceous young women whom I indemnified for their services.

While I doubt Fresno still had the thirty-two houses of prostitution the nationally syndicated columnist Drew Pearson wrote about in one of his dispatches on January 24, 1950, in reference to the city's widespread

racketeering activities, that particular trade still flourished in the early 1960s when a phone call to a lady named Jean would result in an alluring thirty-minute session at a local motel room. She always had four lovelies on duty, would provide the vitals on each in descriptive language calculated to arouse and would set up the appointment.

Most of the women came from either San Francisco or Los Angeles and were all in their early twenties or late teens, and all were exceedingly attractive. None spent more than a week in Fresno, as newcomers continually were added to the rotation to keep the excitement fresh.

The fare originally was ten dollars, but inflation eventually hit the market, much to the horror of the bargain-seeking clients, and it had gone all the way up to twenty dollars when I departed Fresno for good in 1966.

While I never met Jean, I did meet another madam named Betty, who had been a veteran of the profession for many decades and who had a two-story home on north Van Ness—an upscale area—in which she usually had at least three young women ready to deliver gratification.

Not all practitioners of sexual delights in Fresno were young. There was an elderly lady in town named Myrtle whose skill at fellatio had become so legendary that Herb Caen even dropped an item on her in his widely read column in the *San Francisco Chronicle*. While Myrtle's age might have been a deterrent to some, her popularity never wavered, for she dispensed her magical touch for a mere three dollars.

Several generations of Fresno males grew up in such an environment, and it was a rite of passage for many to have their first sexual experience in this manner.

I did as a seventeen-year-old in the summer of 1960 before my senior year in high school—I was employed as a busboy at the 99 Café Truck Stop in Fowler—when after work one evening I was driven by four Armenian bachelor grape farmers out to the ranch house of one of them, a guy called George (Barn Owl) Stephanian, where I nervously lost my virginity to a slim twenty-two-year-old blonde named Bobbi in one of the guest bedrooms.

It cost me five dollars, and I found out later I had an audience, as the four Armenian farmers peeked through a side window into the room that had a dimmed lamp in it. They didn't exactly see a boffo performance by me, as I consummated the act in an instant.

Anyway, as soon as I began residing in Southern California, I ceased with my pursuit of paid companionship and began navigating a more traditional sexual path, as I finally began discovering the joys of dating and of having sex without time constrictions.

Certainly, none of the women I had taken out in those early days was even vaguely as alluring as X or had her immense experience in sensual pleasures.

At the time I was seeing X, she was working at The Forum—I never really found out what she did—which was owned by a demonstrative one-time Canadian door-to-door encyclopedia salesman named Jack Kent Cooke. Cooke also owned the Lakers and Kings and would go on to own the Chrysler Building in New York and co-own the Washington Redskins with the famed attorney Edward Bennett Williams.

Cooke was a domineering, pompous fellow given to polysyllabic spewings whom I got to know well while covering the Lakers. I was his dinner guest several times at Kings games, and I would sit next to him in his private box during the hockey proceedings that were totally alien to me but a particular passion of Cooke.

X always had been friendly to me, but I never thought that this woman who was eight years older would have an interest in someone like me with hayseed still growing out of my thick brown hair. At least, not one who looked like her.

But apparently she did. She surprised me one evening a few hours after a Lakers game when she asked if I'd give her a ride to her west Los Angeles residence. We had consumed a few drinks at The Forum press lounge, and there were several gentlemen in our gathering who hadn't exactly hidden their desires to take X home.

Yet she chose me for the honor. And I was even more surprised when we reached her apartment and she asked me to come inside and have a drink with her and then asked me to come and spend the night in bed with her, which I gladly did.

At the time I met X, she already had been an experienced traveler on the LA social scene, having dated several actors and been a regular at the most popular nightclubs.

She had done modeling in her younger years, and she had retained her slender five-foot-nine figure that never carried more than 115 pounds on it. She had thick blond hair, high cheekbones, perky breasts and looked as though she had stepped out of *Vogue* magazine.

Like so many women with such attributes, she had gone through a lot of romantic turmoil—she already had been married three times—and I guess she saw in me a naïve guy with a muscular body and a high testosterone level who didn't pose a threat to her tranquility.

For the time I was with X—I saw her on a regular basis for about six months—she opened up stunning new vistas to me.

She took me to hip apparel shops like Fred Segal's on Melrose. She took me to the Luau, which was then a celebrity hangout on Rodeo Drive in Beverly Hills owned by Lana Turner's ex, Stephen Crane. I later would become a close friend of the restaurant's maître d', Joe Stellini, who later would open up his own renowned place bearing his name with O.J. Simpson as one of his financial backers. She took me to Sneeky Pete's on Sunset Boulevard, where the fabled Art Graham Trio performed and where I met a young, thin, unknown actor named Robert De Niro fresh from doing the cult baseball film *Bang the Drum Slowly*. I remember her once taking me to a nightclub in West Hollywood and introducing me to its owner, Eddie Nash, whom I didn't know was then already a major drug dealer and who a few years later was linked to the infamous Wonderland Murders. She took me to a lot of places where I was introduced to a lot of interesting people and where we drank, ate and frolicked.

Those were giddy times for a rube from Fowler, and X, who was thirty-two, often introduced me laughingly to her friends as "her pinkie," an antecedent to "toy boy." While X doted on me, she also demanded my time, too much of it after the months elapsed, and my fondness for her waned as other, younger ladies began diverting my attention.

One of my hangouts in those long-ago days was a darkened downstairs bar in downtown LA on Figueroa near Ninth Street called The Gala that was operated by a gentleman named Ernie Tassop, a smoker, drinker, gambler and womanizer who was a friend of many boxers and baseball players, with the pitcher who delivered the Brooklyn Dodgers their only World Series triumph, Johnny Podres, being his closest.

I began going to The Gala when I joined the *Herald Examiner*, as Van Barbieri, who was then the Olympic fight publicist, would take me and other sportswriters there for dinner before the Thursday night matches. Tassop, who consumed stingers (white crème de menthe and brandy) with an unrivaled frequency, took a liking to me. And what made his place even more inviting to favored customers like myself is that it was attached to a motel.

A woman who caught my attention during the time I was seeing X was a young reporter—she was a recent Yale graduate—from my newspaper, and one Friday night we met for dinner at The Gala and then had drinks at the bar, with Tassop keeping them coming at a steady pace.

I had lied to X earlier in the day that I would be tied up that evening at a Dodgers game and told her we'd get together on Saturday. We certainly did, but not in the manner I expected.

I drank a lot more than usual that evening and a lot more than the young reporter did, but she did have her share, and she did accept my invitation to spend the night with me in one of The Gala motel rooms, which Tassop arranged for me to have gratis, as he had done on several previous occasions when I was with X.

Apparently, long after we left the tavern and retired to the room, X showed up looking for me near closing time, and she quickly found out from one of the customers—I never did find out who the stoolie was—that I still was on the premises.

X was a shrewd lady with Sherlock Holmes instincts and happened to know the woman who worked at the motel's front desk, and I suspect she bribed her to secure a key to my room.

To this day, I have no idea how I wasn't awakened when X entered the room—I never heard a peep and, clearly, had drank myself into oblivion—but the young reporter lying next to me was, and X instructed the frightened woman to depart promptly.

"The woman had her hand over my mouth and whispered into my ear to get out immediately and do it without making any noise—or I'd get hurt," the young reporter later told me. "I was frightened to death. She had an absolutely murderous look on her face. She told me she was your wife, and I got out as quickly as I could. You were like under the covers next to me and didn't move."

When I awoke early the next morning, I thought I was in the midst of a deep dream, or that I was hallucinating or that I was in some sort of weird trance.

There, lying next to me nude, flashing daggers in my direction, was X.

"You rotten, two-timin' sonofabitch!" she roared.

I recalled a line my pal Johnny Ortiz told me he once uttered—"Don't believe your lying eyes"—when caught in a similar situation, and for a moment I thought of using it.

But that glare X fixed me with was bereft of any sign of humor or forgiveness, and I meekly managed to mutter only, "Sorry."

That embarrassing episode would mark the end of my relationship with X, although we still would see each other on occasion for the next decade.

I swore to myself afterward that I never again would be with a woman who acted as though I were her private chattel, and yet, for reasons that puzzle me to this day, I wound up marrying one.

Chapter 8

Although I had been enamored by Gillian during our two brief times together, I wasn't smitten like a love-crazed teenager, especially since I felt the distance between us conspired against a lasting affiliation. But I did find myself being drawn to her in an enigmatic manner that I found both intriguing and worrisome.

Gillian and I had planned to reconnect in London on New Year's Eve 1992, and I was looking forward to seeing her, although I wouldn't be seeing her alone. I had arrived in Europe that late December with one of my pals, Mike "The Hammer" DiMarzo, who was then a member of the Los Angeles County Sheriff's Department and making his first European trip.

It's perhaps a reflection of the conflicting feelings I was having toward Gillian at the time that I would bring along DiMarzo, a bachelor with a mighty penchant for bar-shopping and women-chasing and late-night carousing. If I were truly serious about my romantic intentions with Gillian, why wouldn't I have come alone instead of hauling along someone given to constant revelry? Was this my way of counteracting whatever emotions I had for Gillian?

We landed in Paris, where we spent a couple days visiting the sights, sampling the food and spirits, sleeping minimally and nursing gut-wrenching hangovers that we vainly attempted to cure with early morning Bloody Marys. I then made a fateful decision that, in looking back, might have been responsible for Gillian and me not seeing each other for a lengthy period.

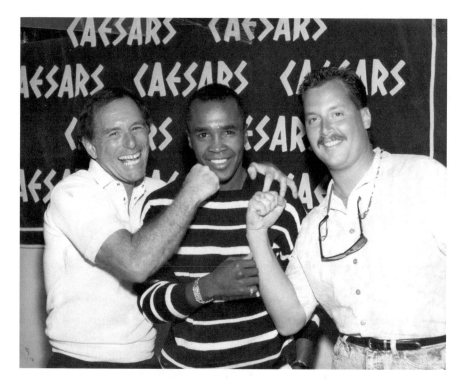

Sugar Ray Leonard doesn't seem too concerned with Doug's pending knuckle sandwich. Mike "The Hammer" DiMarzo is on the right.

We still had a week to go before hooking up with Gillian in London—she was set to bring a close lady friend from Hartlepool to be DiMarzo's New Year's Eve date—and we decided we had seen enough of Paris and would move on either to Rome or Budapest. Perhaps because I already had been to Rome a couple of times, I persuaded DiMarzo that Budapest would be a more exotic destination, not realizing that the capital of Hungary was being besieged by an awful cold front.

We had a blast on the train from Paris to Munich—we spent most of it in the lounge car flirting with ladies and consuming vodka—and switched to another train in Munich on which we stayed in an overnight sleeper on the way to Budapest. But the carriage's heater malfunctioned—the room felt like being stuck in a supermarket freezer—and DiMarzo came down with the chills, which resulted in his having a high temperature by the time we reached Budapest. I doubt DiMarzo would have fallen sick had we gone to Rome with its milder climate.

We checked into the Budapest Hilton, which was located on a hill in the Castle District overlooking the Danube River, and DiMarzo, despite still being ill, gallantly joined me the first couple of evenings in forays around the old city. I'm sure it didn't help his condition that we drank far too much on the second night and then, after the bars closed, walked along nearly deserted streets for an hour in subzero temperatures without proper apparel trying vainly to locate a cab. By the time we finally did, we both were close to suffering hypothermia.

When we got back to the hotel, DiMarzo's condition had worsened significantly. A doctor was called to the room and found DiMarzo's temperature had reached 103. He stayed in bed the next day and felt slightly better the following one, when we decided to fly to London earlier than we had planned. We figured a few days of resting comfortably in London would restore DiMarzo's health.

It didn't. By the time we reached London and checked into the Park Lane Hilton, DiMarzo had become even sicker than he had been in Budapest. He remained bedridden the next two days and desperately wanted to return to America, despite his condition. Poor Mike DiMarzo. The beleaguered cop's first trip to Europe had turned out to be a disaster. Except for the brief time in Paris, he had been sick the entire trip and wound up spending far more time in beds than he did in taverns, a terrible deprivation for him. We wound up flying out of London on December 29.

What exacerbated an unfortunate scenario was that I somehow had lost my address book that contained not only Gillian's Streatham Hill phone number but also the phone number of her parents' home near Hartlepool, where she had been staying during Christmas.

DiMarzo had pleaded for me to remain and insisted I didn't have to accompany him back to LA. I was in a quandary. If I remained in London, my sick pal, still running a fever that had subsided slightly, would be making the long trek back alone, and I knew he wasn't an experienced traveler and that he could face the misery of being bumped from a capacity flight because of his non-revenue buddy pass ticket. I also realized if I checked out of the Park Lane Hilton, where I knew Gillian would be able to reach me, I would be committing a terrible breach of etiquette. She and her girlfriend would be expecting to go out with Mike and me on New Year's Eve, and they wouldn't even hear from us, much less see us.

I didn't know quite what to do, but I guess loyalty to a pal trumped whatever feelings I then had for Gillian. Or did it? I easily could have chosen to remain alone at the Park Lane Hilton and wait for Gillian to contact

me, which she attempted to do. DiMarzo wasn't exactly on death's door, and I'm sure this tough cop who had recently earned a Medal of Valor commendation from his department for bravery in the apprehension of an armed felon would have been able to make it back to LA on his own. I now think I chose to leave with DiMarzo because I had a subconscious desire to permanently cut off ties with Gillian, a tack I had taken with other women since my failed marriage.

Still, when I got back to Long Beach, I felt guilty about not even giving Gillian an explanation for my absence. A couple weeks elapsed, and when I finally got my telephone bill—remember, those were the pre-cellphone days—that had Gillian's number on it, I phoned her immediately and apologized profusely.

She wasn't exactly appeased.

"How could you do that to me, Douglas?" she replied with irritation. "I called the hotel, and they told me you had checked out two days earlier. I asked them if you left any messages, and they said there were none. I couldn't believe it. Here I brought my childhood girlfriend with me all the way from Hartlepool to go out with your friend, and you stood us up without any explanation. I was mad, and she was mad. We went to a bar in Streatham Hill, and we wound up both drinking too much. We had a terrible New Year's Eve. Terrible. And I think you were very rude. I've been treated badly by men in the past, but not that badly. I really don't want to talk to you again."

The phone went dead, and I suddenly felt terribly remorseful. How could I have lost my address book at such an inopportune time? I long had been irritatingly absent-minded, misplaced over the years keys, eyeglasses, wallets, documents and checks. But never before had I lost a lady's phone number, and Gillian deserved better treatment than what she and her girlfriend had endured on that New Year's Eve.

I figured I'd soon forget Gillian and go on with my life, but I didn't forget her.

I did wait two months to call her again, figuring by then her anger toward me would have subsided. It hadn't. She was civil but cool and reiterated her feelings about not wanting to see me again.

Chapter 9

At the dawn of 1993, the *McDonnell-Douglas Show* had become the hottest one in Southern California. We were commanding a lot of attention and had become an influential part of the Southern California sporting scene.

Two days after Riddick Bowe became the world heavyweight champion by dethroning Evander Holyfield in Las Vegas in November, he and his entourage showed up at our Sunset Boulevard studio and went on the air with us. As he rode in a limo from LAX on the way to doing a taped appearance on Jay Leno's TV show after winning Wimbledon the previous week at the age of thirty-three, Andre Agassi gave us a call. And later, Jay Leno himself came on and did a brief bit with us.

Joe McDonnell and I were seen on a segment of Dan Rather's nightly news show on CBS, and we made a couple other national TV appearances on that network with sportscaster Pat O'Brien. We did an hour hookup with Suzyn Waldman on WFAN in New York that was broadcast live in both Los Angeles and New York markets.

When it was revealed in early January that John Robinson, who had been fired the previous year by the Los Angeles Rams, was returning for a second tour of coaching duty at the University of Southern California, Joe and I caused a major ruckus by spending four hours on our show eviscerating Robinson. Larry Stewart in the *Times* took issue with our treatment of Robinson, spending an entire column characterizing it as nothing more than a mean-spirited, vindictive public persecution of a

In the KMPC Radio days, Doug (right) and on-air partner Joe McDonnell (left) were known as the team of McDonnell-Douglas. Here, Doug puts the grab on Tommy Lasorda.

person without even a vague semblance of balance, which, of course, was true. But the negative publicity only garnered us more widespread notoriety and increased our ratings.

The Super Bowl that year was between the Buffalo Bills and Dallas Cowboys at the Rose Bowl, and we did our shows during the week preceding it at the Century Plaza Hotel in Beverly Hills; among many others, our guests included O.J. Simpson, Joe Namath and the actor John Goodman, who turned out to be a loyal listener.

I had known Simpson since his days at USC, and our conversations always centered on boxing and women when we ran into each other. I recall coming across Simpson once in the late 1970s at Joe Stellini's restaurant on Pico Boulevard in Beverly Hills. He was seated in a booth with a stunning blonde and motioned me over to join him. As I sat down, she got up to talk to a friend at the bar, and I said to Simpson, "Wow! Who's that?" "Her name is Nicole, and I'm going to marry her one day," he replied. He did and

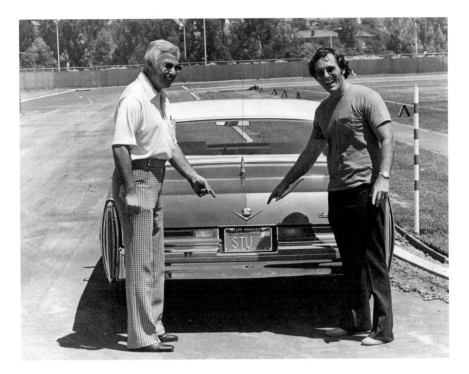

KTLA-TV, Channel 7 sportscaster Stu Nahan points out his personalized California license plate for Doug.

later would be the only defendant in the Trial of the Century that absorbed the American public for the first ten months of 1995 when Simpson was accused of murdering Nicole Brown Simpson and a friend, Ronald Goldman. Simpson was found not guilty by a nullification jury, despite an overwhelming preponderance of evidence to indicate he was.

On the day before the Bills and Cowboys were to meet in Super Bowl XXVII on January 31, Joe and I did our show on the grounds outside the Rose Bowl, where the NFL was staging an expo, and more than one thousand people showed up to watch the event, chanting throughout the show, "McDonnell-Douglas! McDonnell-Douglas! McDonnell-Douglas!" It was heady stuff—we stayed afterward signing autographs for more than an hour—and it seemed we were destined for a long and prosperous career together in the LA radio market that ranks as the top one in the country because of the millions of weekday commuters on the area's many freeways.

Ah, was I naïve! I still didn't comprehend the notoriously dysfunctional nature of the radio business. Despite our success, our growing popularity,

This KMPC Sports Radio publicity still features partners Joe McDonnell and Doug.

our high-profile status, the original *McDonnell-Douglas Show*—there would be later incarnations—came to an abrupt end in June when I was let go by the station's management.

No plausible explanation was given, but by the sheerest coincidence, my one-year contract was up, and I was due to receive a sizable raise in the new one. And since the station was up for sale—the Cap Cities organization would purchase it the following year—and since cost cutting had become an imperative, I was summarily dismissed.

There also might have been other contributing factors. Our show had stirred up its share of powerful detractors—including one sportscasting institution at the station who put the shiv in us to management—which, unfortunately, might have had an impact with general manager Bill Ward and also with Jackie Autry, wife of Gene, who was pulling the levers of power.

I figured that would be the end of my time in radio, but naturally, I was offered a position again at KMPC at my former salary a few months later. But instead of being reunited with McDonnell, I was paired with a velvet-voiced newspaperman and Penn State graduate—he was a sports

Sports Illustrated swimsuit model and entrepreneur Kathy Ireland shares a moment with Doug at KMPC.

columnist for the *Antelope Valley Press*—named Brian Golden, nowhere near as shrill and outrageous as McDonnell but quite knowledgeable and likeable. We did the ten-to-two midday shift, and although our show wasn't nearly as strident and controversial as the one I did with McDonnell, we managed to double the time slot ratings during our time together, which ended rather ignominiously.

If, as a kid growing up amid grape vineyards and fruit trees in a joyless agricultural area of appalling tedium, someone had told me one day I would be fired from a Hollywood radio station because I was burdened by a role in a Hollywood movie, I would have reacted to such a ridiculous prophesy with sustained howls of laughter.

But that's precisely what occurred on March 3, 1994. I had taken a day off from my program to fulfill a small role I had in *Cobb*—I was typecast as a sportswriter— and the shooting took place at an old Hollywood tavern called Boardner's. At about 3:00 p.m., during a break, I received a phone call from KMPC's program director, Scotty O'Neil, who informed me he was firing me because I had failed to show up at an event that day in Willow Springs—about an hour's drive north of Los Angeles in Kern County—to test drive a corporate sponsor's car.

"You gave me permission to miss it," I reminded O'Neil.

"Yes, I did," he replied sheepishly. "But your partner [Brian Golden] didn't show up, and the general manager [Bill Ward] decided both of you had to go."

The rest of the afternoon I was subjected to the taunts of Bozo Caplan, who also was appearing in *Cobb*. "You traded a radio career for a movie career," he kept chiding, expressing no empathy for my having lost my radio gig. Leave it to ol' Bozo to inject humor at such an inappropriate time, although my latest firing was perfect fodder for his rakish humor.

Shockingly, my movie career didn't exactly take off, although I would go on to make nonspeaking appearances in Ron Shelton's *Play It to the Bone* with Woody Harrelson and Antonio Banderas and *Dollar for the Dead* with Howie Long and Emilio Estevez. The latter was filmed in the same location in Spain where Sergio Leone and Clint Eastwood made their famous cowboy flicks and where *The Magnificent Seven*, *El Cid*, *Lawrence of Arabia* and many other movies had been shot.

I thought now, for sure, I was finished with radio—oh, was I wrong! Suddenly I had a lot more leisure time, since the *L.A. Football Company* TV gig also had come to an end when CBS lost its NFL contract and, shockingly, I wasn't being bombarded with film offers as Bozo Caplan had so blithely predicted would be the case.

At the end of the year, as always in those days, I headed off to the south of France—I usually stayed a week at the Noga Hilton in Cannes before going on to other European destinations—but before I did, I called Gillian and extended her an invitation to join me. "No, I don't think that would be good," she said. "I just can't forget what you did to me."

But at least she no longer was hanging up on me. We actually spoke for twenty minutes on that occasion, and I felt her softening toward me. "We'll get together in the south of France next year," I said before hanging up.

And I did visit Cannes the following year, and I did once again ask Gillian to join me. Once again, she declined, and I decided at that point not to call her again.

And I never would have had Gillian herself not prompted it.

Chapter 10

In March 1995, McDonnell-Douglas rose again, out of the radio ashes. This time, Joe and I landed on an FM station called KMAX located in Sierra Madre, near Pasadena, and it was a small-time operation with a small-time management with, as it turned out, a small-time bankroll.

I never was overjoyed by the lengthy drive—it was an eighty-mile round trip from Long Beach—and the fact that I didn't receive a paycheck for my final three weeks of employment inspired my departure in July. Joe got mad at me for leaving, although he, too, later got stiffed, prompting his departure.

The KMAX venture didn't last long, but there were some memorable stunts we pulled like the day we contacted an English-speaking fellow at Saddam Hussein's government office in Baghdad and vainly attempted to speak to Mr. Hussein, or the time we attempted to get the televangelist healer of ailing people Benny Hinn to come on with us and exorcise the many sins committed by our radio program, or the time we got O.J. Simpson's confidant/freeway chauffeur Al Cowlings on the air live and asked him if his pal O.J. was guilty of murder.

Incidentally, I wrote a lot of columns that year on the O.J. Simpson trial for the Long Beach paper. I reacted to his farcical acquittal with outrage and sarcasm, warning the good burghers of Brentwood to keep off the streets at night and be on the lookout for a serial killer since, after all, Simpson was found not guilty of murdering his former wife and Ronald Goldman (the Los Angeles Police Department closed its investigation of the case shortly after the Simpson verdict was announced, since it and almost everyone except the

numskulls on the Simpson jury came to the conclusion that Simpson had committed the homicides).

At that time, I once again reverted to being a dedicated participant on the dating scene. The heavy workload had slowed me down a bit in this area for a few years, but now that I was down to just my newspaper job, I resumed what had been a salient part of my existence for a good part of two decades.

Indeed, after my departure from M in June 1981, I became like one of those wrongly convicted guys who suddenly gains his freedom after years of incarceration—only my incarceration was the prison of marriage.

In looking back, I think I became a little crazed, manically determined to make up for the years the marriage had taken from me. I routinely went up to women I was attracted to and struck up impromptu conversations in every place imaginable—taverns, nightclubs, restaurants, shopping malls, dry cleaning outlets, grocery stores, drugstores, liquor stores, hotel lobbies, arenas, stadiums, parking lots, airplanes, trains, buses, elevators and public sidewalks.

It was a hit-and-miss numbers game, and I was like a high-pressure salesman. I found the more women I pitched, the greater likelihood it was for me to make a connection.

A person who enlightened me in this area was Johnny Ortiz, whom I met shortly after I had joined the *Herald Examiner*. Johnny later would become a high-profile Los Angeles fight figure, but at that time, he and his brother Ray owned a popular saloon in Downey called the Stardust Lounge. And at that time, Johnny already had established a widespread reputation for his seduction of women.

In fact, the first time I ever heard Johnny's name mentioned came in the spring of 1968 when I still was a wide-eyed sportswriter just a couple years removed from college. I happened to be riding in a car one afternoon with Bud Furillo, my boss at the *Herald Examiner*.

Elvis Presley, a friend of Furillo, had called the *Herald Examiner* the previous day seeking information on some sporting event—Marlon Brando was another frequent caller to the newspaper—and I off-handedly said to Furillo, "Can you imagine all the women Elvis goes to bed with?" And Bud responded, "There's a guy in Downey named Johnny Ortiz who fucks more women than anyone in the world. More than Elvis Presley. More than Frank Sinatra. More than Warren Beatty. More than Porfirio Rubirosa ever did. You can only can fuck so many women in a twenty-four-hour period, and Johnny averages at least two or three every day. And his record I hear is six."

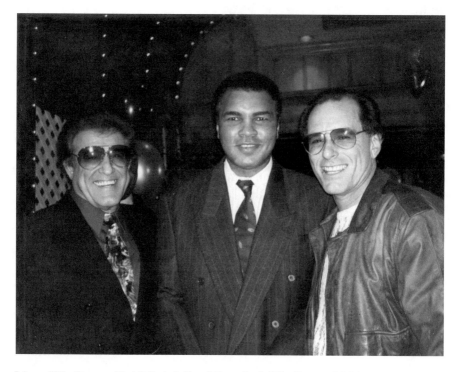

Johnny "The Downey Flash" Ortiz (left) and Doug flank "The Greatest," Muhammad Ali.

I soon got to know Ortiz well—my first beat for the *Herald Examiner* was boxing—and began prying out of him the techniques he employed for his astonishing success with the ladies.

"I found the key with women is to keep everything light and be a fun guy," he said. "And don't ever say anything of a negative nature. I found if you can get ladies to relax and to laugh, you can get them into bed. And you also have to show them a good time and never get uptight about anything. And don't be fearful of poking fun at yourself. Self-deprecating humor can be very disarming to women. A lot of good-looking guys with great bodies can't score on women because they have no idea what to say to them or how to act around them."

It took me a few years to embrace all of Ortiz's theories, but I found out that they did work.

I even wound up borrowing many of the inveigling spiels with which Ortiz charmed women.

"We found each other at last—and now all that's left for us to do is to start dating and prove it," was one that always inspired a laugh from the ladies.

"Pardon me, madame, I'm looking to find someone who will love me as much as I love myself, and I just know you're that person," was another one that inevitably drew a giggle.

So did, "A person who is conceited is foolishly in love with himself. With me, it's the real thing."

As did, "We've known each other for ten minutes now, and when do I get to meet mom?"

One that I came up with was insufferably trite without a hint of humor until I added a desperately needed punch line.

"My name is Doug Krikorian, I'm a sportswriter at the *Herald Examiner* and I'd love to take you out," was the original bromide I dispensed to mostly head-shaking recipients.

But when a few ladies responded by saying, "But I don't even know you," I instinctively began retorting, "That's why I want to take you out. You have no idea of the cultural vacuum you've been enduring without me."

Laughter often would ensue, and so would many phone numbers and romantic adventures during those years that I squandered in a haze of alcohol, drugs and hangovers both in this country and Europe.

Chapter 11

I did enjoy many enchanting evenings during my dating heyday when I went from being a mere sensualist to such a knowledgeable connoisseur that I even wrote a small pamphlet on the subject with my then best friend, Tom Hodges, who went on to become a relationship advisor to men known now on the Internet as Doc Love.

I suspect if I related all the compelling, if not in many cases implausible, tales, I would come off as an insufferable kiss-and-tell braggart or a laughable fabulist creating fiction à la Wilt Chamberlain and his claim of twenty thousand sexual conquests. I'm not proud one bit of my behavior—I'm actually now ashamed of it—since I didn't gain anything tangible from it except a string of liaisons with ladies whose names long have faded in the mist of time.

There are of course those I haven't forgotten by the sheer dint of the feelings I had for them—two moved into my home after my divorce—or by the sheer dint of their unique sagas.

I certainly never will forget the lady who linked me to, of all people, Howard Hughes, the famously reclusive billionaire Hollywood filmmaker, aerospace magnate, aviator pioneer and Las Vegas casino owner.

It's not exactly a startling revelation that Johnny Ortiz was responsible for such a bizarre quirk of nature.

It happened in the spring of 1976, when David Mirisch, a well-known Beverly Hills public relations figure who was credited with discovering Farrah Fawcett, invited me to one of his charity celebrity tennis tournaments, which he was staging this time at the El Tapatio Hotel in Guadalajara, Mexico.

While it's verboten now for a newspaperman to accept gratuities, it was a common practice in those days when professional athletic teams and racetracks were generous with Christmas presents and when high-powered PR guys like Mirisch routinely tendered invitations to events in exotic locations.

Indeed, many sports columnists in that era attended the American Airlines Celebrity Golf Tournament that was annually held in up-market places like Palm Springs and Scottsdale at the behest of the New York PR bigwig Nat Fields—and gifts included shoes, shirts, sports coats and various other items.

There was no such largesse waiting for Johnny Ortiz and me in Guadalajara, although a five-day stay in a sprawling resort hotel certainly was enticing, since our airplane tickets, rooms, meals and beverages were taken care of by Mirisch's company.

When Johnny and I boarded the flight to Guadalajara at LAX, we found ourselves seated by two of the celebrities headed to the event, the actress Terry Moore, once married to Heisman Trophy winner Glenn Davis and one-time lover of Howard Hughes, and the singer Davy Jones, who had been a teenage heartthrob with The Monkees.

We got to know each other well that day after a stop in Tijuana, where the flight was delayed for five hours. Ortiz, Moore and I started belting down drinks—Jones went off on his own for a while—and Johnny began dispensing his magical charm on Moore, who was reacting favorably to it.

By the time we checked into the El Tapatio later that evening and ventured into its nightclub with its blaring disco music, Terry, Johnny and I were in a drunken state.

It was apparent to me that Terry Moore was destined to be Johnny Ortiz's latest conquest, but he whispered into my ear that he was sneaking away so I could be alone with Terry.

He explained he was appreciative of my bringing him to Guadalajara instead of my wife, who, incidentally, was back home fuming that I had accepted Mirisch's invitation (she'd have gone absolutely bonkers had she known I brought Johnny along with me, since she was quite aware of his libertine reputation).

As he did so often behind the bar when he steered women who wanted him to male friends who wanted action, Johnny unselfishly sacrificed himself, and anyway, he knew there would be plenty of opportunities for lady companionship in the upcoming days, which there were (Johnny wound up spending most of his time at the El Tapatio with the beautiful wife of a wealthy Dallas heart surgeon who was vacationing alone).

I escorted Terry Moore, who appeared in such films as *Mighty Joe Young, Peyton Place* and *Beneath the 12-Mile Reef,* back to her room after we danced a bit and wound up spending the night with a woman who had once lived with Howard Hughes and later claimed to have married him, which resulted in her receiving a reported seven-figure settlement from his estate in 1984.

I wound up writing a column on Moore in the *Herald Examiner* and listed her age as forty-two, a fact disputed by several letter-writers who claimed to have graduated with her from Glendale High in 1949 and insisted that Moore was forty-seven.

I ran into Terry Moore on several occasions in later years—twice at the Buggy Whip Restaurant in Westchester—and we'd laugh about that evening we shared together in a Guadalajara hotel room, during which a portion of our bedsheets wound up being singed by a fumbled lit cigarette.

Another woman I'll always recall with fondness was Cookie, who lived next door to me in the Downey apartment I moved into after my separation from M. We met one late evening when I went over and complained about her loud stereo music that had been reverberating against my bedroom wall, keeping me awake.

She had a lank figure—I later would find out she spread only 105 pounds over her five-foot-eight frame—and a pretty, youthful face. She was twenty-one but easily could have passed for being a high school senior.

She had a radiant smile and gave the instant impression of being one of those vibrant people game for anything, which she was. After asking her politely to turn down the music, I introduced myself and said, with tongue lodged firmly against my cheek, that it was now my fervent desire in life to take her to a Lakers game.

She responded that she had never been to one and that she'd gladly go with me. She did, and that resulted in us dating during the next few months.

During that time in which we danced a lot and drank a lot and did a lot of other things a lot, I became aware for the first time—it wouldn't be the last—of incest. I had never known anyone who had been a victim of it, and frankly, I had never even given it any thought.

As a youngster, Cookie had been forced to have sexual relations with her natural father for many years, as was her sister. She related the ghoulish story to me one emotional night and started crying hysterically.

"I have nightmares about it all the time even though I'm not around my father any longer," she would say. "It's had a terrible effect on me."

I never knew how terrible it was until I received a phone call a few years later at the *Herald Examiner* from her sister informing me that Cookie had died from cirrhosis of the liver that was caused from alcoholism.

"Cookie couldn't stop drinking because of what my perverted father did to her," said the sister. "I learned to live with the terrible memory. Cookie never did. And she was too thin to handle all the alcohol she consumed."

Cookie and I stopped seeing each other shortly after I got her a job as a chip girl at a Bell Gardens casino—The Bicycle Club—when she apparently got involved with a fast crowd that hastened her death.

She was twenty-six.

There were a couple women I went out with in those days who had similar experiences, including one whose stepfather had started violating her when she was five and continued until she ran away from home at fifteen and wound up living with foster parents.

"My mom was always gone at night working as a waitress, and my younger sister, younger brother and I would be left alone with my stepfather," she said. "There were times when he'd force me to drink with him, as my brother and sister were sleeping. And other times, before I was allowed to go to a high school football game, he'd force me to have sex with him. I was just a young girl totally intimidated by him.

"When I told my foster parents about him, they went to the police, and he was arrested. But my mom refused to believe it even happened—she thought I was making it all up because I didn't like him—and she even testified against me in court. She said I used to wear tight shorts that caused the creep to become sexually aroused. And he got off Scot-free. Can you believe that?"

No, and her admission and Cookie's and that of another lady I saw for a while—she told me her grandfather had often fondled her—enlightened me on a subject with which I had been totally unaware.

It has made me more empathic to those who have been victimized by deviant sexual conduct—and its cruel aftereffects—and also made me even more grateful that I was fortunate to have grown up in a normal, pleasant, loving household.

Chapter 12

I found serial dating to be an exhausting regimen. While the thrills of newness were intoxicating, there was a lot of rejection, heartache and monetary stress involved in it. You have to have a thick epidermis—sensitive souls should remain safely on the sidelines!—and marriage is a pleasing alternative to those who can't handle the instability of single life.

At least I can take solace in the fact that I never was mean-spirited or exploitative. Certainly, I took liberties with the truth on occasion, but I never fleeced anyone out of money or made promises I didn't plan to keep save for one notable exception. Still, the inevitable partings resulted in hurt feelings for those who invested an emotional stake for a long-term commitment.

The latter became a particular source of frustration to one lady I had been seeing for a time who startled me one Sunday morning in January 1990 when she issued a daring manifesto that left me speechless.

Julie B. was a tall, determined, striking lady of Danish origin accustomed to getting her way, since she had set sales records peddling perfume for Nordstrom, an upscale department store. "I want a ring and a date," she told me in no uncertain terms. I gave her a blank stare and didn't answer.

My friend Mark Emerzian stopped by a few minutes after her declaration. While I was out jogging, she asked Emerzian, "Do you think Doug will marry me?"

"No," he replied honestly. She and I stopped seeing each other within a week.

No matter who was culpable of the various breakups with which I was involved, I always attempted to maintain an affable posture in the aftermath,

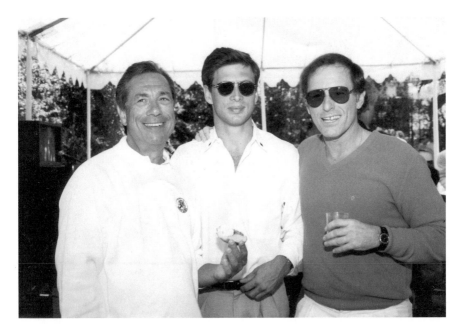

Donald Sterling (left), the owner of the Los Angeles Clippers, is seen in this shot with Doug and his longtime friend Mark Emerzian.

although there were those women who weren't forgiving of sudden departures. Twice during that period, I brought ladies I had met in Europe—one a Paris bartender, another a six-foot-two Amsterdam model—to Long Beach. Both times, for various reasons, I sent them back prematurely. And they weren't exactly joyful about it, expressing their displeasure loudly, albeit in their native tongues, which, thankfully, I couldn't understand. I felt so bad about my treatment of the Dutch woman—her only offense was bad timing—that I even bought her a ticket to San Francisco, where she stayed three days at the Hilton Hotel on my dime before she returned to Amsterdam.

Another time, I was to set to have a weekend stay at the Mirage in Las Vegas with a lady flying in from Chicago named Mary B. We had seen each other periodically since we had met eight and a half years earlier in Miami at the first Alexis Arguello–Aaron Pryor fight. But before I went out to McCarran Airport to pick her up on that long-ago Friday evening in June 1990, I decided to have a few drinks at the Mirage Sports Bar, where my old pal from Long Beach, Leon Bartolino, was the mixologist.

I spotted an athletic-looking lady with close-cropped blond hair seated a few stools away talking to Bartolino, and moments later I asked him who she was.

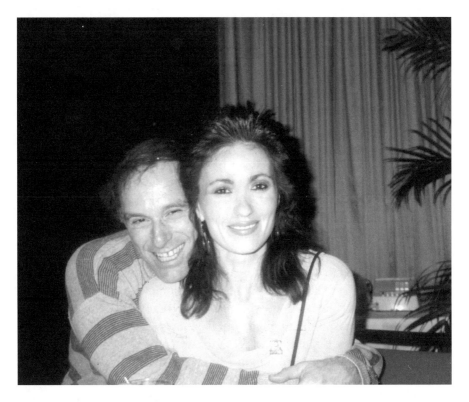

Doug is depicted with Mary B.

"You know Karin, she worked at Recreation Golf Course in Long Beach as a bartender when she was going to Long Beach State," he said.

"No, I really don't remember her. Introduce her to me," I said.

Well, to make a lengthy story concise, Karin R., whom I mentioned earlier as the lady I had parted ways with a few days before meeting Gillian, joined me for drinks. I liked her immediately, and she accepted my brazen invitation to join Mary B. and me for Chinese food later that evening at the Mirage, much to Mary B.'s displeasure.

Mary B. got excessively drunk in reaction, and I feigned outrage and kicked her out of my room the next morning, which resulted in her immediately returning to Chicago and my being able to spend the rest of the weekend with Karin R., who within a month moved in with me. Such is the maddening fickleness and numbing disloyalty of single life.

Actually, the quickest I had anyone move into my house—I was able to retain it after my split with M with a $33,000 settlement, which was a lot of money in those days—was in the spring of 1983 when I went to Palm

Springs to do a story on the heavyweight fighter Gerry Cooney, who was in training after being stopped by Larry Holmes in a much ballyhooed world heavyweight title fight the previous year.

I checked into the hotel where Cooney was staying and instantly became enamored by the young gal at the front desk. I'll call her Karen D., and she was a stunner with all the requisite curves.

Well, to make still another lengthy story concise, I coaxed her into having lunch with me the next day, which she had off—she brought along her two-year-old daughter—and I invited her to visit me in Long Beach. And a week later, she called to tell me she had been fired from her job and that she'd be coming over to see me along with her daughter. But what she didn't tell me was that she would be coming with her car filled with all her belongings.

She arrived on a Sunday morning, and after locating a babysitter for her daughter, I took Karen D. to a Los Angeles Dodgers game that afternoon and a Lakers game that evening—and she moved in with me the next day.

I was thirty-nine at the time—she had just turned twenty-three—and for a few months at least, I didn't mind curtailing my social activities since I was totally absorbed by Karen D.'s dazzling beauty and body. "It's like you're suddenly living with a *Playboy* foldout," said my friend Joe Dee Fox, a keen observer of female culture who summed up my feelings perfectly.

All Karen D., an Indiana native with a refreshing innocence for someone possessing such virtues, wanted in those days was to get married, which eventually led to our downfall. She is the one I still have guilty feelings about because I lied terribly to her, promising to marry her in the wake of losing an enormous amount of money gambling even though I had no intention of doing so.

I later had many rollicking adventures during my travels on the European trains—I always purchased a Euro Rail pass—and one of the most memorable came during the nine-hour trip between Vienna and Berlin in which I met in the dining car a recently separated blond dentist from Vienna who was on the way to attend a dental convention in Leipzig. She never made it there. We wound up having a few days of gaiety in Berlin and a few more in Hamburg, where we stayed at one of my favorite hotels in Europe, the Atlantic on Alster Lake, and where the party ended. Actually, it could have continued the following weekend in Paris, and she thought it would. But I called her from Paris to tell her that something had come up and that I had to cancel. Nothing more important came up other than my wanting to be with a Parisian lady friend, Françoise—and I never saw the Austrian dentist again.

This is the way I was before I fell in love with Gillian, who was to change me like no one else was able to do.

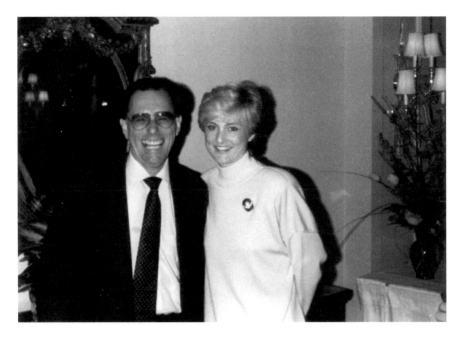

Doug and Karin R. share a reflective moment.

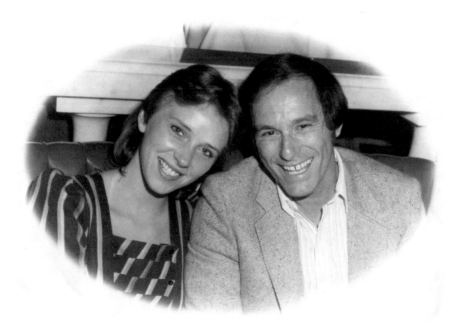

Karen D. poses with Doug.

September 1999 [The Revelation]

I'll never forget the moment Gillian mentioned it to me, although at the time I didn't think anything of it. I mean, at the time, she was exercising strenuously and enthused about being enrolled for the second year at Long Beach State, taking courses that she needed to complete in order to take the California physical therapy exam.

At the time, we were so happy together, set to celebrate our second wedding anniversary, planning for a future we hoped would include a child.

We still were basking in the afterglow of our August vacation in which almost every day had been a pleasurable experience, especially for someone like Gillian who had never traveled extensively in this country or Canada.

I rented a new Lincoln Town Car, and we took a two-week journey through Nevada, Utah, Idaho, Wyoming, Montana, Washington, Oregon and down the California coast. We also went into Canada, where we drove across the Canadian Rocky Mountains from Banff to Vancouver.

It was a grueling trip because we were always on the move, except for an extended stay in Ketchum, a quaint town located in the Idaho ski paradise of Sun Valley. And we hadn't even planned on that five-day diversion and did so only at the vehement insistence of my sister, Ginny (Bunny) Clements, an energetic livewire who had successfully taken over the family Budweiser distributorship in Tucson and other Arizona locales after the 1994 death of her husband, Bill Clements. We stayed at her summer home in Ketchum.

Gillian was awed by the alpine beauty we encountered throughout the trip, and no place impressed her more than Lake Louise with its crystal-

clear blue water at the base of glacier-clad peaks in Banff National Park in Alberta.

"I've seen things I never thought in my life I would see, and many things I didn't even know existed," she later would say when we went through the giant redwoods in Humboldt County along the northern California coast and stayed one evening at a bed-and-breakfast near Mendocino, birthplace of my mother.

We both were passionate about traveling and experiencing new places—in three months we would welcome the twenty-first century in the Syrian capital of Damascus—and I recall us early one evening sitting in the front room of my small Long Beach tract home when she said casually to me, "I've had some blood in my stool recently."

In light of ensuing developments, I should have reacted with concern. But I didn't. I had no idea about the potential dangers of such symptoms. I only said, "We'll have the doctor check it out."

I had a family doctor I had been seeing for eighteen years and had a good rapport with him. He also took care of the medical needs of a couple local professional athletic teams. I had total trust in him, which, as it turned out, was a horrific mistake on my part. We went to see the doctor, and he gave Gillian a blood test and a rectal exam. Apparently, he found nothing seriously wrong, although there certainly was something seriously wrong.

In retrospect, the doctor should have ordered a colonoscopy, as several other physicians have since told me. But he didn't. It was an unconscionable oversight, a malpractice-caliber transgression, since a colonoscopy would have quickly detected the cause of her bleeding. Perhaps the good doctor was overburdened by his duties with the professional athletic teams that did take up a lot of his time. Gillian later would tell me she didn't mention her condition to me for another six months because she felt the rectal bleeding was caused by hemorrhoids and was embarrassed to make such an admission.

During that time, I forgot about it, actually thought it had gone away since Gillian had remained quiet. I now wish I had brought up the subject again to Gillian. She later would admit to me that the bleeding never stopped and that she began experiencing increasing pain in that region.

In a movie, when an actor fumbles a line, the director can do another take to rectify it. I wish it were like that in the medical field when a doctor fumbles his job.

If it was, Gillian still might be alive.

To this moment, I'm still haunted by my not being unduly alarmed by Gillian's revelation—and not pressing the family doctor for a comprehensive explanation, which he never offered. The doctor, to his shame, acted as though Gillian was perfectly healthy. But she wasn't. She was sick, very sick, only we wouldn't find out the graveness of her sickness until it was too late.

Chapter 13

I was surprised in early November 1995 when I received a letter from Gillian. While I certainly hadn't forgotten her, I finally had given up attempting to get together with her again, since she had firmly been resisting my periodic blandishments.

In fact, I hadn't spoken to her in almost a year, and time had dimmed the memory. But as I read her letter with its tone of sadness and hurt—apparently, a lengthy on-and-off relationship had totally disintegrated—my interest in her suddenly again stirred.

I phoned her immediately, and we had a light, pleasant conversation about sundry subjects when I informed her I would be in Cannes again for New Year's. "You have to fly over and meet me there this year," I said, and I expected another refusal that this time wouldn't bother me one bit because my feelings for Gillian had waned, or so I thought. "You can't stay mad at me forever. How are we ever going to get married if you continue to stay mad at me and not want to see me?"

I could hear her laughing softly, and I realized maybe, just maybe, this time she might relent. "You'll love Cannes," I went on. "We'll have lunch one day in Monte Carlo and visit the Maeght Gallery in the Saint Paul de Vence. There is so much to see in the South of France. It's a wonderful place. Oh yes, there's also a Renoir museum located in the home where he lived in Cagnes-sur-Mer. I'm sure you'll love that, Gillian, because it's supposed to be a beautiful place overlooking the Mediterranean."

Gillian remained silent, hadn't interrupted me, hadn't said, "It all sounds good, but no thanks, Douglas, because I still don't trust you and I still haven't forgotten what you did."

I perceived this as a good sign. And then I couldn't believe what I was hearing when she finally spoke.

"OK, Douglas, I'll go, but we must sleep in separate beds," she said.

"Oh, that'll be no problem," I said, barely able to contain my joy.

"I mean it, Douglas—separate beds," she said.

After three years, Gillian finally had relented, finally was willing to see me again—with conditions, of course.

After I hung up, I felt regretful and thought about my many misguided decisions across the years. Why did I treat Gillian so badly? Why did I marry my first wife when I knew from the start it never would last? Why did I allow myself to get caught up in something as insidious as gambling? Why did I so blithely once reject Arnold Schwarzenegger's persistent offer to write his first book?

I figure a psychiatrist could figure out my self-destructive tendencies that were graphically reflected in my folly with Schwarzenegger, who went on to become an internationally famous action film star not that long after I first made his acquaintance.

"You fucked up, Krikorian," Schwarzenegger would say years later to me one evening when we came across each other after a Lakers game in The Forum press lounge.

"Yes, I did," I answered.

And, oh, did I!

I had written a column in 1976 on Arnold Schwarzenegger in the *Herald Examiner* centered on a book called *Pumping Iron* that featured Schwarzenegger and later was made into a critically acclaimed documentary. It was written by George Butler and Charles Gaines.

I met with Schwarzenegger and Butler one morning at the Case Delicatessen across the street from the historic Herald Examiner Building at Eleventh and Broadway in downtown Los Angeles and interviewed the pair for more than two hours.

Schwarzenegger and I hit it off immediately when he realized I had an extensive weightlifting background.

When the story appeared two days later in the *Herald Examiner*—it was stripped across the top of the sports page with a photo of a buff, flexing Schwarzenegger accompanying it—Schwarzenegger called me at the newspaper.

"I can't thank you enough," said the future governor of California, who was twenty-nine at the time and the reigning Mr. Olympia. "This is the first time I've ever been featured in a mainstream publication."

He paused a moment and then said, "Look, I have an offer from Simon & Schuster to write a bodybuilding book. And I want you to write it with me. I feel comfortable with you, and I know you're my kind of guy."

He gave me his home number, and I told him the idea intrigued me and that I would get back to him, which I quickly did after consulting with a literary agent named Mike Hamilburg.

When I spoke to Schwarzenegger again, he told me I'd get $5,000 up front and would receive 20 percent of the royalties.

Hamilburg said I should get a larger slice, and the next time I spoke to Schwarzenegger I told him I wanted a fifty-fifty split on the royalties.

He said 30 percent was the best he could do, and I told him I'd think about it.

In looking back, I probably was uninterested in taking on what would have been a laborious writing project and was subconsciously looking for a plausible excuse to get out of doing it.

But I didn't come up with one. What I did, instead, was simply not call Schwarzenegger back. A month elapsed without us talking, and I figured he had found another author, which was fine with me.

But one early evening, while I was watching TV in the front room of our Long Beach home, the phone rang, and my wife, M, answered it in the kitchen. "Some guy named Arnold wants to talk to you," she yelled out.

It turned out to be Arnold Schwarzenegger.

"Hey, Doug, you must have lost my number because I haven't heard from you, but I still want you to write the book," was the first thing he said when I got on the line. "Let's get this done. Let's meet. C'mon out to my apartment in Santa Monica."

So a couple days later I went to Santa Monica and never will forget seeing Arnold Schwarzenegger and his close bodybuilding friend Franco Columbu working feverishly in the front yard of Schwarzenegger's apartment. They looked like heavily muscled carpenters as they hammered away on a wooden couch.

"Let's get this book thing done today," said Schwarzenegger. "Like I said before, you're my kind of guy. I know you know a lot about weightlifting. I know I can work with you. I'll give you sixty-forty on the royalties. OK? That should settle it. Have your agent call me. OK?"

I remember gazing thoughtfully at these men who already had won many international physique contests and were featured regularly in Joe Weider's

physique magazines, and it seemed such an anomaly to see them there in the middle of the afternoon working on a piece of furniture in a quiet Santa Monica neighborhood. They were far removed from what both eventually would become—Schwarzenegger a major player in the movie industry and California politics and Columbu a successful chiropractor.

Schwarzenegger and I shook hands, but we didn't see each other again until our paths crossed twenty-two years later at The Forum.

I went home that day after the meeting with Schwarzenegger and decided covering the Rams for the *Herald Examiner* took up enough of my time. I never bothered to phone Schwarzenegger, and I guess he got the hint since he never again phoned me.

Schwarzenegger went on to do the book with a freelance writer named Douglas Kent Hall, and it wound up on the *New York Times* bestseller list for eleven weeks.

I often wonder what would have happened to me had I done Schwarzenegger's book.

Schwarzenegger is known to be unfailingly loyal to his friends—just look how many of his old bodybuilding pals appeared in his many films—and I might have missed a lucrative opportunity to be involved in his enterprises.

I'm sure I did.

But at least I now had an opportunity with Gillian to atone for another one of my numerous misjudgments. Or was it a misjudgment?

Chapter 14

As I flew to Nice that late December, I remember being comfortably inclined in a Delta business class seat—God bless the buddy passes!—immersed in a book, which long had been a hallowed ritual of mine on those lengthy flights to Europe.

I recall it being George Clare's *Last Waltz in Vienna*, because I later would discuss it in detail with Gillian. This moving, tragic account of Austria's Jews after the Anschluss—the annexation of that country by Nazi Germany on March 12, 1938—and Clare's parents' ill-fated destiny to Auschwitz after escaping to France ranks among the most compelling I've ever read.

It wasn't exactly unusual that I was reading an Austrian author since in the previous few years I had become addicted to such other ones as Stefan Zweig, Arthur Schnitzler, Joseph Roth, Egon Friedell and Franz Werfel, all exquisite craftsmen and artful storytellers. This was before Gillian introduced me to Iris Murdoch, the great English novelist.

Anyway, I also remember on that momentous flight that, after turning off the overhead light to snooze, I began reflecting deeply on this strange renewal I was about to have with a lady I hadn't seen in almost thirty-nine months.

Thoughts flowed ceaselessly across my mental screen that kept me awake until I later alleviated such a condition with a Valium. How surprising it was that I was actually going to see Gillian again after I long ago had concluded such an occurrence never would happen.

But then I began thinking about how unlikely developments, even shocking ones, had long become almost commonplace in my life, even

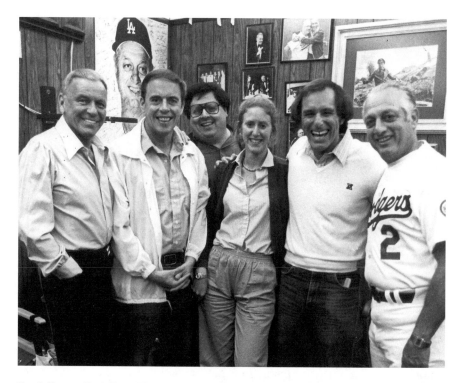

Frank Sinatra (far left) and Tommy Lasorda (far right) pose with *Los Angeles Herald Examiner* sportswriters (from left) Jack Disney, Allan Malamud, Pam King and Doug.

before my being nabbed *in flagrante delicto* by X in my early days at the *Herald Examiner.*

What line would odds makers have posted on my traveling around the country with the Los Angeles Dodgers and realizing my goal of becoming a sportswriter on a metropolitan newspaper by the time I turned twenty-four?

And I doubt there is a high school senior in America—definitely not these days—who experienced what I did in April 1961 after getting into a brief noontime scuffle with a tough Mexican kid in front of Fowler High School.

A teacher broke it up and ushered the pair of us into the office of the vice-principal, Dan Petersen, a stern fellow who was in charge of disciplining students.

Neither of us was contrite during the session with Petersen, and I was especially vocal about what I would do to the Mexican kid if I had a chance to duke it out with him again.

"OK, guys," Petersen finally said in exasperation. "You wanna settle it? I'm going to give you guys a chance to do so. Let's go to the gym, and you guys can put on the boxing gloves and go at it."

And so a few minutes later, in the middle of the old Fowler High basketball gym, there were this Mexican kid and me flailing away at each other as Dan Petersen, John Pereira (the head football coach) and Helen Jorgensen (the school nurse) observed the spectacle.

I landed the harder punches in the early stages, which I dominated. But the other guy never went down and never got tired. Alas, I did. After a while, I couldn't catch my breath and couldn't raise my hands, and the Mexican kid pummeled me unmercifully. I finally fell to my knees in surrender.

I'll never forget when I went to my sixth period a cappella class and one of my friends—his name was Bobby Eiland—asked me, "How badly did you kick the guy's ass?" I looked at him with embarrassed humility and said, honestly, "I didn't. I got tired, and he wound up kicking my ass."

We both suffered facial bruises and black eyes—the fight lasted more than ten minutes—and could you imagine the legal uproar and lawsuits that would ensue today if a high school vice-principal forced a couple students to settle their differences with their fists?

Actually, I have no problem with what Dan Petersen did, since it resolved the issue between the Mexican kid and me. We got along fine after that.

Another implausible incident—oh, was it!—came during my gambling peak in September 1984 when I came to the conclusion early one week that the New England Patriots, who were three-point favorites, were an absolute certainty to cover the spread at home against the Seattle Seahawks.

I told my friend Donnie "No Win" Kramer, a total gambling degenerate, about my prediction, and he readily agreed with me.

"Let's go to Las Vegas and bet on it," I said, even though I could have done it with one of my bookmakers. "They'll be showing the game live there on satellite." This was long before the advent of DirecTV and the NFL Package.

I was living at the time with Karen D., the lady I had met when I was in Palm Springs to interview the boxer Gerry Cooney, and told her I had to go to a stag party my brother-in-law was giving in Tucson. That was a minor fib compared to the whopper I later would lay on her that caused our final breakup.

So Donnie No Win and I departed for Las Vegas on a Saturday afternoon, stayed that evening at the El Cortez and scurried down to the Barbary Coast the next morning to bet $3,300 to win $3,000 on the Patriots minus three

Heavyweight contender Gerry Cooney clowns around with Doug and Johnny Ortiz (right).

Doug shares a laugh with former Rams and Giants defensive lineman Fred Dryer, whose post-football career included starring in the TV series *Hunter*.

points. We then sat in the hotel's sports book to watch New England reap us a nice profit.

Only we watched in disgust as the Seahawks streaked to a 23–7 halftime lead, meaning we were behind nineteen points in our betting proposition, meaning we figured to lose our $3,300 investment.

We decided to fly back immediately to Los Angeles to spare us further frustration, and the mid-morning game—it started at 10:00 a.m. (Pacific Standard Time)—was over by the time we reached LAX. We were both sullen and depressed, as all gamblers are who have blown a large amount of money they can't afford to blow.

As we slowly walked through the terminal, I noticed a television showing a football game in one of the lounges. I curiously peeked in, and NFL scores were streaming across the bottom of the screen. And then I saw an amazing sight that resulted in my screaming out to Kramer, "We won! We won! We won! The Patriots won 38–23. They outscored the Seahawks 31–0 in the second half! Incredible!"

I began jumping crazily around, and the lounge patrons stared at me curiously. "Buy all these people a drink," I told the bartender. "I just found out I won $3,000 after I thought I had lost $3,300." All the patrons started cheering.

Another surprising development in my life—actually, a frightening one that came ominously close to my suffering severe bodily damage—resulted in my making the news instead of reporting it. It happened on a Thursday afternoon in mid-December 1978 when I was at Blair Field in Long Beach, where the Rams held their weekday practices.

I was in my seventh season of covering the Rams for the *Herald Examiner* and took particular delight in breaking stories before they appeared in the rival, much larger *Los Angeles Times*, which I did often because of the close relationships I had built up with several Rams players, including Fred Dryer, a star defensive end who would go on to become a TV star in the hit series *Hunter*.

I was fed a lot of information that wasn't privy to other reporters, and Fred Dryer had phoned late the previous evening to inform me about a locker room fight that had taken place earlier in the day between the Rams' tough linebacker, Isiah Robertson, and the team's center, Rich Saul.

Dryer told me that Saul had choked Robertson into unconsciousness.

"Rich came out to the field after the fight and said, 'I think I just killed Isiah,'" related Dryer.

I already had had several obscenity-strewn run-ins that season with Robertson about negative items I had written about him in the *Herald*

Examiner—he had threatened to dislodge my head from my shoulders more than once—and I was wary about questioning Robertson about the incident as he walked off the Blair practice field.

But I did, and Robertson didn't react well to such interrogation. His eyes widened malevolently, he yanked off his helmet and was set to bash my noggin with it when a couple individuals—the Rams' coach, Ray Malavasi, and a reserve running back named Larry Marshall—tackled Robertson to the turf.

"Worst decision I ever made...I should have let Isiah kill you," Malavasi later would often tell me.

I'm sure Malavasi, a peerless defensive coordinator but a mediocre head coach who wound up being fired by the Rams, was kidding—or was he?

After Robertson's attack, which was reported in all the media outlets and stripped across the top of the *Herald Examiner* sports section's front page in an article written by Melvin Durslag, the Rams owner, Carroll Rosenbloom, angrily ordered me off the Blair Field premises.

Both Durslag and I that season had fallen out of favor with Rosenbloom for our persistent criticism of his intemperate decision to fire George Allen—and replace him with Malavasi—during the summer after the Rams lost their first two exhibition games.

A Robertson sequel occurred a short while later on New Year's Eve when I walked into a Long Beach nightclub called Bobby McGee's searching for a lady friend—naturally, I had strayed from my wife that evening—and nearly collided with Robertson.

When he saw me, his eyes once again widened malevolently, and he once again came after me but was intercepted by the nightclub's bouncers, one of whom, John Corbett, became a well-known actor. I didn't realize that Robertson had stopped pursuing me and frantically sprinted out the front door all the way to my car, where a friend of mine was seated in the passenger seat.

"That was the fastest I've ever seen a human being run," he said. "You could be an Olympic sprinter."

Once again, I had escaped the wrath of Isiah Robertson, who, to paraphrase Mike Tyson, had evil intentions on my anatomy, which he easily could have ravaged since he was a powerfully built six-foot-three, 240-pounder accustomed to delivering bone-jarring hits. Isiah and I made up a few years later, and he even came down one afternoon to our ESPN studio in Culver City and spent an hour with Joe McDonnell and me reminiscing fondly about our differences.

Famous Los Angeles criminal attorney Paul Caruso (left) poses with Doug and Rams quarterback Vince Ferragamo.

Doug meets with former Rams coach George Allen (center). The late *Los Angeles Times* sportswriter Bob Oates is at right.

And now yet another unlikely occurrence was about to transpire in my orbit. Why did Gillian decide to send such a conciliatory letter to me last month after such a long period of intractable coldness? Was she reeling that badly from a romantic breakup, or was there another reason? Why, suddenly, had she even agreed to meet me in Cannes? Why did I even want to see her again when I had other women, a couple of whom I actually liked, I was seeing in Los Angeles?

It's not as though I had been sitting forlornly around pining for Gillian, which I certainly hadn't been.

Strange.

Chapter 15

On the early evening of December 29, I left the Noga Hilton in Cannes in a rented car for the short ride—less than twenty miles—to the Nice Cote d'Azur Airport to pick up Gillian, who was due to arrive at 8:00 p.m. In those days, non-ticketed folk were allowed to go to arrival gates and greet incoming passengers.

I was an hour early, and a little nervous, which necessitated my having a couple vodkas to calm the nerves. Naturally, Gillian's flight from London was delayed, necessitating my having a few more toddies during the agonizing wait.

When the plane finally arrived at 10:30 p.m., I was standing behind the roped-off area as the passengers exited the gate, curious what Gillian would look like to me after such a lengthy absence, curious how the imminent interaction would unfold between us.

When I saw her emerge, I couldn't believe it. I was immediately captivated by her youthful features that had such an angelic quality about them. I'm not sure I had even noticed those qualities in the past, or at least hadn't dwelled on them as I was doing now. I couldn't contain my enthusiasm, and perhaps fueled by the excessive amount of alcohol I had consumed, I blurted out loud enough for everyone to hear, "Gillian, I love you!"

Gillian turned and looked at me, managed a wry smile and shook her head slightly. What had I been thinking three years ago when I so cavalierly stood Gillian up on a New Year's Eve date? Was I a total numskull? I knew the instant Gillian emerged from that passenger gate that long-ago night at

the Nice airport that I wanted this woman to become a permanent part of my life.

We made it back to the Noga Hilton by midnight and went up to the room to get rid of her suitcase. Since there was only a king-size bed in it, I said quickly upon entering, "Don't worry, I'll stay on my side of the bed."

She nodded softly, and a few minutes later we were on our way down the La Croisette to Farfalla, a popular restaurant located across the street from Palais des Festivals, headquarters of the Cannes Film Festival. I was on an adrenalin high, in an ecstatic state and excitedly kept telling Gillian how badly I still felt about what had happened between us and also kept telling her how great she looked.

My contrition seemed to have an effect on her, since she was smiling and laughing and evincing a sense of warmness as I went through my usual tavern ritual of talking to everybody in our vicinity. Like in the past, Gillian was enjoying it, which only spurred me on more. Of course, I didn't ignore Gillian; I asked her about her personal life, which she told me hadn't exactly been filled with happiness in recent times. We stayed for a couple hours and straggled back to the Noga, where I kept my promise. I slept on my side of the bed.

I had been coming to the South of France—and staying in Cannes—for several years at the instigation of Melvin Durslag, who was an early mentor of mine at the *Herald Examiner*, along with Bud Furillo, and whose sage advice on pertinent life matters long had been vital to me.

Melvin was a nationally acclaimed syndicated sports columnist for Hearst's King Features for many decades, and he was an elegant wordsmith with a light touch. He also was a regular contributor to *TV Guide* when that publication was owned by the media mogul Walter Annenberg and had a weekly circulation of more than twenty million at its peak.

Melvin and his wife, Lorayne, were Europhiles—they'd had been visiting the old continent at least twice a year since the 1950s—and the South of France was one of their favorite destinations.

I, too, immediately became enamored by the area and, in particular, with Cannes. I savored its food; its nightlife; its bright, picturesque setting; and its scenic boardwalk next to the Mediterranean that was terrific for strolling, jogging and people gazing. I had been visiting Cannes annually since 1989.

Gillian and I went for an hour-long run the next morning—it was a cold but clear day—and then we took a train to Monte Carlo, where we visited the casino. It was in front of that famous edifice that I took a photograph of Gillian, and little did I know that five and a half years later it would appear

Prior to the Mike Tyson–Leon Spinks heavyweight fight in Atlantic City in June 1988, longtime *Los Angeles Herald Examiner* sports columnist Melvin Durslag (left) is seen with (from left) Doug, Leon "The Bartender" Bartolini and Donnie Srabian.

in the *Press-Telegram* after her death. In it, Gillian, wearing gloves and a dark overcoat with her thick brown hair cascading down past her right shoulder, peers strangely away from the camera, and there is a look of inscrutability on her face.

Gillian in front of the Monte Carlo Casino in Monaco in December 1997.

I've studied it closely over the years, and while I originally thought I detected a barely perceptible grin on Gillian, it no longer is visible to me. I now see a wistfulness covering her poised features that might well have unconsciously been betraying a presentiment that lurked deep in the recesses of her soul. Indeed, when I behold the picture now, I find it a little haunting and often get the chills.

We had lunch that day at the Café de Paris near the casino and then walked up to the Palace, where my favorite childhood actress, Grace Kelly, once held sway as a princess, married to Prince Rainier.

After leaving Monte Carlo, we went to the quaint seaside village of Beaulieu and then walked a mile to Cap Ferrat, one-time residence of David Niven, Charlie Chaplin, Liz Taylor and Richard Burton, Somerset Maugham, Winston Churchill, King Leopold of Belgium, Jean Cocteau and many other celebrated individuals.

It's a gorgeous area along a peninsula that juts out to the Mediterranean, and there is an astonishing serenity about it.

"Ah, if only I was a descendant of a Rothschild, we'd be living here one day," I told Gillian as we walked around the Villa Ephrussi de Rothschild that once belonged to a member of the legendary banking family, Beatrice de Rothschild, who willed the extensive property overlooking the Mediterranean that featured nine gardens to the French government.

"No, Douglas, I don't ever want to live in one of these villas," she said. "I don't need one of these huge homes to be happy."

"Good," I countered. "Because one day you're going to reside in my 1,400-square-foot hovel in Long Beach."

She laughed heartily. The statement seemed outrageous at the time, but I meant it.

After being reunited with Gillian for less than twenty-four hours, I already had made up my mind that I wanted her one day to be my wife. Certainly, it was an impulsive feeling, and Gillian herself would have to be amenable to such a union, no certainty. But I viewed Gillian differently this time and had quickly come to realize that she was a special commodity without vexing encumbrances.

And, at twenty-nine, time still was her ally. At fifty-two, it wasn't mine, and I had a standard explanation to those wondering the reason for my preference for younger women. "I don't want to date anyone who looks like me," I would say.

I also, finally, had become totally worn out by the single scene with its bright moments of jollity that too often were overshadowed by its gnawing moments of loneliness and sorrow. I had been seeing a couple of nice ladies, but I quickly realized neither measured up to Gillian. I also realized the calendar was closing in on my late-blooming desire to become a father.

Still, I knew there was a barrier I might not be able to surmount. I was born on August 12, 1943. She was born on July 25, 1966. That's a twenty-three-year gap in age, and I was certain that wouldn't exactly inspire hosannas from her parents, as well as her brother, sister and friends and maybe even Gillian herself.

I already had experienced a couple of recent disappointments from my having come into this world in the middle of World War II.

On a Friday night a few months earlier, I had met for the first time a *Press Telegram* sales lady named Violet at a downtown Long Beach restaurant called Mum's, and it turned out that she was a loyal reader of my column. We had a few drinks, exchanged phone numbers and were having a blissful time until, that is, she suddenly asked me in what year I was born.

"Nineteen forty-three," I said honestly.

"Lemme see, 1953 makes you thirteen years older than me," she said. "I was born in 1966."

"No," I corrected, above the din of the tavern. "I was born in 1943."

"Nineteen forty-three!" she said incredulously.

She was momentarily speechless, and when she finally resumed speaking, she informed me her father was born that year. The evening took a severe downturn after that. It was as though a light switch had been turned off in her personality. From warmth and radiance, she became subdued and cold. We never went out, and I threw away her number later that night.

A different occurrence, but with a similarly negative outcome, had happened a year earlier. I once again had been gallivanting around Europe with Mike "The Hammer" DiMarzo, and we were on a train going from Munich to Dachau when we met a young lady named Katharine—she was twenty-six—who lived in an apartment overlooking the site of the infamous Nazi concentration camp in Dachau.

She was a friendly sort with clear blue eyes who worked at an accounting firm in Munich, and Mike and I took her and her girlfriend to dinner that evening at a German restaurant in Dachau. There was much merriment, and I later wound up staying in Dachau with Katharine for a week after DiMarzo had returned to LA.

I got along well with Katharine, who let me use her car on the days she was at work in Munich. I spent that time driving around the many villages in the Dachau area. I'd get out and walk around in each one and couldn't help but notice that the cemeteries at the Catholic churches had dozens of crosses above the graves of men born between 1916 and 1924 and perished in the early 1940s. I asked Katharine about it, and she said, "Thousands of young soldiers from this area died during World War II on the Russian front. We lost more than a million soldiers in Hitler's stupid campaign to conquer Russia. I still don't understand how our country ever allowed that madman to take control of it and allowed the slaughter of the Jewish people. What an embarrassing part of our national history."

Katharine's father owned a large textile firm in Kassel, and she promised to visit me in Long Beach during her upcoming Canadian vacation with her family. "I'll fly to Los Angeles for a couple of days," she promised.

A week before she departed for Canada, we spoke on the phone, and she said, quite bluntly, "Sorry, I can't come and see you. My dad says you're too old for me, and so I guess I can't see you anymore."

That was the last contact I had with Katharine, but that recollection and the recent one with the sales lady from my newspaper had me wary that

Doug with Katharine
in Munich.

evening in Cannes during supper at Vesuvio when Gillian suddenly brought up the subject I knew was inevitable.

"Douglas, I don't even know how old you are," she said.

I remember thinking to myself, "Should I lop a few years off my age, or should I simply tell her the awful truth?"

The latter is the daring course I decided to take, and I chuckled nervously when I said, "I'm fifty-two."

I tried to detect a change in Gillian's expression, but she remained remarkably impassive.

"Oh," she said simply.

"Does that bother you?" I wondered, displaying my insecurity.

"Why would it bother me?" she replied. "Age is irrelevant as far as I'm concerned. What is relevant to me is if a person is decent and honest. What also is relevant is if I like the person. And I like you, Douglas. I wouldn't be here if I didn't. I always liked you, Douglas, from the very first day I met you."

It was the first time she had ever made such a revelation, and she did it with a warmth and sincerity that moved me.

"I like you, too," I said, and leaned across the small table and kissed her fervently.

Chapter 16

We returned to the hotel after dinner, and our emotions for each other were strongly magnetic, drawing us together in an ethereal tableau of sexual ecstasy. Although both of us had had an exhausting day, neither of us could sleep during the intervals as we laid there in the dark affectionately entwined, alternating between periods of silence and periods of talking.

And it was I who did most of the talking that glorious night, as I let loose the reins and opened up to Gillian about myself like I had done with no other woman—the tender and warm feelings I was experiencing seem to have had a metamorphosing effect on me.

It was as though I were releasing pent-up memories I had long buried to a person I knew would listen with an understanding interest. I suddenly had total trust in this young lady from Britain and no longer was fearful that she would chafe from my talking about myself.

I revealed to her my addictive inclinations and how they had been a part of me going back to my youth, when I had my heart set on becoming a Major League Baseball player, and how I played out such a delusion with lengthy daily pickup games with neighborhood kids in the sweltering heat of the San Joaquin Valley summers.

"A bunch of us would play for seven, even eight hours a day—we'd start at 7:00 a.m.—in temperatures that sometimes reached 110 degrees," I said. "We were all crazy about baseball. And during the cold Fresno winters, I'd spend hours in my backyard almost every day practicing my fielding by

throwing a baseball against the garage door. One of our next-door neighbors complained about the noise, but I continued to do it."

I was in an expansive mood and began telling Gillian about an activity that had radically changed the contours of my anatomy and even for a time changed the way I deported myself.

"Gillian, you wouldn't believe how much weightlifting once dominated my life," I said. "And what an impact it has had on it, probably even being responsible for keeping me out of the Vietnam War. I started dabbling in it a little bit in high school, but once I got out, it took over my life. It commanded more of my attention in college than sorority girls and classroom studies. I weighed 145 pounds when I entered Fresno State, and within three years I was up to 215 pounds. I put on 70 pounds during that time, and my workouts lasted between three and four hours. I'd go to the gym at least five days a week. I was totally obsessed with the weights and drove my mother nuts. She was a nurse and kept saying it wasn't good what I was doing to my body. She'd cringe when I'd take my shirt off and see how excessively large my arms, shoulders and biceps had become."

"How did you put on so much weight?" asked Gillian.

"The easiest way to put on weight so fast was to supplement your diet with steroids, but I never used any drugs like Dianabol, which all the weightlifters were then using," I answered. "But what I did do was become a ravenous eater. I lived at the Theta Chi Fraternity house for a couple of those years, and the cook would routinely serve me a breakfast consisting of twelve scrambled eggs and a pound of bacon. I'd also eat at least ten pieces of toast. But that paled in comparison to the seventeen pieces of chicken and fifteen tacos I often consumed when I had dinner at Sir George's Smorgasbord. I'd also often down a loaf of bread before sleep.

"Naturally, I became very strong, as I could bench press 375 pounds and could do seven repetitions with 135-pound dumbbells on the incline bench. I became this bulging, macho person—I wore tight shirts that accentuated my physique and strutted around like a tough guy, which I certainly wasn't."

Gillian then asked me a question that I never had before answered honestly.

Indeed, when I had previously been asked about what inspired my becoming a serious weightlifter, I always said it was just a case of my wanting to put on a few needed pounds on a skinny frame that badly needed strengthening.

That was true to a certain extent, but what I told Gillian that night was the *real* reason for my weightlifting fanaticism.

"No doubt its genesis can be traced to my freshman year at Fowler High when I was bullied by a couple of long-haired Mexican guys—we referred to

them as *pachucos* in those long-ago times—who would thumb my ears during my wood shop class," I began.

"Gillian, you wouldn't believe how terrified I was of those fellows who were a lot bigger—I was a scrawny 115 pounds on a five-foot-nine frame—and tougher than I was. I took my fear home with me and became quiet and solemn around the house, spending a lot of time in bed reading books and watching TV. One of the antagonists, in particular—his surname was Leyva—took special delight in harassing me, since I visibly cowered in his presence.

"My father grew up in Fresno early in the twentieth century when there was widespread prejudice against Armenians—and had countless fights as a youngster with those who taunted his heritage. He wasn't a man who retreated meekly when his hand was called, and he chided me when he found out my sudden despondency was caused by the harassment I was enduring at school.

"I told him about how this Leyva guy scared me to death, and he said sternly to me, 'Either you turn around and smack the guy as hard as you can in his nose, or I'm going to smack you.' His admonishment came on a Sunday.

"And late the next morning during wood class, Leyva, as usual, moved behind me and started thumbing my ears as the instructor demonstrated how to use an electric saw. But this time I had worked myself into a rage, and with my father's words echoing in my head, I whirled quickly around and fired a right hand as hard as my flimsy body could propel it, and it struck squarely on Levya's rather large proboscis.

"Blood spurted everywhere, and I landed a few more punches on the face of the dazed fellow before the instructor intervened. I was screaming as loudly as I could, although I don't remember doing so. I guess I momentarily had lost total control of myself. My Mexican pals I had grown up with in Fowler—Leyva was from a poverty-stricken Mexican hamlet five miles away called Malaga—later told me the *pachucos* said I was *loco en la cabeza*, which in Spanish means that I was crazy in the head.

"The *pachucos* never tormented me again in high school, but I still think that bullying episode had a huge impact on my life. I'm not sure I ever would have become so obsessive about building up my body and becoming so extraordinarily strong had I not gone through such a frightening experience."

I had never told that story before out of embarrassment, and Gillian could feel my reluctance.

"That bullying must have been difficult," she said softly.

"It was," I agreed. "Just look at the effect it had on my life. I have painfully arthritic shoulders now because of the thousands of hours I spent lifting

weights. I now wish I had spent all those hours I wasted in gyms reading books and working on my writing skills."

"But lifting weights couldn't have been all bad for you since you said it kept you out of the Vietnam War," said Gillian. "Can you tell me the story of that?"

I had been prattling on for several minutes and figured Gillian had heard enough of my life story for one night.

"That's for another time," I said. "Aren't you about ready for sleep?"

"I'm wide awake and want to hear how your weightlifting might have gotten you out of that awful Vietnam War," she replied. "Please, Douglas, you know I always love listening to you talk."

And so I blithely went on talking and related an episode from my life that I seldom discussed, not so much out of shame—thousands of men got out of serving in the military during the Vietnam War for less valid reasons than I did—but out of a respectful regard for those who did serve in one of this country's most unpopular conflicts.

"After I obtained my degree in journalism at Fresno State in June 1966, I was persuaded by an army recruiter in Fresno to sign up for the army's Officer Candidate School," I began. "It would have been a four-year commitment, but I was young and dumb and had a lot of machismo and actually had these fanciful visions of becoming a war hero.

"I took the physical but, to my disappointment, flunked it because of high blood pressure, which I didn't even know I had. I went to see my family doctor about it, and he told me there was nothing wrong with me and that such a condition was due to my heavy weightlifting.

"I mistakenly thought I was out of the service and went down to Southern California and got my first full-time newspaper job at the *Pacific Palisadian Post*. But in the middle of September, I got a call one evening from my mother informing me that I had received a draft notice in the mail. I figured the Selective Service Board had made a mistake, since I thought I already had been rejected for military service.

"But I was wrong. I called the Selective Service Board, and a representative told me it didn't recognize the Officer Candidate School physical. I was then residing in a studio apartment in Santa Monica, which was near Pacific Palisades, and was working out daily at the Muscle Beach Gym. It was known as 'The Dungeon' because it was dark and dank and downstairs and located in downtown Santa Monica, a few blocks from my residence. One of the guys who I trained with there on occasion was Dave Draper, who that year was Mr. Universe.

"Even though I was experiencing periods of loneliness, I already had grown to like Southern California and its mild climate, major-league sports teams and many entertaining diversions. I suddenly no longer was as gung ho about becoming a soldier as I had been a few months earlier. I wasn't the only prospective draftee not anxious to participate in the Vietnam War in those days.

"And so this time I was determined not to go into the service. On the evening before I took my second military physical, I strenuously lifted weights for four hours at a friend's gym in Fresno, smoked a pack of cigarettes, drank several cups of coffee and never went to sleep.

"We recruits were stripped to our shorts in the lengthy medical examination queue at the Fresno Induction Center that next morning, and I stood out because of my bulging, well-muscled body at a time when few individuals engaged in serious weightlifting. The attending physician shook his head upon taking my blood pressure. 'Two twenty over 110,' he said. 'It's too high. Too bad. You'd have made a fine soldier.' I was '1Y' and was never contacted again by the Selective Service Board."

"I'm glad you didn't get involved in that awful, wasteful war," said Gillian. "Who knows what might have happened had you gone to Vietnam. I'm just glad you didn't and that you're here with me."

"So am I," I said, and we soon lapsed into sleep.

Chapter 17

We rose early the next morning on the final day of the year and went on another lengthy run. We decided to spend the afternoon visiting a few cultural outposts about twenty miles away in the hills above Cagnes-sur-Mer. As we drove up to the fortified medieval village of Vence to see the historic Matisse Chapel created by the accomplished twentieth-century artist Henri Matisse, Gillian was in an unusually talkative mood, as she related to me her rebelliousness as a teenager and her indifference to school.

"I ran away from home once with one of my girlfriends, but only for a couple of days," she said. "We stayed in a hostel in Newcastle, and when I got home my parents were really upset with me. I was pretty out of control for a time, although I didn't do anything bad. I didn't drink or was into drugs. Just rebellious."

"What changed?" I wondered.

"Well, when I was fifteen, one of my teachers told me I'd never amount to anything because of my poor grades," she related. "I was embarrassed by her comment because she said it in front of other students. From that moment on, I took school seriously. I was determined to show that teacher that she was mistaken, and I did. I began studying very hard and began getting such excellent grades that I qualified to attend the University of Newcastle. That teacher's negative comment changed the direction of my life."

I listened attentively, and then she asked me about a comment I had made the previous evening when we walked past the casino at the Noga Hilton.

"I'm curious, Douglas, you said last night you hadn't made a bet since January 1, 1991, and that you never will make another one," she said. "Were you once a gambler?"

I chuckled to myself and thought back to those eight harrowing years when I engaged in such a dangerous pursuit in which the pleasure of winning bets never quite exceeded the agony of losing them.

Oh, what I could tell Gillian about that particular addiction—I had my share—that well might have had the greatest hold on me, with my degeneracy reaching its crest in 1985 when my wagers easily exceeded more than $1 million and when nary a day would pass without my calling in bets to any of the six bookmakers I had at my disposal in those pre-Internet times.

I momentarily reflected to myself all the agonizing and exhilarating moments I had when I was heavily involved in gambling and all the famous denizens of the trade I met like Bob Martin, Jack Franzi, Jimmy Vaccaro, Kale Kalustian, Jimmy "The Greek" Snyder, Harry Gross, Satellite Mike Economou, Fast Eddie Cosek and the legendary Ron "Cigar" Sacco, the offshore betting pioneer who was featured prominently on CBS's popular Sunday night news show *60 Minutes*.

I often had Thursday night dinners with Sacco at his favorite restaurant, Dan Tana's, in West Hollywood, during my gambling years, and his stories about his profession always kept me entranced.

When Harry Gross committed suicide in April 1986 in Long Beach, the *New York Times* ran a lengthy obituary in which it detailed his $20-million-a-year bookmaking empire in New York during the 1940s, when he had more than thirty-five betting shops.

Gross also spent more than $1 million a year paying off cops and politicians and was involved in a well-publicized two-year trial that resulted in the conviction of 22 New York policemen and 240 others being dismissed from the department.

I got to know Harry well—he resided in Long Beach the final fifteen years of his life—and always recall his saying to me, "At the end, the players always lose. I remember one guy in New York who owned a major trucking firm, and he beat me for hundreds of thousands of dollars for a couple of years. And he wasn't one bit humble about it and always was telling me how I reminded him of Santa Claus, giving out free gifts. By the end of the third year, I owned his trucking firm. I took the action over the years of some of the biggest gamblers in the country, people like the Las Vegas casino owner Sidney Wyman and the New York mobster Albert Anastasia. And every single one of them lost. I don't think anyone ever mistook me for Santa Claus."

I thought of what Harry Gross had once said to me as I got set to respond to Gillian's inquiry.

"Oh, I was fibbing…I've made a few bets since January 1, 1991," I finally said. "I bet on a couple of horse races and played some blackjack on occasion. But never lost more than forty or fifty bucks. And I only did it, like I said, a few times. But I was never interested in the horses and the casino games. When I was gambling, I was strictly a sports bettor. I made my last serious bet on January 1, 1991."

"Why January 1, 1991?" she wondered.

"I lost $17,500 on a football game between Notre Dame and Colorado in something called the Orange Bowl," I said. "I took Notre Dame [I had taken the Fighting Irish plus a half point), and it lost 10–9. But the Fighting Irish should have won. One of their players [Rocket Ismail] scored on a ninety-two-yard punt return with forty-three seconds remaining, only for an official to nullify it with a penalty. And it was a penalty that should not have been called. It was known as the 'Phantom Penalty.' I had bet on the right side, but I still lost. I looked at myself in a mirror above my restroom sink later that night and said out loud to myself, 'I'll never again make another sports bet.' And I haven't."

"What do you mean by your being strictly a sports bettor?" asked Gillian.

"Like betting on football, baseball, basketball and boxing," I said. "Like not betting on casino games like blackjack, baccarat, roulette and craps. Believe me, Gillian, I once was a compulsive gambler. I was out of my mind. I bought a $3,000 satellite dish in 1986 that I placed atop my garage, and it looked like the ones they have at NASA in Houston, so I could watch all the events I was betting on. I was routinely making four- and even five-figure bets, and I was a newspaperman earning less than $40,000 a year. And what was so weird was that I didn't even make my first serious bet until I was forty."

"Douglas, I could never live with a person who was doing that," she said with typical honesty.

"It was hard for me to live with myself when I was doing that!" I responded. "I was engulfed in a raging fever. I fortunately stopped before I went broke, which happens to all compulsive gamblers."

"Do you think you'll ever go back?"

"No way. The only element that keeps compulsive gamblers from stopping is a lack of funds—and too many times that doesn't stop them, either. Fortunately, I never got broke, but I also have never gone back. Not once. And never will."

I shuddered inwardly as I thought back to those stressful days—and there were plenty of them—that I myself created.

How different I was now. We human beings can be so mercurial in our changing of hues, altering of courses, embracing of wicked compulsions. I always was stable when it came to my work, but such stability never carried over to my private life, in which I too often trespassed the borders of moderation.

"How did you ever get started gambling when you were in your forties?" I suddenly could hear Gillian asking me, jarring me out of my reverie.

"I've talked enough about my gambling," I said. "Let's talk about it another time, and I'll relate tales you might find difficult to believe. And believe me, Gillian, there are many incredible ones. But not now. We're in the French Riviera, and my gambling days are long behind me. I'm just looking forward to seeing the Matisse Chapel and the Maeght museum at Saint-Paul de Vence. And if we have time, we'll visit Renoir's old home in Cagnes-sur-Mer."

Chapter 18

The Matisse Chapel turned out to be a small but appealing structure with tall, gracefully designed stained-glass windows and three large wall murals. We spent a short time there, had lunch in Vence and then drove the short distance near Saint Paul Vence, where we roamed around the Maeght with its collection of modern art paintings, sculptures and ceramics. It included works by such artists as Pierre Bonnard, Georges Braque, Alexander Calder, Marc Chagall, Alberto Giacometti, Fernand Leger and Joan Miro.

But the seminal highlight of that day for us—and one that neither of us ever forgot—was the visit to Renoir's villa in the hills above Cagnes-sur-Mer. Renoir was one of the most famous of the Impressionists—his popularity rivaled Monet's—and you could actually feel his presence when you walked around his residence that had his original furniture in place, a lot of old photos and mementos and the wheelchair he used in front of the easel in his atelier. There were a few of his paintings and sculptures in the home where he resided in the final years of his life. There also was a garden on the six-acre plot of land that brimmed with Renoir's beloved olive trees and that afforded a breathtakingly picturesque view of the Mediterranean. There was an emotional chord about Renoir's place that resonated strongly with both of us.

Before that first date with Gillian when she showed me around the National Gallery, I had no knowledge of Renoir or other renowned painters. But in the ensuing years, despite not seeing Gillian since September 1992, I had

devoured many books on these gifted people, including James Lord's stellar biography on Giacometti. Lord, an American expatriate who long had resided in Paris, was a memoirist extraordinaire who related fascinating stories about people he knew like Giacometti, Picasso, Cocteau, Gertrude Stein, Georges Braque and countless other cultural icons. I actually met Lord one evening at a Paris restaurant and told him how much I enjoyed his work.

Anyway, after we got back to Cannes late in the afternoon, I was in a joyful mood. And in those days, when I was in a joyful mood and when I was with a lady for whom I had a deep fondness, I always felt like having fun. Which meant I felt like drinking and laughing and conversing with everybody as though I were a politician at a fundraiser.

"Let's go hit a few places," I said. "Let's start celebrating the coming of the New Year early."

"Sure…why not?" replied Gillian obligingly.

And we did. We must have visited seven or eight taverns near the hotel in the first two or three hours, and I had a drink, or two or more, at every one of them, while Gillian, who it turned out was a modest drinker, began ordering Perrier after consuming her usual limit of two glasses of wine.

We had made a reservation that night at a small brasserie called Grill 22 behind our hotel that was operated by a friendly French couple. I had gone there earlier in the week and had been a regular at the place for several years.

When we arrived at nine o'clock, I was in a jovial, if not inebriated, state. I guess I wound up ordering five bottles of Dom Perignon during dinner, and I guess we shared the champagne with many of the customers. I say I guess because I have only a faint recollection of what happened at the dinner and beyond—Gillian said I insisted on us going to a nearby disco and that we did some serious dancing—although I do remember horns blaring at midnight and her having to hold me up as I staggered back to the hotel at 4:00 a.m. I also remember the next day having a stunning financial shock when I looked at my American Express receipt from the restaurant. With tip, it was $704. But even worse than that revelation the next morning was what happened next.

"Take it easy, Douglas, you're going to be sick," warned Gillian.

"I feel all right," I said as I got up to go to the restroom.

"Just take it easy," she reiterated.

And Gillian certainly was right.

I had my share of hangovers across the decades, but this one left me almost immobile. My legs were unsteady, my stomach was nauseous, my eyes

were heavy, my head was throbbing. Other than that, I was in prime fettle. I did somehow manage to stagger back into the bed after loudly vomiting, got under the blankets and curled up in the fetal position.

"I can't move," I said haplessly.

"I knew you'd feel that way," she said. "I tried to warn you last night to take it easy. But you were in a zone. Your own private zone. You were pretty whacked out at the disco. I even got mad at you, but it didn't make any difference. You just stayed out on the dance floor and left me alone and kept dancing."

I was embarrassed as I listened to her words delivered without anger and promised her that never would happen again, which it didn't. Wasn't I now too old to be acting as though I were back in the disco era when I was much younger and more durable?

I spent most of that day in bed, trying vainly to sleep. I felt horrendous. I always found there is only one certain cure for a hangover: tomorrow. And even that, on occasion, isn't enough time to remedy one of nature's cruelest self-inflicted punishments. I didn't make it out of the hotel that day until mid-evening, when we walked along the boardwalk and wound up having dinner at Farfalla.

Gillian flew back to London early the next morning, and I remember feeling sad. We'd had such a rapturous time together, and I yearned for it to extend into infinity. Suddenly, I was in love, and I think she was, too. It was nice, a feeling of gladness.

Chapter 19

It is a romantic reality that lengthy distances (like eight thousand miles) and lengthy absences (like months at a time) are not conducive to lasting relationships. As Gillian returned to London on January 2, 1996, I thought about that reality and decided I'd do something about it.

After I returned home, I began phoning her almost every day to make sure the intimacy that we had formed in Cannes wouldn't dissipate. Still, I also realized that phone calls alone wouldn't be enough to sustain what we had going—and decided on a slightly more radical course.

Why not simply go see Gillian?

After all, I still had access to those moderately priced airline buddy passes from a pal, Bill Dandridge, and Delta still had a co-share with Virgin Atlantic. Sure, being a non-revenue traveler, I was always wait listed for a flight, but I knew the only way I would miss one was if it was filled to capacity, which never happened in those days on the 747s that Virgin Atlantic used on its London run.

My boss at the time at the *Press-Telegram*, Jim McCormack, was a kindly, understanding fellow, a beloved Long Beach sporting figure—he covered the local university's sports teams for more than two decades for the *P-T*—and booster of mine who always displayed a sense of compassionate tolerance when I sought a favor.

After I explained the situation with Gillian and the necessity of making periodic visits to see her, Jim said, "No problem. You do what you have to do."

Celebrating with renowned jockey Willie Shoemaker (second from right) are (from left) former *Long Beach Press-Telegram* senior sports editor Jim McCormack, Doug, former *Los Angeles Herald Examiner* sports columnist Melvin Durslag and *P-T* editor Rich Archbold.

And so seven times that year I flew to London. I'd depart LAX on Wednesday afternoons, arrive at Heathrow late on Thursday mornings and would depart on Sundays. I'd always write my Thursday and Friday columns for the *Press-Telegram* in advance, and Jim McCormack graciously gave me Sundays off.

"I know you'll make it up to us down the road," said Jim, which certainly was the case that summer when I worked the Olympic Games in Atlanta.

After flying into Heathrow, I'd take a cab to Gillian's flat in Streatham Hill and would immediately head to the tiny store around the corner where the spinster sisters were always behind the counter and where I always purchased the usual six London papers. I'd then return to Gillian's place and would lie in bed and read the papers as long as I could before falling asleep, which usually lasted for four hours. I'd then go on an hour-long run, shower, walk the neighborhood, have a couple beers and then return to the flat and wait for Gillian's arrival, which usually came around 8:00 p.m.

It was a draining, exciting five days for me. The weather was typically dreary—cold and gray with periods of rain—but that didn't keep me from

running. One evening, Gillian and I walked to nearby Brixton and dined at a Jamaican restaurant. The food was delicious, and later we went to a popular rum bar that was owned by a Jamaican. I asked the gentleman for his finest rum, and I wound up consuming five shots of it. We laughed and giggled all the way home, as we were pelted by the ever-present raindrops.

We continued to enjoy each other's company immensely, and our common interests—jogging, movies, reading, art—only drew us closer.

I continued to find the London tabloids to be a scream—their specialty was exposing the marital infidelities of entertainers, athletes and politicians—and I also became an admirer of a polemical writer for the *Times*, a fellow named A.A. Gill, a restaurant and TV critic of astonishing acerbity, and by the nightclub musings of a columnist for the same paper, Tara Palmer-Tomkinson, a socialite playgirl who was the Kim Kardashian of her day, albeit a lot taller and a lot more attractive. Ironically, on one of my return trips to LA, I struck up a conversation with a gentleman from London who produced and directed TV documentaries. His name was Michael Gill, and he was the father of the notorious *Times* author.

I felt during those brief trips to London that Gillian and I kept getting closer and more affectionate.

As we dined one night at Gillian's favorite Indian restaurant in Streatham Hill, she asked me if I ever wanted to get married again.

"Of course, I've told you before...I'm going to marry you," I said.

She remained silent and shyly bowed her head.

"Honestly," I said. "I'm going to marry you."

I was looking for a negative response but didn't get one; she had a radiant look on her face.

I noticed how Gillian became more interested in my life as a sportswriter during this period and began asking me more about it during our conversations.

"If I died this moment, please, don't shed a tear for me if you attend my funeral because I've had a life one could only dream about, especially considering where I came from," I told her on one occasion. "I've always said that the worst and best thing that ever happened to me is that I found my quintessentially perfect job at twenty-four years old. During the late '60s and throughout the '70s, I flew everywhere around the United States with professional athletic teams. I first covered the Lakers and then for seven years covered the Rams, a football team once located in Los Angeles and now in St. Louis. If I had gone into real estate at that time in Southern California, I'm sure I'd have become very wealthy, as

a few of my friends did. But they didn't live the kind of life I did, which was never dull and always fun.

"I remember once when I was in Boston where the Lakers were set to play a regular season game. The team had an off day, and Wilt Chamberlain called my room early in the evening and invited me to go out with him for dinner. I, of course, did, and later we went to a nightclub—it was called the Point After—and everyone made all over Wilt. And because I was with him, I also was treated like a celebrity. And I got to know the American actor Ryan O'Neal, who had scored big with *Love Story*, because he was a co-manager of a terrific welterweight fighter named Hedgemon Lewis, and I covered some of Lewis's fights for the *Herald Examiner*. One night I took a date with me to see a world title fight at the Olympic Auditorium, which is a famous fight arena near downtown LA. And as we're walking down the aisle to our seats, I hear someone yell out, 'Doug!' And it's Ryan O'Neal. And he happened to be the favorite actor of the date I was with, and obviously, that made quite an impression on her, especially when I introduced her to Ryan. That was before I got married.

"Gillian, I was so enthralled by my job that I overlooked the fact that I was stuck in a bad marriage that I detested. It's not that my wife was a bad person. She wasn't. It's just that she was possessive and jealous, and I was simply too young and didn't want to be tied down. I had a lot of thrilling times in the '70s, but I would have had a lot more had I not been married. I made up for it in the '80s when I was single and have had my share of fun moments this decade, too. Oh, how I have made it up for it!"

"What did you do?" she asked.

"Let's talk about that some other time," I said. "I've talked enough about myself."

"What about you?" I said. "I know you were good in judo. I know you had a long relationship with some guy that ended badly. I know you had a difficult time when you first moved to London. I know I'm the first American guy you've ever dated. I know you're close to your parents and that your dad would take the family on vacations to as far away as Rome when you were a kid in a small car that often broke down and…"

"Really, there's nothing exceptional about my life, like yours," she responded. "I have my good friends I've made at work that I'm close to. I've never been much of a big party person or big drinker. I love my job. I love helping people. I get great gratification out of it. But really, Douglas, I've lived a pretty nondescript life. I did march for the miners during their strike against Margaret Thatcher's union busting in 1984 and 1985. I've never met famous people like you have so many times. Well, I have now met

Former pro fighter Dave Centi, who became a legendary bar bouncer, is shown ringside with Doug before a championship fight at the old Olympic Auditorium, once located at Eighteenth Street and Grand Avenue in downtown Los Angeles.

George Foreman. I'm just one of the faceless plebeians on earth that puts in an honest day's work and comes home and takes care of chores, reads the papers, watches the TV news, listens to the BBC on radio and attends movies. I guess if there's been anything exceptional about my life it's that I've been blessed with pretty good health."

I remember that evening marveling how Gillian cut such a healthy figure, and I uttered a phrase of hoary triteness that turned out to be hauntingly prescient: "If you don't have your health, you don't have anything."

April 2000 [The Diagnosis]

I didn't notice any ominous signs, and Gillian never mentioned the discomfort she had been feeling for several months.

It was I who had been ailing in early February, and I spent almost a week at a Torrance hospital after coming back from covering the Super Bowl in Atlanta between the St. Louis Rams and Tennessee Titans.

I hadn't been feeling well since we had returned in early January from our trip to Syria, where halfway through it I was afflicted with a severe case of food poisoning.

I still was in a weakened state when we flew from Damascus to London before returning to Long Beach.

I spent the final week of January in Atlanta at the Super Bowl that was staged on the last day of the month. Midway through it, I came down with what I thought was the flu. I was bedridden for four days, managed to make it to the game despite having a fever and returned home on February 1 with a 101-degree temperature.

Gillian picked me up at LAX and drove me to nearby Hawthorne to the office of my family doctor, the family doctor who a few months earlier had declared there was nothing wrong with Gillian despite her rectal bleeding. He wisely decided to hospitalize me, but he originally misdiagnosed my condition. He thought I had a gall bladder infection and that I might have to have the gall bladder removed. But more comprehensive blood tests were done, and it was revealed I had Hepatitis A, which is curable and not potentially life threatening like Hepatitis B and C.

As I look back to that time when I was sick and Gillian would break away from her studies to visit me at the hospital, neither of us had the faintest idea that she was the one who was seriously ill.

By the end of February, I had regained my health and was back writing my column. Gillian seemed to be spending all her time concentrating on the final class she was taking at Long Beach State—physics—before she would take the California state physical therapy exam.

Life was normal and pleasant for the next couple of months.

But it would change forever on that Easter weekend that we were planning to spend with my parents and sister in Fowler.

On Friday morning, a few hours before we were set to depart, I noticed Gillian was lying on the bed next to her office desk, busily working on a physics assignment.

In the past, she always had been seated at the desk, and I found it odd that she had chosen a new spot to study.

"Why're you lying on the bed?" I wondered.

Gillian looked up at me, and I still can remember the grimace that covered her face.

"My bottom hurts so much…it's painful for me to sit," she said.

At that precise moment, the phone rang, and it was my sister, Ginny Clements.

I told her about Gillian's discomfort, and she voiced alarm.

"You get Gillian to a doctor immediately to have it checked out," she said. "Do you realize those are dangerous symptoms? Let me talk to Gillian."

Gillian informed my sister about her rectal bleeding.

"Yes," I could hear Gillian saying with exasperation. "OK…Yes, we'll see a doctor. We'll have it checked out."

She handed the phone to me.

My sister had a frantic tone in her voice.

"You gotta get her to a doctor, today!" she demanded. "This is nothing to fool with. She's bleeding. That's not good."

I immediately called my family doctor, and he lined up an afternoon appointment with a gastroenterologist in Inglewood—and that day would mark the start for Gillian of a ceaseless stream of dark revelations she would hear from doctors during the next year and a half.

"I think I feel a mass up there, and you definitely need a colonoscopy," the gastroenterologist told Gillian.

And so, on Easter morning, April 23, 2000, a day we had planned to be in Fowler visiting my family, we were at the Torrance Memorial Medical Center, where Gillian had her colonoscopy.

I was waiting outside the room where the procedure took place, and I never will forget the grave look on the face of the doctor who performed it when he opened the door and came out.

He was a tall Asian gentleman and spoke in a hushed tone.

"It's not good," he said.

I remember a bolt of adrenaline knifing through me, and I sighed deeply.

"What do you mean?" I managed to respond.

"She has a very large mass," he said. "It's probably cancerous."

"Is it life threatening?"

He grew silent.

"Just make sure you get her the best doctors you can, and do something immediately," he said.

"Do you think it's spread?"

"I don't know. Just make sure she sees an oncologist as soon as she can."

I couldn't believe what I was hearing. I was listening to the doctor's words, but they weren't computing with me. My Gillian, my beloved Brit, had a large mass, an ominous mass? At thirty-three, she faced major surgery? How could this be? Was this all real? Was she going to die from it? How could someone I thought was so healthy be in such a predicament?

I went to a nearby pay phone and called Gillian's parents in Hartlepool. I wept as I spoke, just as I had when I informed them of Gillian's miscarriage two years earlier. Gillian's mother, Mary, said she'd come over to be with her daughter. I phoned my parents, and they were saddened by the news, as was my sister, who said she'd also come down and spend a few days with us for support.

When Gillian emerged from the room about a half hour later, she wore an expression of resigned despair, which I would see often in the coming months. With her extensive background in the healthcare system, she understood the difficult medical challenge that she now faced.

"This is going to change my life forever," she said simply.

"Why didn't you tell me how you've been feeling?" I wondered.

"I was embarrassed," she said. "I thought I had hemorrhoids. Remember when we were in Lake Arrowhead last weekend? You didn't notice, but I used the lobby restroom several times even though we were upstairs watching TV in our room. I didn't want you to find out there was any trouble."

I noticed her eyes tearing up and could feel her anxiety.

I warmly embraced her.

"You're going to be all right," I said. "You're the toughest fighter I've ever known—and, as you know, I've known a lot of them. Whatever it is, you're

going to beat it. You've always come out on top in your competitions—either in the classroom or in the dojo. And you'll come out on top in this one, too."

I gazed into Gillian's large brown eyes, and the usual glow had been replaced by a somber wariness. Clearly, she was frightened.

Gillian seemed to already know she had colorectal cancer.

Chapter 20

I couldn't believe what was happening to me. My feelings for Gillian kept getting stronger after each trip I took to England in 1996 instead of subsiding. I wasn't even fooling around on her when I was at home! This was in such a contrast to what had been my lifestyle, my persona, my laissez-faire attitude toward women since my divorce, if not before it. I never thought I would have a strong emotional attachment to a lady again, since I figured the many romantic indulgences I had been involved in over the years would have built up an impregnable barrier in me against such an occurrence.

Love? Please! An ephemeral phenomenon inspired by beauty, need, money, status, sex, power, ad nauseam. For me, at least, love had become nothing more than a brief interlude, and I had become a stern cynic on the subject going back to the breakup of my marriage and then having such sentiments strongly reinforced by the breakup I had with Karin R., which happened right before I met Gillian, and the breakup I had a few years earlier with Karen D., for whom I also had great fondness.

Karin R. and I had actually come close to getting married in late 1991. But those plans went awry because I still retained the grave fear of being trapped in another suffocating alliance. In fact, it was less than a week before I was set to marry Karin R.—she already had picked out a gown—when I abruptly called it off, a decision that resulted in Karin R. straying out on her own even though we continued to see each other on occasion until I became seriously aligned with Gillian.

I now look back on those long-ago days when my testosterone count was at dizzying heights and when I celebrated birthdays instead of mourned them and when the limitless tomorrows conspired against conventional reasoning and inspired in me a false sense of immortality.

One of the few virtues—and, believe me, there aren't many when you consider the physical deterioration and total loss of even the barest vestige of innocence—of growing old is to have a clearer perspective of the past and be able to analyze in depth who the person was that inhabited your body, mind and soul in younger times.

I have no idea who that guy impersonating me was who was once such a maniacal weightlifter that he spent more time at Fresno State studying the measurements of his arms, chest and neck than he did studying textbooks. I have no idea who that guy impersonating me was who suddenly went from going into a depression losing $50 at the blackjack table to routinely making large wagers on sporting events, including $13,000 on the 1985 three-round brawl between Thomas Hearns and Marvelous Marvin Hagler—which he lost, to go with the $13,000 he lost the previous day on an NBA game. I have no idea who that guy impersonating me was who, during an eight-hour train trip between Paris and Munich, engaged no fewer than sixteen women in conversation, according to his traveling partner Mike "The Hammer" DiMarzo, who kept close tabs on such important minutiae.

I know I was that person, but it's now hard to comprehend it since I'm so radically different. Such unrestrained and reckless behavior is now totally alien to me, but that certainly wasn't the case during the 1980s when my workload was light.

I spent a good portion of my idle time during that period doing nothing more compelling than betting, exercising and frolicking in saloons and nightclubs. And I had a lot of idle time in those days, writing a mere three columns a week for the *Herald Examiner* (I'd knock out more when I was on assignment at a major sporting event).

The Showtime era of the Lakers was at its height then, and the team's games at The Forum became an integral part of my social activities.

I had become a friend of the team's sybaritic owner, Jerry Buss, who usually brought a gaggle of well-endowed ladies barely out of their teens to the Lakers' home games. Buss was, indisputably, the Hugh Hefner of the sporting world.

Although I wasn't a member of Buss's private posse that scoured hither and yon to find ladies worthy of Buss's affections—I dubbed the group the Seven Dwarves in the *Herald Examiner*—I did become a regular in his private

Doug did some behind-the-scenes maneuvering to have Gillian welcomed at the Great Western Forum in Inglewood, the former home of the Los Angeles Lakers (see above the Marlboro sign).

box at Lakers games and on occasion joined him and his entourage at post-game soirees at various Los Angeles and Beverly Hills nightclubs.

Which meant I often had pre-game dinners at Buss's table at The Forum Club, which meant the young ladies I brought to the game wound up meeting all sorts of celebrities, like Sean Connery, Jane Fonda, Robert Wagner, Bruce Willis, Hulk Hogan, Beau Bridges, Rick Dees, Ed Asner and many others who were guests of Buss, which meant I had no problem whatsoever finding women to attend Lakers games with me.

I mean, an opportunity to attend such a glamorous attraction in that glittering Showtime era of Magic Johnson, Kareem Abdul-Jabbar and James Worthy was a lure few women would resist—and it certainly gave me a considerable advantage in my frenetic endeavors with them.

The 1980s were a most memorable time for me in so many ways, and—like so many others in America—they brought cocaine into my life. I never had been a drug guy, even when the marijuana craze commenced in the 1960s.

At the gala premiere of the 1980 James Caan film, *Hide in Plain Sight*, at the Fox Village Theater in Westwood, Doug shakes hands with Los Angeles Lakers owner Jerry Buss. The venerable LA-event emcee *Variety* columnist Army Archerd is in the background.

I tried it once with my childhood friend Lloyd Koski and his friend, singer/ songwriter the late Dobie Gray, one evening in 1971 at Gray's Hollywood apartment. I detested it.

A couple months after I left my first wife, I was at one of my favorite spots in those days, the Stardust Lounge in Downey, with my first cousin, Steve Krikorian. We were drinking heavily, and in the darkened tavern he suddenly pulled out a small capsule with a tip attached to its cap. Suddenly, that tip was covered with a white powdery substance—and he stuck it under one of my nostrils.

"Take a whiff," he said.

"What is it?" I wondered.

"Just take a whiff."

I did, and suddenly my whole body was immured in euphoria. Wow! I had never felt so good.

"What is it?" I asked again.

"Cocaine," he said.

Fortunately, I never became addicted to the drug, but I did my share of it during the next seven years, and unlike liquor, I always consciously looked forward to using it. But cocaine had a couple unsettling side effects—it made me drink too much alcohol, which led to appalling hangovers that often extended beyond a day, and it made me sexually impotent, which led to some embarrassing moments.

In fact, in the spring of 1986, I wound up being nothing more than a hapless bystander because of it in what could have been a *ménage à trois* experience of pleasurable remembrance rather than one of wistful frustration.

At the time, I had been taking out a tall, attractive young lady I shall call Zee—she was a five-foot-eleven twenty-one-year-old—I had met at a popular tavern in the Long Beach area, where she was a waitress. The owner liked me and urged Zee to go with me to a Lakers game. She did—we saw the final one that season when the Lakers were eliminated from the playoffs by the Houston Rockets on a last-second shot by Ralph Sampson—and she wound up meeting that evening at The Forum such people as Pat Riley, Magic Johnson, Jerry West, Chick Hearn and Jerry Buss.

She was totally overwhelmed by the thrilling Showtime ambiance, and for the next few months she accompanied me to many of my favorite watering holes around Long Beach as we engaged in a lot of booze-driven merriment complemented by occasional usage of drugs.

Well, one evening, Zee surprised me by bringing a twenty-one-year-old girlfriend of hers over to the home—she also was quite slender and also five-foot-eleven—and we all went out and hit the usual saloons, drinking, dancing and partaking in cocaine.

We returned to my home near 1:00 a.m. and, high from booze and drugs, wound up going skinny-dipping in my pool and then, somehow, wound up in the shower together, whereupon the two ladies began getting quite sensuous with each other, to my prurient fascination.

They urged me to become an active participant, which I did to some extent, but the wicked cocaine once again had prevented me from having an arousal. Finally, in frustration, the ladies encouraged me to depart the scene so they could continue their sexual frolic without interference from a person unable to perform. And I reluctantly repaired to the couch in the nearby den, glumly listening to their moans and groans as I downed another screwdriver (the cocaine had been used up).

I gave up the drug for good in November 1988 after I once again failed in my manhood, this time with a young German-born cocktail waitress I had

Former middleweight champion Michael Nunn gets the point from Sugar Ray Leonard (right) while Doug (left) and Lakers owner Dr. Jerry Buss (second from right) get the joke.

coveted for more than two years. We came across each other one Monday evening at a Long Beach tavern, the Captain's Quarters, and went on to visit a few more places around town. We also snorted several lines of cocaine before returning to my home, where we wound up in bed. She reacted to my incapability with disdainful contempt, uttering a shattering comment that even questioned my masculinity. "And here all along I thought you were a stud," she sniffed.

I never used cocaine again after still another humbling incident with it.

Chapter 21

While my fondness for Gillian never wavered during my frequent trips to London, I did on occasion have second thoughts about what I was doing, especially when the long journey left me worn out and sleep deprived. Was I *that* much in love with Gillian, or was I flattered that a lady twenty-three years younger had a fixation on me? Was there some sort of unconscious allure—glamour?—for my involving myself in such an intense international romance?

But those doubts quickly would drift away, as I realized I had simply fallen in love with Gillian for her many commendable qualities, including her strong family ties, tender heart and sweet disposition. The fact that I was attracted physically to her also was vital, since all her other commendable qualities would have been quite irrelevant if I weren't. And I'm sure my advancing age also might have had an influence on my feelings, as I found it increasingly difficult to look at myself in a mirror since I no longer recognized the impersonator staring back at me.

Actually, a person who peripherally might have had an impact on me was the actor Warren Beatty, a legendary Lothario who for decades was linked with hundreds of stunning women.

But then, a couple weeks before his fifty-fifth birthday in March 1992, the devoted bachelor shockingly decided to end his freelance existence, marrying the actress Annette Bening, thirty-four, with whom he would go on to have four children.

What might have spurred Beatty to make such an unexpected decision was a humiliating public incident the previous year when a twenty-two-year-

old model he was dating, Stephanie Seymour, coldly dumped him for Axl Rose of Guns N' Roses.

"Beatty finally got his romantic comeuppance and quickly decided to settle down with a younger woman who actually liked him before it was too late," said my pal Joe Dee Fox, a veteran participant of romantic interplay himself who later counteracted his advancing age—he's now in his mid-seventies—by moving permanently to Rosarito Beach in Mexico, where he now dates women one-fourth his age for a modest fee.

I knew the time was now right for me to settle down before it was too late, and it just seemed to me that Gillian and I were so perfectly aligned on so many different levels, despite being different in so many ways—a contradiction that in a weird way worked in our favor.

That summer, I covered the Olympic Games in Atlanta, and it was a debilitating two-and-a-half-week assignment in which I wrote two columns a day, plus a news story. I stayed in a small, cut-rate motel ten miles from downtown Atlanta and had to endure a two-mile round-trip daily walk to the MARTA station, where I took the rapid transit railway to the media transportation outlet in the city center.

And then I'd catch buses that would take me to the different venues—sometimes as many as three, even four in a day. I usually didn't get back to my motel room until eleven o'clock in the evening and often would phone Gillian to relate the day's events, which included some remarkable achievements like Michael Johnson's world record–setting runs in the two hundred and four hundred meters and Kerri Strug's dramatic leap on a sprained ankle that ensured the U.S. gymnastic team its first gold medal. And there was that terroristic non-sports development—the Centennial Park bombing—that kept me up an entire evening covering it.

Gillian always boosted my spirits during our phone discussions. I found myself missing her terribly. Up to that time, nothing in my newspaper career had been as challenging for me as covering those Atlanta Olympics. I would go through it again four years later in Sydney. There's no letdown in the work, and stern discipline must be maintained each day because of the constant writing, constant interviewing, constant bus traveling and constant tight deadlines in an unfamiliar environment among a swarm of people. And also, for good measure, there is never enough sleep.

I enjoyed being a sportswriter for so many reasons—the games, the travel, the relationships, the myriad PR gatherings, the thrill of seeing my name in print, etc.—but there always was a downside to it. There was no glamour in the tense periods of deadline writing, nor was there any glamour when you

had to produce articles of interest day after cloying day, as was the case when laboring at the Olympics, as well as the Super Bowl and World Series and other high-profile events.

My newspaper gave me a couple weeks off in comp time when the Olympics ended, and Gillian flew out to LA to be with me. I had a surprise for her.

Hawaii.

Chapter 22

Whlie Maui long has been the destination of choice for couples in the early stages of romance, I decided on the more crowded Oahu since I've always enjoyed the rowdy liveliness of Waikiki and since I always have been crazily entertained by one of its cherished personalities, Gary "Mad Dog" Derks, a Long Beach transplant with a prodigious thirst for booze who, fittingly, opened a popular bar in the area called Mad Dog's Saloon, which still is in existence.

As I've stated, one of my many private failings always has been a fascination for those individuals who live outside the categories, and, oh, have I known many over the years on the Southern California terrain with colorful nicknames like Craig "Five Bellies" Vestermark, a zany Long Beach fireman whose foghorn-blaring voice was exceeded in magnitude only by his outlandishly large girth; five-foot-three, 260-pound octogenarian bar owner Dickie "2Fast, 2Furious" Babian, who is as wide as he is tall and who out-drinks all his customers; and the Holy Grail of such types, Donnie "No Win" Kramer, who has an unrivaled propensity for losing bets, syntax-fracturing malapropos and hilarious non sequiturs.

Donnie No Win began as a ticket hustler as a ten-year-old water boy for the USC football team. Some of the players would give him their tickets, and Kramer would go out in front of the Memorial Coliseum and make a few bucks selling them to fans. When I first went to work at the *Herald Examiner*, I always heard Kramer's name being mentioned when someone was talking about the best ticket scalper in LA, and I often came across

The legendary Los Angeles ticket scalper Donnie "No Win" Kramer is pictured with his wife, Debbie.

him in front of the Coliseum, Dodger Stadium, sports arenas, the Olympic Auditorium and The Forum.

He is perhaps the goofiest guy I've ever known, but he had an innate knack for peddling tickets on the street before the business was transformed by Stub Hub. I first wrote about him in the *Herald Examiner* before the 1978 Super Bowl between the Dallas Cowboys and Denver Broncos when, on game day morning, I spotted him in the coffee shop of the Regency Hyatt in New Orleans with a brown paper bag filled with $20,000. He was buying $30 Super Bowl tickets from fans in the buffet line for the then unheard-of price of $300 for travel agents who had come up short in their Super Bowl packages. People couldn't believe it. Kramer was a sick gambler who once bet a guy he could jog from downtown Los Angeles to Long Beach—and he did it in seven hours. That's about a twenty-eight-mile jog, and he did it in the middle of a warm summer day wearing flip flops and carrying 250 unflattering pounds on his beefy frame! That might well be the only bet he's ever won. The guy's absolutely bonkers!

Another ticket guy just as colorful as Kramer was Alex Henig, a big, boisterous fellow, who, like Donnie No Win, stepped right out of a Damon

Runyon novel and worked his trade in his early years not out of an office but out of the trunk of his car and a telephone booth. Everyone on the LA sporting scene knew Alex Henig, with his booming voice and hulking frame, and he became a close friend of O.J. Simpson, who sold Alex his Rose Bowl and Super Bowl tickets and who served as a pallbearer at Alex's funeral. Alex went everywhere, and one of his closest pals was Heckle Lynn, an assistant equipment manager with the Los Angeles Rams who owned a popular restaurant in Pasadena called Heckle's. I was in Henig's West Hollywood office one day when the actress Cloris Leachman called him for tickets, and Alex said in his booming voice, "Cloris, I gotta be in your next picture!" He handled tickets for a lot of celebrities in LA.

Another ticket guy who was a fixture at all the big fights—I always saw him in Las Vegas, where he had RF&B (room, food and beverage) privileges at Caesars Palace—was a tall, thin African American gentleman named Flip Speight, who always wore a black derby and who lived at the Hollywood Roosevelt Hotel. What a character he was! He was part of the Muhammad Ali entourage, and I was told he moved tickets for Don King. He always picked up my bill at the Caesars coffee shop and was a fixture at all the big sports event, including annually appearing in the winner's circle at the Kentucky Derby.

Another guy in the Muhammad Ali entourage who actually is a close friend of mine is Gene Kilroy. He's been a casino host for years in Las Vegas but was a financial adviser to Ali and introduced Ali to the Kennedys. Gene knows everybody, and everybody knows Gene, including every boxing writer. Gene's a lifetime bachelor, and he thinks any female past nineteen is past her prime. He's always had an eye for very young ladies and has dated literally hundreds of them. And one of his standard lines to these women when he gets mad at them is, "If you don't shape up, I'm going to put you on 'The Dog,'" which meant he'd put them on the Greyhound bus.

And then there's a guy I grew up with in Fowler, Donnie Srabian, toughest guy I've ever known. Fearless. Came from a rich grape-growing family and was a terrific high school and college football player. He took up boxing in Fresno and became a sparring partner of Max Foster, who fought Muhammad Ali for the world heavyweight title. The fight promoter Don Chargin offered him $50,000 to turn pro, but he wasn't interested.

I can go on and on and on with stories about Donnie knocking out guys in street fights around Fresno and other places. I doubt any of his fights lasted longer than ten seconds. He also was ungodly strong. I won fifty dollars one

Doug talks with heavyweight champion Muhammad Ali.

Heavyweight boxing champion Larry Holmes (right) makes a point with Doug and Donnie Srabian (left), who was known as a tough street fighter back in the day.

Rams quarterback Vince Ferragamo stops a bike ride for this shot with Donnie Srabian (left) and Doug.

night on him in an arm wrestling contest at a nightclub in Downey called the Staircase, operated at the time by the gambling figure Fast Eddie Cosek. The guy he beat didn't want to pay me, and I pursued him into the restroom. As we're walking behind the guy, Donnie says to me loud enough for the guy to hear, "Let him take a punch at you, and I'll knock him out." The guy, who was big and very intimidating-looking with a shaved head and a lot of tattoos, must have heard what Donnie said because he immediately reached into his wallet and handed me the fifty dollars. In his own macho way, Donnie Srabian was an unforgettable character, albeit not one to rile up.

By far, the biggest sports gambler I've ever known was Norm Gray, whom I called "The Plunger" in the *Herald Examiner*. He owned one of the most successful Ford, Lincoln, Mercury dealerships in America out in the Santa Clarita Valley, and what a gambler he was! He'd bet up to $250,000 on a single football game, and I was with him one afternoon at the Mirage sports book when he was betting $50,000 a horse race—and there were ten of them that day. And then that night I saw him win one hundred grand at the

craps table. I flew back with him and his brother, Bobby, the next evening to the Burbank Airport on the private jet of Steve Wynn, the owner of the Mirage, and idly asked The Plunger how he did for the weekend. He said coolly, "Not bad. It was a good weekend. Lost only about $35,000."

I remember once having dinner before a Lakers game at The Forum Club, and I was in conversation with a guy named R.D. Hubbard, who then ran Hollywood Park. I said to R.D., "I heard Norm Gray won a $1.4 million Pick Six." And R.D. replied, "Yeah, he needs it. I hope he wins ten or twenty more. Then he might be even." The Plunger was a real sportsman, and I love the guy, as well as his brother, Bobby, also a prolific gambler at the time. The Plunger invited me several times to have dinner with him in Las Vegas, and once at the Palace Court at Caesars the bill was more than $8,000, and he left a $5,000 tip. That was Norm The Plunger. What a sport. When he got married, he hired the famous singer Smokey Robinson to perform. I heard his wedding cost around $1 million.

And of course, there was Wilt Chamberlain, whose prodigious scoring and rebounding exploits were exceeded only by his prodigious boasting that oft-times was pure fantasy. I remember once taking a cab in the late morning from the Boston airport to the Lakers' hotel with Wilt. On the way, he spotted a couple pretty coeds walking down the street, had the cabbie stop the car, jumped out and spoke to them for a couple minutes. Later that evening, I ran into Wilt at the Point After, a Boston nightclub, and asked him if he had seen the coeds again. "Oh, I nailed both of them later in the day," he said. Oh, please! I guess they were part of his twenty thousand sexual conquests!

And then there was the heavyweight boxer Tex Cobb, whom I had come to know well and adored. Howard Cosell covered Cobb's world title fight against Larry Holmes that was so bloodily one-sided—Holmes won easily—that Cosell vowed never to broadcast another professional fight, which he didn't.

Tex was a guy who said whatever he felt like, and political correctness wasn't part of his nature. Once we were at the old PSA Hotel near The Forum having drinks in the lobby bar when a couple of quite large African American gentlemen spotted Cobb, and one said, "Tex Cobb!" And Tex looked at the guy congenially and responded, "What's going on, black boy?" I winced, but the African American guys just laughed, understanding that Tex was just being Tex and wasn't being racist.

Mad Dog Derks, of course, lived up to his billing during the four days Gillian and I were in Hawaii, as he took us to his favorite spots, which included his own tavern just once because, as he said, he'd drink all the profits

Dinner in Las Vegas often meant good times, as evinced here. Doug has his arm around Johnny "The Downey Flash" Ortiz in the back row. Famous Los Angeles sports bettor Norm "The Plunger" Gray is seated to the right and his brother, Bobby, is behind him.

if he frequented the place, which is located at the back of the International Market Place. What I always found most amazing about Mad Dog is not his staggering capacity to imbibe alcohol but that he always managed to keep himself in flawless shape—he is a devoted runner—despite his excesses. Incredibly, the six-foot-one Mad Dog maintains a buff body and has matinee idol looks that belie his frenzied lifestyle, even to this day! And he's one of earth's blessed souls—he doesn't get hangovers!

We stayed at the oceanfront Hilton Hawaiian Village; sunbathed on the beach; went kayaking; went sightseeing around the island, including an afternoon at Pearl Harbor; and spent a lot of time at Mad Dog's favorite watering hole, Duke's, an open-air tavern at the Outrigger Hotel.

Mad Dog held court at Duke's—he was its unofficial greeter—and gave out periodic dog barking sounds, which increased in piercing volume as his consumption of booze increased. Naturally, Gillian liked Mad Dog, and she would turn out to like all my goofy friends.

There never was a dull moment, and Gillian kept saying to me, "This is just so different than London. It's like another world to me, another planet. Warm. Tranquil. Relaxing. Everyone friendly, helpful, in bright moods. What a place. Now I know why people talk so fondly about Hawaii. Douglas, can we come back here someday?"

"Of course," I said, not realizing that circumstances would keep that from ever happening.

From Hawaii, we flew to San Francisco, where we checked into the downtown Hilton Hotel. We spent our first night at a party staged at the Pacific Heights mansion of Doug Knittle, a one-time street ticket scalper from Southern California who, through foresight, guile and the courage of his visionary convictions, rose to the top of his profession and was the first person in America to make serious money from the World Cup Soccer competition.

Knittle started a firm called Razor Gator—he later sold it—and always was ahead of the curve in his industry but lagged behind when the Internet started to make its widespread impact on it. A couple Stanford graduates came to him with a business model about distributing tickets on the Internet and even offered Knittle a piece of the action. Unfortunately, he turned it down, and Stub Hub revolutionized the ticket market—and made those Stanford graduates incredibly wealthy.

Like so many other tourists through the ages, Gillian became instantly enamored with San Francisco. We stayed for only three days but never relaxed and never stopped moving. We rode the cable car to Fisherman's Wharf, visited Alcatraz, had breakfast at Sear's, lunch at Lefty O'Doul's, dinner at Capp's and brunch at Sam's waterfront café in Tiburon. We also went to Santa Rosa one day to see my cousin, Kenny Comali, who lived alone on the 250-acre ranch he had inherited from his parents and that later was bought by Simi Winery. I spent a lot of time during my childhood hunting birds on that picturesque ranch with its rolling hills and fifty acres of oak trees—the most on any ranch in Sonoma County—when I often would come to Santa Rosa with my mother and sister to visit my Italian grandparents.

I felt a sense of melancholy because the old ranch that was now desolate—my cousin was an alcoholic who would die a few years later from cirrhosis of the liver—revived fond memories of the long-ago days when it was brimming with cows, turkeys, pigs, dogs, cats and farmhands. We left after a couple hours and drove through Wine Country, with stops in Calistoga and St. Helena. We returned to San Francisco late in the afternoon and that evening had dinner with a friend of mine who owned

Gillian pets a horse at Doug's relatives' ranch in Santa Rosa. Doug's cousin, Ken Comali, is in the background.

a small ticket agency in San Francisco and his wife, a tall, attractive lady not shy about expressing her views on various matters.

After we finished and went back to the hotel, Gillian said to me, "Douglas, I don't like that lady. All she did was talk about herself and talk about money and clothes and jewelry. I simply couldn't stand being around her. Can we not have dinner with them again?"

I nodded.

I never had heard Gillian talk negatively about anyone, but clearly she had an aversion to those given to materialism and affectations.

It was just another quality that further endeared her to me.

May 2000 [The Metastasis]

The devastating phone call came at nine thirty on a Wednesday morning, just after I had finished writing my newspaper column and was getting ready to drive up to Westwood to visit Gillian at the UCLA Medical Center.

She had undergone surgery the previous Thursday, and the surgeon had taken out a sizable tumor in her colon. Everything had gone well, and the surgeon was optimistic that nothing had spread. There was an initial fear that Gillian might have to permanently wear a colostomy bag—or even one temporarily—but that wasn't the case. She was making a rapid recovery from the procedure, and I was confident everything soon would be back to normal.

That is, until I received that phone call, one whose memory still sends shivers down my spine. It came from Gillian's oncologist, Dr. Peter Rosen.

"There's a spot we found on her chest X-ray," he told me, and my heart sank. I felt exactly like I had a couple weeks earlier after her colonoscopy.

"What's that mean?" I said with alarm.

"We'll have to wait and see," he said cautiously. "We don't know for sure what it is."

"But what could it indicate?"

"It could indicate the cancer from her colon has spread to her lungs."

"In other words, it might have metastasized."

"Yes."

"We'll talk later."

I hung up the phone and realized that Gillian now faced a serious crisis.

After I left Long Beach and headed up the San Diego Freeway to the hospital, I kept thinking how I was going to present this dark news to Gillian without alarming her.

And I also kept thinking back to February of the previous year when Gillian and I had gone to the Long Beach Veterans' Hospital to visit one of my pals, Bobby "Bullets" Babian, a colorful bartender known for doing back flips behind the bar and also for stuffing an enormous amount of cocktail napkins in his mouth while pouring drinks amid loud laughter from the patrons. He also was known for having shined Al Capone's shoes as a youngster growing up in Chicago. Bullets had lung cancer, and I recall Gillian telling me when we left the hospital, "I've never known anyone who's survived lung cancer because it always seems to spread all over the body."

I felt I had to tell Gillian about Dr. Rosen's revelation because Rosen would eventually do so himself. And I'm simply not a good actor. I couldn't walk in her room with a big smile and act like everything was perfectly normal. It wasn't. I would learn in the next year and a half dealing with Gillian's condition that an essential part of the doctors' Hippocratic oath is to inform their patients about the truth. And not once during this chilling period were the reports from doctors uplifting to Gillian.

I never will forget the beatific expression that was on Gillian's face that late morning when I walked into her hospital room. She was in bed propped up against a pillow reading Auden, and she smiled so sweetly upon seeing me. She looked so young and so angelic, much like she had when I saw her coming out of that exit gate at the Nice airport. But this time, she also looked vulnerable and fragile.

"Feeling better every day," she said. But her smile quickly disappeared when she noticed my grave expression. As I said, I'm not much of an actor and didn't attempt to be one on this occasion.

"What's wrong?" she wondered.

I slowly pulled a chair up to the bed, pursed my lips and said, "They found a spot on your chest X-rays."

I remember Gillian looking straight ahead, and her smile soon was replaced by tears.

"Oh," she finally said after a brief silence.

"But they don't know for sure what it is," I said. "It could be something else."

"No it isn't," she said. "I was fearful of that."

Gillian was informed officially a week later in a meeting in Dr. Rosen's office at the UCLA Medical Center that, indeed, the colon cancer had metastasized into her lungs.

International soccer great Pelé is flanked by longtime Long Beach bartender Bobby "Bullets" Babian (left) and Doug.

After Rosen went over with Gillian the specifics of her upcoming chemotherapy regimen, she asked him what her chances were of survival.

"About 20 percent," he said candidly.

After returning to Long Beach that day, we went to the Nature Center at El Dorado Park, a 105-acre forested oasis with streams, lakes and various habitats.

We had often walked its two miles of dirt trails in the past after lengthy runs, and we decided this would be a good place for Gillian to resume her fitness program. Midway through the walk, we took a break and sat on a bench in a secluded area, silently gazing at the idyllic sights that surrounded us.

And then Gillian began crying.

"Douglas, I'm going to die," she said. "I don't want to die. I'm only thirty-three. I want to have kids. I love life. I love you. I don't want to die."

"You're not going to die," is all I managed to say in a feeble attempt to calm her down.

"Remember, what I said after we visited Bobby Babian at the hospital, how no one survives lung cancer?" she said. "Well, I have lung cancer, and I know it's going to spread to my lymph nodes and then my brain and then my liver and then…"

I quickly gathered myself.

"Listen, Gillian," I said sternly. "Are you going to die tomorrow?"

"No."

"Are you going to die next week?"

"No."

"Next month?"

"No."

"You're not going to die next year, or the year after or the year after that. I don't ever want to hear you say that you're going to die. Promise me that. Never again will you say that. You're going to fight this like Lance Armstrong [American cyclist who had cancer] fought his. Cancer spread over all his body, and he survived. I don't ever want to hear you again talk about dying."

Gillian became ill a few weeks after her surgery and for precautionary reasons wound up back at the UCLA Medical Center. On May 23, my father, Leo Krikorian, eighty-nine, died of congestive heart failure. He was a decent man with high morals who labored most of his life as a sales manager for the Peloian Packing Company in Dinuba, a first-generation Armenian workaholic who never retired and never made a lot of money.

But our family never lacked for comforts, and my father was loyally married to my mother for sixty-four years and was responsible for my lifelong passion for sports.

When I was a youngster, he often took me to Kezar Stadium in San Francisco to see the 49ers play, and he'd also take me every year to the college football match known as the Big Game between Stanford and California.

He was a man dedicated to his wife, his children and his job, and his brother, Sam Krikorian, a Fresno nightclub owner, once said of my father, "Leo could be stuck in a Tijuana whore house and would not cheat on your mother."

He would pass away on a Tuesday night in a Fresno hospital, and his funeral was scheduled on a Saturday. Because Gillian was in the hospital

that week and I didn't want to be apart from her—I made daily visits up to the UCLA Medical Center—I wasn't able to make it to Fresno until Friday evening.

I returned to Los Angeles shortly after my father's burial on Saturday and visited Gillian at the hospital early that evening. I later felt guilty about not feeling the deep grief for my father's passing that I should have felt—I later wrote a cathartic newspaper article on that subject—but Gillian's condition dominated my thoughts in those depressing days.

Chapter 23

For several reasons, the 1996 World Series between the New York Yankees and Atlanta Braves that I covered for the *Press-Telegram* is etched indelibly in my memory.

The Series itself was riveting, as the Yankees were impaled in the first two games in their storied Bronx stadium, only to come off the mat spectacularly to win in four straight games that gave them their first world championship since 1978.

Then there was the poignant sight of the Yankees' third baseman, Wade Boggs, galloping around the Yankee Stadium outfield on a policeman's horse in a seminal image of the raucous celebration that erupted in the historic structure after the final out was recorded in the Series amid loud cheers and Frank Sinatra's "New York, New York" crooning over the public address system (perfect conditions for a reporter on a tight deadline).

And lastly, I was in a perpetual mood of tranquil joy at that time because of my blossoming relationship with Gillian, in which there were no lingering doubts and the usual impulse to stray had remained muted.

This was in such dramatic contrast to so much of my past when seeking new female companionship had been a daily sport. I now actually found myself feeling empty and sad when Gillian and I were apart.

Soon after the World Series, I returned to London, and this, for sure, was going to be the watershed moment for us because I finally was going to meet her parents. Frankly, I was wary. I realized most parents wouldn't be thrilled about one of their daughters being romantically involved with a man twenty-three years her senior. I know I wouldn't be.

We drove the 250 miles from London to the northeast village of Elwick, where Gillian's parents had a comfortable single-story, two-bedroom home.

Elwick had a population of fewer than six hundred and was less than three miles from Hartlepool and a mile from Dalton-Piercy, where Gillian grew up. Elwick turned out to be a charming place right out of central casting with its side-by-side pubs, the Spotted Cow and McCorville; its tiny food store that served also as a post office; its one church; its two small schools; its tiny cemetery; its old town hall; and its panoramic view of the North Sea.

It also turned out that Gillian's parents were like, well, Gillian in that my age didn't bother them. Her father—his name was Jim—was sixty-seven, a mere fifteen years older than I was, and he was retired. When I discovered he was in the British army for a couple years and stationed in Palestine, I peppered him with questions about the experience, which he liked.

He related some interesting stories, and we also talked about World War I, long a particular passion of mine since visiting one of the Western Front's most notorious sites, Ypres, where more than one million soldiers died in a twenty-eight-square-mile area in three major battles in four years in the Flanders enclave in Belgium. He had an uncle who fought in the Great War in which more than one million British Commonwealth soldiers lost their lives, many of the deaths coming at Passchendale, near Ypres, and also at the Somme in France, which I had also visited.

Gillian's father enjoyed having a beer, and I wound up accompanying him on his daily afternoon visits to the Spotted Cow. Gillian's mother—her name was Mary—was a retired schoolteacher with a soft, quiet disposition who spent a lot of time caring for her two young grandchildren, Victoria and David, when her other daughter, Katharine, and son-in-law, John Elliott, were at work. Both were radiologists.

While I'm sure Gillian's family was skeptical of my being so much older than Gillian and also because of my 1992 New Year's Eve betrayal, I never was made to feel uncomfortable and was treated with warmth and kindness.

I enjoyed those early morning runs that Gillian and I took in the neighboring countryside dotted with cow pastures. It always was cold, windy and rainy, and I came to quickly realize that Gillian grew up in an area far removed from Southern California. But I found such an environment to be enchanting—perhaps because it was so different—and the people I met couldn't have been nicer to me.

We stayed in Elwick for three days and took side trips to Newcastle, Durham and York.

After meeting all the members of her immediate family, I was more certain than ever that I wanted Gillian to become my wife. I remember my father once saying to me that daughters were extensions of their mothers, and Gillian was a mirror image of her mother.

On the way back to London, we took a slight detour to Bristol, where Gillian and I spent the evening at a bed-and-breakfast inn on a large sheep ranch. The next day, we went into the city and visited the mother of a close friend of Gillian who had terminal cancer and was expected to die within weeks.

Gillian was visibly distraught when we departed, and I remember her saying to me, "I come across cases like this sometimes at work, and you feel so helpless. It's very difficult. What always amazes me is how brave these people are. They try not to let on what they're going through. I'm not sure I ever could be that strong and brave if I were in that condition."

June 2000 [The Treatment]

I'll never forget Gillian's first chemotherapy session at the UCLA Medical Center for a couple of reasons. In the room next to hers sat a fellow I had known since 1969, when he joined the Los Angeles Lakers.

I was stunned to see Happy Hairston going through a chemo session, but the starting forward on the 1971–72 Lakers team that set a record that might never be broken—thirty-three straight victories—insisted he was fine.

"I was diagnosed with prostate cancer, but it's under control," said Hairston with assurance.

I figured Hairston soon would return to good health, but the next time I came across Happy was in a hallway at the hospital almost a year later. He was lying on a gurney being pushed by an attendant. He gave me a thumbs-up hello but would die a couple of weeks later, on May 1.

After Gillian received her dose of chemotherapy, which took around three hours, we drove back to Long Beach, and she accompanied me to El Dorado Park, where I planned to go on a forty-five-minute run. I figured Gillian would walk, since she hadn't done any serious exercise for more than a month. I should have known better. She not only ran alongside me for forty-five minutes but also started sprinting the final one hundred yards to finish well ahead of me. Clearly, she hadn't lost her competitive edge.

I was informed by my newspaper that month that it wanted me to cover the upcoming Olympics in Sydney. I told my editor, Rich Archbold, that it would be a privilege to do so but that I would have to decline because

of Gillian's illness. He said he understood. But when I told Gillian of my decision, she protested.

"No way you're staying home and missing the biggest athletic event of the year because of me," she said. "I'll be all right. I'll be done with the chemo by then, and you'll only be gone for three weeks. My parents will come over and stay with me. Douglas, I insist that you go. The Olympics are a great event, and you should be there."

Gillian's reaction was predictable. She always thought of other people rather than herself. I knew had I remained home and not gone to Sydney that that would have caused her great aggravation. Reluctantly, I went to Sydney.

Near the end of June, we had one of those periodic consultations with Dr. Rosen, and it didn't turn out well. None ever did. I remember Gillian asking him in that one, "If the cancer is not contained, when will I know the end is near?"

He cast a wary eye in her direction and gave an honest answer that would turn out to be sadly true.

"When you are unable to get out of bed and walk," he said.

Gillian nodded grimly.

There always was a solemn silence in the car during the ride back to Long Beach from the UCLA Medical Center.

Gillian always requested to have the radio turned off, and she would sit in the passenger seat, gazing pensively out the window, lost in thought. She never spoke, nor did I, even though I wanted to. But I knew that no matter what words of encouragement I might utter, they would sound contrived and hollow.

At that time, I still was confident Gillian's cancer would go into remission. After all, Lance Armstrong had beaten it, and cancer had spread throughout his body.

Why couldn't Gillian do the same? I asked Dr. Rosen about Armstrong's miraculous recovery, but he pointed out that Armstrong had testicular cancer, which he said was more curable and not nearly as aggressive as colon cancer.

Still, in June 2000, when Gillian began her treatment, I didn't view her illness as being terminal. Perhaps I was deluding myself and simply wouldn't let any other thought invade my mind. But I still was certain that Gillian, with her indomitable will, would survive her condition.

Chapter 24

On December 29, 1996, a couple months after I met her parents, Gillian flew to New York from London, and we planned to celebrate New Year's Eve among the hordes at Times Square.

Actually, we had been making a lot of plans, with the most important one being Gillian agreeing to soon give up her ten-year job with the National Health Service and relocate to the United States to live with me as a prelude to our getting married in the fall.

Gillian had never been to New York, and I knew she would like it, much like I had on my first visit to the great metropolis. That came in the summer of 1968, when I took a nine-hour flight from LAX—with a fuel stop in Kansas City—on the Los Angeles Dodgers' old turboprop Electra 2 named the Kay O.

What an experience I had on that three-game road trip with the Dodgers—the team also journeyed to Pittsburgh and Houston—and never will forget on that long flight actually sitting across the aisle from future Hall of Fame pitcher Don Drysdale and Ken Boyer, who should be in the Hall.

After reaching New York and checking into a Midtown hotel at nine o'clock in the evening, I walked the streets alone for a couple hours, mouth agape.

I was totally mesmerized by the towering buildings, the reverberating subway trains, the horn-blaring taxis, the architectural and cacophonous ambiance that sets New York apart from any other city in the world.

In looking back, that was a transformative development in my life, for being on assignment with the Dodgers in New York meant I had already realized my fervent ambition of traveling with a major-league sports team.

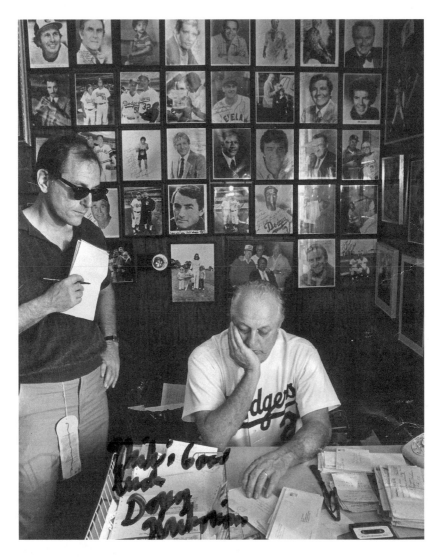

The sportswriter and his familiar subject—Doug and Tommy Lasorda—share a pensive moment in the manager's office moments after the St. Louis Cardinals' Jack Clark hit a three-run homer to defeat Los Angeles in Game Six of the 1985 National League Championship Series.

I would go to New York many times in the ensuing years, but those early visits with the Dodgers and then the Lakers and also the Rams remain particularly vivid to me.

I'll always remember the first off day I had in New York that came in my first season of covering the Lakers—it was in February 1969—when I went

bar-hopping during the afternoon with Hot Rod Hundley, a one-time Lakers player himself and one-time University of West Virginia All-American whose scoring records at the school later were eclipsed by Jerry West.

At the time, Hundley served as a broadcasting caddy for the Lakers' inimitable announcer, Chick Hearn, managing to dispense a few innocuous opinions during one of Hearn's rare silent periods.

Hundley enjoyed liquor and women, and as it turned out, he also enjoyed fleecing me of my per diem allowance by continually beating me in gin rummy games on flights and in hotel rooms that season.

And even on the infrequent occasions when I did beat Hundley, he always would force me to continue playing until he'd recoup his losses, even if it meant our having to stay up until the early morning hours. I don't think I ever came away with money from Hot Rod, who possessed every sly trick of the cad he was.

Anyway, on that afternoon when Hundley and I were making our rounds, one of the saloons we visited was Mr. Laffs, which was co-owned by the former New York Yankee infielder Phil Linz.

We were sitting at the bar when two brawny, uniformed New York cops walked into the place and sidled up next to us. I didn't know what was going on—were they going to bust the joint?—but to my surprise the bartender brought over two shot glasses and a bottle of J&B.

I couldn't help but notice that the officers proceeded to pour themselves three drinks in less than ten minutes, and they then walked coolly out the door without paying. I turned to Hundley and said, "I can't believe what I just witnessed. Never seen cops in uniforms down drinks in a bar before." Hundley shrugged and said, "Kid, this is New York. Welcome to the big show. They do things differently here."

Another unforgettable time in New York would come a year later—the exact date was February 16, 1970—when once again I was there with the Lakers during an off day.

The sports editor of the *Herald Examiner*, Bud Furillo, and another writer on the paper, Allan Malamud, my pal, also were in town for the heavyweight title match between champion Joe Frazier and Jimmy Ellis. The bout was taking place that evening at Madison Square Garden.

Bud decided to have me write a supplementary story on the fight—Frazier stopped Ellis in five rounds—and on the day of it he took Malamud and me to Jack Dempsey's restaurant on Broadway, where he introduced us to the legendary Dempsey. We stayed only a few minutes—I was impressed with Dempsey's immense hand size when I shook it—and then Bud took us to Toots Shor's joint at 33 West Fifty-first Street.

Los Angeles Clippers owner Donald Sterling (center) poses with Doug and fellow sportswriter Allan Malamud.

We had lunch at Shor's, and the celebrated saloonkeeper actually came over to our booth and sat down to have a drink with Bud, who got to know Shor from his days as an Angel beat writer for the defunct *Los Angeles Herald Express* when Furillo would bring the womanizing pitcher Bo Belinsky into Shor's place.

The golfer Arnold Palmer came by to say hello to Shor and Bud. Bud knew everybody, and later that day we went to the Manhattan office of Ernie Braca, a well-known fight guy with mob connections who once co-managed Sugar Ray Robinson.

Although I had a press pass for the Frazier-Ellis fight and could have sat ringside, I chose to watch the proceedings in the stands next to Jerry West, a rabid boxing fan.

It was all like a fantasy to me—meeting Jack Dempsey, Arnold Palmer and Toots Shor earlier in the day and then covering the Frazier-Ellis fight that evening with Jerry West, one of America's most renowned athletes at the time, seated next to me.

But it became even more so in the press room afterward as I was composing my story for the *Herald Examiner*. I was seated next to one of my sportswriting

idols, Jimmy Cannon, who astonished me when he handed me the first take of his column, which he had typed out on his old Remington.

"What do you think of it, kid?" he asked. I perused it quickly and gulped, "Great. Great." The great Jimmy Cannon, whose lyrical prose was admired by such distinguished authors as Ernest Hemingway and Ian Fleming, seeking my approval? As I have noticed so often, some of the most insecure people are those endowed with greatness.

Later that year, on the evening of May 8, I was once again at Madison Square Garden for a different kind of athletic event—the Game Seven NBA championship final between the Lakers and New York Knicks—and I'm sure my later coming down with tinnitus in my left ear could be linked to the deafening noise that erupted from the crowd when a limping Willis Reed came out of the tunnel for pregame warm-ups.

The Knicks' center had a torn thigh muscle and didn't play in his team's one-sided loss in Game Six. And he played only briefly in this one—he scored the game's first two baskets—but his presence inspired the Knicks to a 114–99 win. I've covered hundreds of loud sporting events over the years, but none matched the noise level that accompanied Willis Reed's emotionally theatrical appearance on the floor that long-ago night at Madison Square Garden. My ears still were ringing when I woke up the next morning.

Incidentally, Bud Furillo sat next to me at that game—he wrote the main story for the *Herald Examiner*—and I'd be remiss if I didn't mention the impact Bud had on my life. Without Bud, I'd have probably wound up selling real estate, or peddling cars or picking grapes and rolling trays in the vineyards of the San Joaquin Valley.

It was Bud who rescued me from oblivion. In the two years after getting out of college, I toiled in the newspaper minor leagues, serving as a sports editor at the *Pacific Palisadian Post, Camarillo Daily News* and *Tulare Advance Register*, as well as being a copy boy at the *LA Times* for a month.

A friend of mine from Fresno, Ron Delpit—we worked together as prep writers at the *Fresno Bee*—was working for the *Herald Examiner* and touted me to Furillo.

I sent Bud a collection of articles, which he liked, and he wound up hiring me despite an awful recommendation from the editor of the *Advance Register* who had fired me for disobedience (I refused his kindly request to become the paper's society editor and pounded a typewriter and overturned a waste basket to show my displeasure).

"Any guy as young as you who already is pissing off editors is my kind of guy," cracked Furillo, whom I looked up to at the time with awed reverence.

I came aboard the *Herald Examiner* when it was embroiled in a bitter dispute with its union—it was in its sixth month—and the newspaper's editor, Don Goodenow, assured me that its publisher, George Hearst, wasn't about to settle and that some employees who had gone out on strike already were returning. It turned out he was right on both accounts.

I worked alongside a lot of accomplished writers and editors at the *Herald Examiner* during my long tenure at the paper, including not only Bud Furillo, Melvin Durslag and Allan Malamud, but also James Bellows, Ben Stein, James Bacon, Joe Morgenstern, Bob Keisser, Larry Merchant, David Israel, Julia Cameron, Mitchell Fink, Elvis Mitchell, Jeff Silverman, Frank Lieberman, Larry Stewart, Steve Bisheff, Gordon Jones, Dave Kirby, Kevin Modesti, Mitch Chortkoff, Morton Moss, John Woolard, Arelo Sederberg, Al Stump, Robert Epstein, John Lindsay, Diane K. Shah, Mary Ann Dolan, Rick Arthur, Rich Levin, Ken Gurnick, Tom Singer, Chuck Culpepper, Tony Castro, Alex Ben Block, Lyle Spencer, Barbara Zuanich, Michael Sragow, Peter Rainer, Don Forst, Winfred Blevins, Dick Adler, Mikal Gilmore, Jim Perry, Denis Hamill (of the famous New York writing family) and countless others.

Bud knew all the sporting bigwigs around the country, and it always was a joy to tag along with him, which I often did in Los Angeles and on other occasions we were together in New York, where he took me to not only Toots Shor's place but also to P.J. Clarke's, Peter Luger's, Mama Leone's, Rao's and Gallagher's Steak House, where I wound up having dinner on that New Year's Eve of 1996 on what was a historic trip for me.

Chapter 25

It was historic because it would be the first time I'd be in New York accompanied by a lady with whom I was in love.

Although we had discussed marriage, I still hadn't given Gillian a ring, and I planned to do that in New York, where we stayed at the Hilton in Midtown.

I also brought along with me from Los Angeles my stepdaughter from my marriage to M, Leigh Anne Kelley, and her husband, Tom. I long had been close with Leigh Anne, a strong-willed lady with two young children who had patiently served as a valuable listening post for me, especially during times of romantic turbulence.

Leigh Anne was twenty years younger than me but three years older than Gillian, and she had voiced serious skepticism about our age disparity. I kiddingly told her that her feelings were inspired by nothing more than sibling rivalry.

I'm sure the motivating factor in my inviting Leigh Anne to New York was to seek her approval of Gillian, not that I would have broken up with Gillian had Leigh Anne voiced disapproval.

The Kelleys also were making their initial New York visit. They and Gillian reacted like I had when I first saw all the towering skyscrapers and heard all the blaring noises.

I knew Leigh Anne would like Gillian—and she did. How could anyone not like Gillian? She had that delightful English accent and that pleasant demeanor, and she was just so easy to be around—no nitpicking, no gratuitous

putdowns, no complaints, no unnecessary verbiage—and those days of her getting uptight about a perceived feminist slight as she had one night with me almost four and a half years earlier in Las Vegas long had disappeared.

There was a genuineness about her that made a distinct impression on those with whom she came in contact. "Gillian's an absolute sweetheart," said Tom Kelley after spending a few days in her company. Who would have known then that a few years later Tom Kelley would provide valuable relief assistance for me in driving Gillian to the UCLA Medical Center?

On our first full day in New York, we visited a couple museums—the Metropolitan Museum of Art and the Frick Collection—and Gillian and Leigh Anne skated around the ice rink in Central Park. We also walked a lot, and naturally, we stopped at a few saloons where Tom Kelley and I did most of the drinking.

On New Year's Eve, Leigh Anne had a severe cold and remained in her hotel room.

Tom Kelley, Gillian and I had a late dinner at Gallagher's and then joined the nearby assemblage on Seventh Avenue. We were too late to get close to Times Square, but we still were near enough to get caught up in the frantic commotion that ensued after the ball dropped signaling the commencement of the New Year.

There were hundreds of thousands of people packed closely together, and everyone was pushing, shoving, shouting and high-fiving in an unrestrained eruption of joy. Suddenly, I forgot about the numbingly cold weather—I think the temperature had dipped to eight degrees Fahrenheit—and kissed Gillian passionately.

"This will be our lucky year—1997 will be the year you become Gillian Krikorian," I said. She nodded and smiled.

"That'll be nice," she said. We soon managed to return to the hotel, traversing a gauntlet of celebrants in varying degrees of sobriety.

The Kelleys returned to Los Angeles the next afternoon, but we stayed for another two days, during which we visited Ellis Island, where we saw the names of my Armenian and Italian grandparents on the outdoor walls that list all the people who arrived to the United States at that immigrant inspection station in New York Harbor near the Statue of Liberty.

Gillian was in awe at the sight of that storied monument.

"You wonder what all those millions of immigrants who came here thought when they saw the most famous statue in the world," she said. "I feel quite emotional looking at it. You think of America, and the Statue of Liberty always comes to mind. I also feel a little like those immigrants did.

Only I'll soon be coming back to America on a plane and not be treated like a herd of cattle down in a ship's steerage like so many of those poor people were when they came here."

The following day we had lunch in the Windows on the World on the 107th floor in the North Tower of the ill-starred World Trade Center. The place was jammed, and the only reason we were even able to get seated was that my friend Rich Levin, a former *Herald Examiner* sportswriter who had become the top PR guy for the Major League Baseball commissioner, Bud Selig, was able to secure us a reservation.

As Gillian was gazing with fascination over the magnificent New York skyline, she said, "This is absolutely breathtaking. It's like being in an airliner and getting an up-close view of New York City."

It was a couple moments later that I presented Gillian with the wedding ring I had bought her, and her eyes became moist with emotion. "Douglas, this is the happiest day of my life," she said.

We were now so much in love, and one never could envision at that beautiful moment that a few years later a hijacked 767 American Airliner would crash into the North Tower a few stories below where I had officially validated my marital intentions and that a hospice nurse on that tragic morning would be administering that first shot of morphine that would put Gillian in a comatose state in which she would remain until her death a few days later.

I vividly remember looking out at the New York skyline that day and thinking to myself how stunning the view was. There would be 168 people in the Windows on the World premises that ghastly September 11, 2001 morning—and all would perish, as did everyone above the 92nd floor of the 110-floor building.

Gillian would return to London on January 4, and I returned to Los Angeles the same day. She was set to soon come to Long Beach permanently, and the marriage was set for late September. The script was unfolding perfectly. It was a happy time in both our lives.

Chapter 26

On February 28, 1997, Gillian Howgego, twenty-nine years old, arrived at LAX admittedly in a state of apprehension. She had uprooted herself from her native country, quit a secure job she liked and left behind many close friends and family members.

"It's a little scary, but nothing compared to what all those immigrants who came through Ellis Island had to go through," she had said on the phone to me a few days earlier. "Few had any money and had no idea how they'd make it or where they would live. And many didn't even speak English."

Gillian was coming to live with me in my modest tract home in east Long Beach.

I don't know if it was a foreboding of what would occur in the upcoming years, but Gillian arrived on the day of the infamous North Hollywood shootout in which a couple heavily armed bank robbers named Larry Phillips and Emil Matasareanu had a violent confrontation with dozens of police officers from Los Angeles and nearby cities.

During the forty-four-minute battle that was televised live on two LA television stations by hovering helicopters, there were more than two thousand rounds of ammunition fired by the robbers and police as the area resembled a war zone. Eleven officers and seven civilians suffered gunshot wounds, but incredibly, no one died in the bloody incident except the two robbers.

Soon after Gillian had arrived and I had informed her of the wild gunfight, I remember her saying, "I'm a little superstitious on some things. I hope that's not a bad omen for me in America."

Looking southeast on Second Street in the Belmont Shores section of Long Beach, a billboard with Doug's image and proclaiming, "Outspoken Sports" promotes the *Long Beach Press-Telegram*.

I sloughed it off, but now I have a slightly different perspective of that statement. After all, Gillian did enter this country on the day of its most notorious modern bank robbery and did pass away during the week of its most notorious terrorist attack.

I'm sure it's only a strange coincidence, but such chilling bookends to her brief U.S. residency do inspire one to idly reflect on the chilling randomness of coincidence.

Those first few months were a huge adjustment period for Gillian, so accustomed to putting in long workdays and to driving on the left side of thoroughfares and to being around people she knew well. I knew it would take time for her to acclimate herself to her new life in a new country, but her biggest adjustment was her role as my de facto wife.

I was the first man she had lived with in such an arrangement, and at first it didn't bother me that she didn't involve herself in normal household chores. I still had a college coed over twice a month to tidy up the place. And while it would have been nice had Gillian once in a while chosen to water the flowers, I wasn't too bothered that she didn't because I long had done that

myself. And I had a gardener who came weekly to cut the lawn, prune the shrubbery and pull the weeds.

But after awhile, I found myself becoming increasingly irritated by her inaction. I was brought up in a family where my mother did the cooking, the washing and the house cleaning and even occasional watering of plants in the yard.

I certainly didn't expect Gillian to become my private servant—I long had grown accustomed to eating my dinners out and had no plans to change the routine—but I did expect her to do some menial duties around the home.

I think Gillian had been living with me for about six weeks when one afternoon we came home from exercising and I became agitated when I noticed the kitchen was in total disarray, with glasses, dishes and silverware strewn on a counter that needed cleaning. And our bed hadn't been made, either.

I had written my column for the newspaper that morning, and I hadn't paid any attention to the disarray when we hurriedly departed the premises for an hour-and-a-half run at El Dorado Park.

But now I did, and I called Gillian into the front room. We sat across from each other, and I knew the time had come for me to express my feelings on the subject.

I also knew I had to do it in a calm, restrained manner, making my point without offending her too deeply.

"You've been here now for almost two months, and I've never said one word to you about helping with the cleaning and the occasional watering of the roses," I said. "And I know in the past in London, you did things for yourself in your flat and weren't concerned about your roommate's mess. Well, it's different now. I'm more than a platonic roommate. I'm soon going to be your husband. Just look at the way your mother takes care of the family house. I'm not asking you to do that here. I'm asking you just to help out a little more. It's no longer just you, Gillian. I'm part of your life now."

As she had reacted the one other time I gently reprimanded her—four and a half years earlier in Las Vegas—tears formed in Gillian's eyes, and she nodded silently.

"Honey, I don't want you to become my maid. I want you to become my wife," I said.

She got up and came over to me, putting her arms gently around my shoulders and kissing me on the cheek.

"I'm sorry," she said. "This is all so new to me. I've always been used to doing things for myself and not thinking of anyone else. I'll change."

And she did.

From that moment on, Gillian became my wife, even though we didn't make it official until September 27. I honestly believe she wound up keeping the cleanest home in Long Beach. And the roses were always well watered, and they bloomed in the spring like never before.

Chapter 27

That year was an exciting one for Gillian and me. It seemed like every day was an adventure—and for sure, it was for Gillian. In looking back, I definitely got a vicarious thrill from seeing how the young lady from England savored all the new things she was experiencing in her new surroundings.

I was like a travel agency guide as we spent so many weekends visiting my favorite getaway spots in Southern California: Santa Barbara, La Jolla, Lake Arrowhead, Palm Springs. I also took her to Sun Valley, Idaho, where we spent the July 4 holiday with my sister, Ginny Clements.

"What a wonderful country America is," Gillian said often. It would be a spiel she would recite until the end. I never heard her utter a harsh word about this country, and she forever praised its food and energy and the friendliness of its citizens. "I have found the people here all to be so nice and helpful," she said. "They're much more open than the English people."

Naturally, I took Gillian to the newly opened Getty Museum in Brentwood, the Los Angeles County Museum of Art on Wilshire Boulevard in West Los Angeles, the Norton Simon Museum in Pasadena and the Huntington Library in San Marino. She liked the latter with its 120 acres of botanical gardens and many acclaimed English paintings—Thomas Gainsborough's *Blue Boy* hangs there—so much that we became members.

There never was a dull moment that year, especially when she began driving on the Los Angeles freeways, which was quite harrowing the first time she did so when she barely missed colliding with a large truck and trailer on the 91 Freeway. But it didn't take Gillian long to get used to the

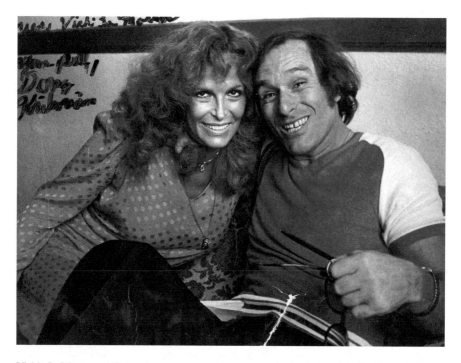

Vickie LaMotta and Doug share a moment. The wife of prizefighter Jake LaMotta, Vickie was portrayed by Cathy Moriarty in Martin Scorsese's great 1980 fight picture, *Raging Bull*.

different traffic setup in this country. She was a skilled driver in England, able to maneuver her car into tiny parking spots, and she soon became one in California after a few riveting trial-and-error journeys.

I also took Gillian with me to different sporting events, and the first major one came on June 28 at the MGM Grand Garden when she sat in the stands with Lynne Brener, wife of the Los Angeles public relations mogul Steve Brener, and watched a world championship heavyweight fight between Mike Tyson and Evander Holyfield. This was the one in which Tyson bit off a portion of Holyfield's ear and was disqualified in the fourth round. There was a tense aftermath; Gillian and Lynne Brener managed to make it out of the MGM Grand Garden safely intact and took refuge in the media trailer outside the arena.

"Oh, Douglas, are all fights like this?" she would ask me later after that unforgettable evening of Tyson's violent meltdown.

"I don't think there's ever been one like this in the history of boxing," I replied.

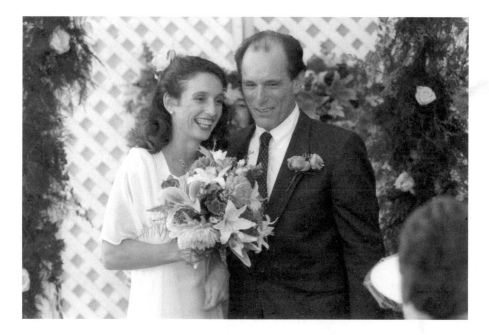

Gillian and Doug on their wedding day at the Portofino Hotel & Yacht Club in Redondo Beach.

Our wedding took place at the Portofino Hotel & Yacht Club in Redondo Beach, and it was a small family affair with only twenty-one people in attendance, including Gillian's parents, sister, brother-in-law, niece and nephew and members of my family, including my parents, sister, nephew and niece, various cousins and a few of my friends. It was organized by the Portofino's event planner, Victoria Durslag, and Gillian looked gorgeous in her flowing white gown as her father escorted her down the pathway amid the "Here Comes the Bride" processional. The Pacific Ocean glistened in the background as she and her father headed for the intimate outdoor gathering that was seated in front of a small ballroom where the wedding party later was held.

I had awakened that morning with an awful sore throat, but it seemed to go away in the jubilation of our eternal vows. I remember as the priest went through the wedding vows ritual becoming spellbound by Gillian, who had such a beatific glow covering her countenance. I never had seen her look so gorgeous, yet in a typically poised, even understated manner.

We spent that night at the Portofino, had breakfast at the hotel the following morning and then Gillian and her family members—there were a

total of eight of us—piled into my 1987 Lincoln Town Car, and we headed down to San Diego to visit the city's famous zoo.

We had a large wedding reception a week later at Phil Trani's restaurant, and more than two hundred people made an appearance, including Jerry West, the Hall of Fame Los Angeles Dodgers manager Tom Lasorda and a couple old heavyweight fighters, Joey Orbillo and Scrap Iron Johnson.

Who could have thought at that blissful time that four years later a funeral reception also would be held at Phil Trani's with a like number of people showing up to offer their condolences, including, once again, Jerry West.

In October 1997, Gillian joined me in Miami for the final two games of the World Series between the Florida Marlins and Cleveland Indians, and we stayed at the Don Shula Hotel in nearby Miami Lakes. She rooted for the Indians because I told her they were the underdogs—kindhearted Gillian always rooted for the disadvantaged—and she enjoyed the proceedings from her seat in the right field bleachers even though she hadn't yet mastered the rudiments of baseball.

We stayed in Miami a couple days after the Series ended, and I took her to two gastronomical institutions: Joe's Stone Crab in Miami Beach and the Versailles Restaurant in Little Cuba. She had never sampled stone crab or Cuban food before and savored both.

"You can't beat the food in America," she kept saying. "It's just so delicious everywhere we eat. And the portions are huge. I'm glad we work out every day, or I'd be putting on a lot of weight."

In early December of that year, we went to Europe, starting off in Rome, where we visited all the tourist spots, and then took the night train to Cannes, where we stayed a few days before going to Paris. We spent Christmas at her parents' home in Hartlepool, flew over to Munich, then took the train to Vienna, then went to Berlin for New Year's and then returned to Long Beach, where we soon found out that Gillian had become pregnant.

Those certainly were memorable times for us. I reveled in showing her this new life, which also was a new life for me. There was much laughter and much fun and much love for each other, but the maddening transitoriness of life soon would erupt.

Chapter 28

Although Gillian's miscarriage on April 1, 1998, was an agonizing letdown, we both were confident that a child was to be in our future. I never realized at the time what a dark omen that disheartening event was, but life did soon return to seeming normality.

We had hired an immigration attorney to help cut through the bureaucratic morass in assisting Gillian in obtaining her green card, which she received in March. In May, I flew to Spain at the behest of producer Stan Brooks for a tiny role in his TNT film *Dollar for the Dead*. I felt strange being dressed in cowboy garb and actually being filmed in the outdoor set near a city called Alemaria, where Clint Eastwood gained his early cinematic fame.

Alas, my movie career didn't exactly take off like Eastwood's, but I'm quite certain I hold the distinction of being the only American sportswriter to do a film in the same location where Eastwood did his spaghetti westerns.

After finishing my role, which consisted of my holding a 30-30 Winchester rifle and marching in unison with a bunch of other guys dressed as cowboys for, oh, ten seconds, I went to Madrid for a few days and spent a lot of time at the Museo Del Prado, its national museum with its massive collection of European art.

I remember becoming physically drained from walking through the building's myriad rooms jammed with the paintings of famed artists. I was astonished to see so many Goyas and Velazquezes and El Grecos, as well as Rembrandts and Poussins and Titians. I then flew to Lisbon, where halfway through a week's stay at the capital of Portugal I met up with Gillian, who had come over to visit her family in Hartlepool and friends in London.

We found Lisbon appealing. We were advised to stick to seafood, and that's what we did, locating small, family restaurants on narrow streets that put out superb fish dishes. We also discovered one of the most unusual taverns in the world, one that has left a lasting impression on me. It's called Pavilhao Chines, and as one Internet review described it so aptly, it's the mother of all flea market bars. There are four rooms in it overflowing with replicas of perhaps every famous person who ever has graced the planet, as well as mugs, baubles, bronze cupids, beads, caricatures, flags, medals, little lead soldiers, electric trains and a lot of Queen Victoria memorabilia. The place doesn't have every odd little object in the world, but not because its management didn't attempt to locate every one.

We also twice went to the Gulbenkian Museum, whose priceless rugs, clocks, sculptures and paintings left us calling it the most elegant and fascinating small museum we had ever visited. We stayed at the Tivoli Hotel, which was near Edward III Park, where we jogged. We visited some of the outlying areas like Sintra and Almada and found those places also delightful.

I think in looking back, that visit to Lisbon was cathartic for both of us after the miscarriage disappointment. I think just vacationing together—even if it was for a brief time—helped both of us emerge from the doldrums.

That year, Gillian started attending Long Beach State to get the necessary credits for her to qualify to take the state physical therapy exam. The president of the school, Dr. Robert Maxson, who had become a close friend, hooked Gillian up with counselors who pointed her in the proper direction.

Gillian took a couple healthcare classes that fall and wound up with A's in both of them, which was what she got in all subsequent classes except the final one, which she was unable to complete.

I got an up-close glimpse of how Gillian was able to become so skilled in judo in such a short time. I've never seen anyone with her determination. Our guest bedroom was converted into her office, and she spent far more time in that room studying than she did in our bedroom sleeping.

I remember that fall inviting her to join me in San Diego for the World Series between the New York Yankees and San Diego Padres. The previous year, she would have attended it, as she did the Cleveland-Florida Fall Classic in Miami, but this time she declined.

Gillian continued such dedication until she had to drop out of her final class—physics—in the spring of 2000, when diagnosed with cancer. The physics teacher was so impressed with her stellar scholarship that he informed Bob Maxson that he was going to give her a passing grade even without her taking the final exam.

"I'm sure Gillian was a great physical therapist, but I think she would have been a great college professor," said Maxson. "I've spoken to her other professors, and they all told me she was absolutely outstanding, the top student in their classes. I think had Gillian lived she would have gone on to get her master's and then doctorate degrees. She was just so intelligent and worked so hard."

We still went to Europe during the holiday seasons during those years, even went to the Middle East, but Gillian only left Long Beach when on school break. The rest of the time she zealously concentrated on her academics, which recalled what her sister, Katharine, once told me: "When Gillian makes up her mind to do something, she becomes totally obsessed with doing it successfully."

My image of Gillian during those times was her seated at her office desk late into the evenings, head buried in a textbook. "I just want to make sure I pass that state physical therapy exam," she often would say to me when I'd question her about her exhausting study habits.

Sadly, she never got the chance to take it.

July 2000 [The Sexual Attempt]

G illian was well into her second month of chemotherapy and, implausibly, still hadn't lost her hair, a development that soon would change. It was early evening, and we were driving to La Jolla for the July 4 holiday.

This had become an annual pilgrimage for me, and I always stayed at the Empress Hotel, where my friend P.J. Macaluso operated one of the best restaurants in San Diego County called The Manhattan. The fireworks show near the beach in the La Jolla Village was always spectacularly entertaining, and I always had a fondness for the area's shops, bars and cafés, as well as for gazing at the sea lions at Casa Beach.

Gillian was in bright spirits as we began the trip. She had gone on a forty-five-minute jog in the afternoon and was talking about signing up to take the state physical therapy exam and about how she was confident that she was going to overcome her illness. We were on the San Diego Freeway in Orange County near San Juan Capistrano when, suddenly, Gillian said she felt nauseous.

"I'm sure it'll pass," she said.

But it didn't. As we drove on, she felt worse, but she pleaded with me not to stop.

"I've been looking so forward to going to La Jolla," said Gillian, who had thoroughly enjoyed our previous visits there. "The doctor and nurses told me there would be times I'd get nauseous. I guess this is one of those times."

I glanced over at her and noticed she had both hands covering her face. She obviously was in great discomfort.

"We'll get off at the next exit," I said.

"No, no, no, no…please, no," she said. "Let's keep going. It'll pass."

Soon, Gillian was groaning.

"We're going to stop at the next rest stop," I said.

And we did at the Aliso Creek one, five miles from Oceanside. I helped Gillian, who now was struggling mightily, to reach the women's restroom. She remained inside for about five minutes, and when she came out her face was pale.

"Oh, Douglas, I'm so sorry," she said. "I hope I don't ruin our trip."

"Please, stop talking like that," I said. "How do you feel?"

"A little weak and still a little nauseous," she answered. "I threw up a lot."

"I think that's pretty normal."

"Yes, normal. I'm not sure anything will be normal for me again."

"Oh yes, it will."

"Oh, I'm sorry. I just, well, I just feel quite ill right now. I'll snap out of it."

Before we reached La Jolla that evening, we had to stop again.

Her response this time afterward was different.

"Oh, I now feel much better," said Gillian, even though I knew she didn't because she still was quite pale.

But Gillian had somehow summoned the resolve to act as though those toxic chemo fluids that they'd been injecting into her no longer were bothering her.

After we checked into the Empress, she insisted on going for a walk before dinner, and we strolled around the La Jolla Village for about an hour, even stopped at The Spot, where I had a drink.

I acted as though I didn't notice it, but I could tell Gillian was laboring. She might have been maintaining a brave front, but her mood, clearly, was subdued.

"Let's skip going to The Manhattan, and I'll order something in," I said when we returned to the hotel.

"No way!" she said, almost angrily. "We're not going to let my little hiccup keep us away from one of your favorite restaurants."

We wound up at The Manhattan, and I finished my osso buco in a hurry. Gillian consumed less than half her minestrone soup and took a few feeble stabs at her linguini and clams. Predictably, she wasn't hungry and simply didn't look well.

After payment of the bill, we repaired to our fourth-story room, where we watched TV for a while.

Before Gillian got sick, we had a normal sex life that increased incrementally during that time of the month when she was ovulating. Indeed, even if I

weren't in a particularly sensuous mood, I would willingly still perform during that period because both of us dearly wanted to have a child. I used to kid about it on occasion, saying, "I feel like an old soldier going off to another battle." Not exactly an apt metaphor since the battle I was referring to was quite pleasurable.

Gillian and I had engaged in no sexual activity since she was diagnosed with cancer that Easter, nor had we even talked about it. Clearly, there were slightly greater priorities now in our relationship.

But as we readied for sleep on that mild evening in La Jolla, Gillian had, to my surprise, shed her nightgown and snuggled up next to me, as she would do in the past in a prelude to sex.

I turned to her and knew from her wan appearance that she didn't feel well and that she had no desire for intimate relations. But typically, I knew she wanted to please whatever desires I might have, that she was willing to give of herself despite finally feeling the adverse effects of her treatment.

My sexual desires had lain dormant now for more than two months, and although I'm sure they could have been reawakened, I felt this wasn't exactly the appropriate time in light of Gillian's condition.

And so, while Gillian feigned randiness, I feigned tiredness, saying as sweetly as I could, "Honey, this is what you get for marrying an old man. I'm totally exhausted. Do you mind if we wait until tomorrow when I'm in a slightly livelier mood?"

"Of course," she said, and I could discern the relief in her voice.

We didn't have sex the next day, or for the rest of our marriage. The subject never arose again.

Chapter 29

If there was a year in our marriage that was devoid of incident, letdown, despondency, disappointment, despair, it was 1999, although we were unaware that a malignant tumor was growing ominously during that time in Gillian's colon. That would be the last year of our marriage in which there were no hospitalizations, no riveting heartache and no bad laboratory reports (even though there should have been one).

It's a curious fact of history that soothing weather often precedes tragic developments. They said Europe was having a gloriously unprecedented mild summer before the guns erupted on the old continent in August 1914 to commence a heinously bloody conflict known as World War I. New York was clear, sunny and in the seventy-degree range on the morning of September 11, 2001, when terrorists flew two airliners into the World Trade Center's Twin Towers and killed thousands of people.

I've often thought about that meteorological calm-before-the-storm phenomenon in reflecting on 1999. Literally, that year turned out to be the calm before a Category 5 hurricane struck, as we not only took that wonderful late summer vacation to picturesque locales in America and Canada but also went to England for Christmas and to Syria for the new millennium on a Middle East trip—we also visited Lebanon—that still ranks as the most culturally enlightening I've ever experienced.

Everything that year went smoothly, except for Gillian not getting pregnant, which was a source of quiet frustration to both of us. She had

made the transition to America well. She had grown accustomed to the warm, clear Southern California climate.

"Douglas, I'm not sure I could ever go back to the gray, cold, rainy England weather," she once said to me. "I think I've become spoiled. I remember in London how precious it was to all of us on a warm, cloudless day. It happened so infrequently, except in the summertime. Here it happens almost every day."

And it seemed every day my love for Gillian grew stronger and deeper. There was nothing about her I didn't like, and her kind heart that was on display daily in London when she worked with physically challenged older people still was on display in her new country.

I'll never forget one day, as we were watching television in the front room of our home, one of those long-legged sac spiders was crawling across the carpet. I got up and was set to squash it with a napkin when Gillian intervened.

"Don't kill it. It wants to live just like we do," she said, as I protested mildly.

She took a section of a newspaper, scooped the spider up and deposited it in the backyard garden. Much to my amusement, I'd see her do that on other occasions.

Gillian wound up becoming a close friend of my stepdaughter, Leigh Anne Kelley, who, along with my sister, introduced her to Nordstrom's, makeup, hair salons, nail parlors and other such places. I couldn't believe how quickly Gillian was becoming Americanized, right down to even not being timid about honking the horn of the car she often drove—my 1987 Lincoln Town—in frustration at an imprudent driver.

She also became close to Leigh Anne's young daughter, Dannielle, emphasizing to her the importance of education and instilling in her a passion for academics.

Dannielle credits Gillian with her going on to become the first person in her family to graduate from college—she obtained a bachelor of science degree in English and communications from Arizona State and also received a master's degree in public health from Virginia Commonwealth University. At twenty-four, she is now working on a doctorate at that school.

"Gillian was a tremendous inspiration in my life, and I'll never forget her," says Dannielle.

In the spring of 1999, Gillian had her heaviest workload at Long Beach State, taking four courses: Physiology for Therapists II, Psychosocial Aspects of Disability, Learning Principles for Therapists and Research Methods (Physical Therapy).

Early that summer she enrolled in two more classes: Early United States History and American Government. And that fall she took two more: Biostatistics and Seminar in Healthcare Issues. I doubt those studying for a bar exam put in as many hours as Gillian did for her courses. She did continue to exercise—we always jogged together, and she joined me for weight training sessions at either Frog's or 24-Hour Fitness when she could—but that was about her only diversion. She'd stay home evenings glued to her textbooks and feverishly jotting down notes, while I'd often have dinner with my pal Don "Donnie No Win" Kramer.

Unlike my first wife, Gillian encouraged me to go out at night with my friends and never questioned my whereabouts. Of course, she had no reason to, since I never came home late.

I had changed totally. My loyalty to her always was ironclad, even though there were opportunities presented to me—an inevitability when one comes into contact with longtime female acquaintances at venues where alcoholic beverages are being served.

After Gillian had concluded summer school, we went on our fourteen-day, 4,400-mile automobile excursion around America and Canada.

I'll never forget the prophetic words uttered by Gillian as we hiked an hour up to the Lake Louise Teahouse. As she looked down at the turquoise majesty of the famously clear lake in Banff National Park in Alberta, she said, "I'm just glad I have lived to see something so magnificently beautiful."

I remember finding it odd that her face had a solemn expression on it, and I quickly said, "You'll live to see a lot more beautiful things, Gillian. A lot more."

She nodded softly and said, "I hope so, Douglas, but strange things can happen in life."

I now wonder if she was experiencing a premonition.

Chapter 30

That vacation, which we enjoyed so much, was dramatically different from the ones we took in Europe, where we traveled by train and stayed in major hotels in major cities.

Although we did have one-night stays in two historic establishments—the Banff Springs Hotel and the Empress Hotel in Victoria, British Columbia—the rest of the time we checked into small, low-budget places like the Ranch Inn Motel in Jackson Hole, Wyoming; the Best Western Motel in Bozeman, Montana; the Super 8 Hotel in Pincher Creek, Alberta; Motel 6 in Coos Bay, Oregon; and the charming bed-and-breakfast in Fort Bragg, California, called the Lodge at Noyo River.

It was on this trip that I finally related in depth to Gillian how I got so seriously addicted to sports wagering at the rather elderly age of forty even though I knew nothing about it when I started, never even had paid any attention to it.

I told her I never had an urge to do it until the afternoon of September 9, 1983, when I was at the Caesars Palace sports book with that hotel's boxing coordinator, Bob Halloran, who had become a good friend of mine. I was in town for the *Herald Examiner* covering that evening's title fight between the champion, Aaron Pryor, and Alexis Arguello. The two junior welterweights had fought a classic the previous November at the Orange Bowl in Miami, and I had covered it for the *Herald Examiner*. It was a vicious brawl in which both combatants hammered each other round after round until Pryor wound up knocking out Arguello in the fourteenth round. I was ringside and saw

Doug poses for a snap with former junior welterweight champion Aaron Pryor.

the horrific damage that Pryor had done to Arguello. The referee finally halted the bout in the fourteenth when Pryor struck Arguello with twenty-six unanswered punches.

I knew Arguello would be unable to recover physically and mentally from such a beating and knew he had no chance against Pryor in the rematch. I looked up at the odds of the fight and didn't even understand the numbers. "What does minus $180 mean?" I asked Halloran, pointing to the number next to Pryor's name. "That means you put up $180 to win $100," he answered.

"In other words, if I put up $4,000, I'd get back $2,400," I said, as I did the math quickly.

"Yes," replied Halloran.

"It's an absolute cinch that Pryor's going to win…I wish I had $4,000," I said.

"No problem," said Halloran. "I can get you a $4,000 marker."

I assured Halloran that I'd make good on it if I lost. But I knew I wouldn't lose. I knew Arguello had no chance. I had seen him beaten

to a pulp in Miami, and I knew he would be beaten to a pulp again. Now, you must understand that before I made that bet I had never made a sports wager in my life except as a favor for a *Herald Examiner* sportswriter named Larry Allen shortly before the kickoff of the 1980 Super Bowl between the Pittsburgh Steelers and the Los Angeles Rams at the Rose Bowl. And even in that bet, I had no idea what I was doing— and committed a terrible indiscretion. Allen told me he wanted the Rams plus eleven and a half for $300, and so I called my tavern owner friend in Downey, Ray Ortiz, whom I knew bet football, and asked him if he'd put the bet in with his bookie, which he did. Only I didn't convey the information to Ortiz very clearly. I'm not sure how I made the mistake, but I remember saying to Ortiz that I'll lay the eleven and a half points, which I mistakenly thought meant taking the Rams.

So Ray Ortiz put my bet in on the Steelers, since he heard me say I wanted to lay the points. I should have told Ortiz I was taking the points and going with the Rams. I goofed it all up and realized my mistake halfway through the game when the Rams seemed destined for an easy cover. I informed Allen of my blunder, and he really got upset with me. I told him I'd make good on the bet if the Rams covered the spread, which they didn't. The Steelers wound up winning by twelve points, and Larry Allen wound up making $300 because of my miscalculation.

As one might notice, I knew absolutely nothing about the intricacies of sports gambling. But I knew Alexis Arguello had no chance against Aaron Pryor—and he didn't. The one-sided fight was stopped in the ninth round—and I, suddenly, was $2,400 richer. I flew my then girlfriend (Karen D.) and her two-year-old daughter over to Las Vegas, and we had a great time for the next two days, spending most of my winnings playing in the Caesars pool and even getting comped at the hotel's ritzy Palace Court restaurant. I became absolutely intoxicated by the thrill of making so much money so quickly without having to work for it. I figured I had found an easy way to make a lot of money quickly on the side—it would have taken me more than a month to make that much at the *Herald Examiner*—and I immediately became hooked. Oh, how naïve I was!

Actually, I did make a lot of money in the pursuit, but I also lost a lot during the next eight years. There were a lot of ups, a lot of downs, a lot of joy, a lot of heartache. There are enough things that go wrong in life without self-inflicted aggravation like gambling. It took me eight years to learn such a painful lesson. But at least I didn't come out of it broke or owing anyone money. I might even have wound up making a few bucks overall.

Left: Jack Youngblood (center), a Rams defensive end who played in the 1980 Super Bowl against Pittsburgh with a broken leg, is seen with Doug. Youngblood was inducted into the Pro Football Hall of Fame in 2001.

Below: Doug with his longtime live-in girlfriend, Karen D.

I definitely came out of it with a bountiful supply of intriguing tales that Gillian found captivating, like the one I told about how an interview with Pat Riley for a Lakers program piece wound up making me $5,000 (I made $75 for the article). That came on the morning of April 3, 1985, when I spoke on the phone to Riley, who was in Denver. The previous evening, his Lakers had clinched the Pacific Division title by beating the Nuggets, and midway through the interview Riley informed me he had sent his star center, Kareem Abdul-Jabbar, back to Los Angeles with a migraine headache.

The Lakers were playing the San Antonio Spurs that night in San Antonio, and the Spurs had a very good team with guys I know you've never heard of like Artis Gilmore, Mike Mitchell, George Gervin, Johnny Moore and others. I found out the Lakers were favored by three points. I knew the team would be drained from playing in the Mile-High City—and would have the inevitable letdown from such an emotional triumph. The game meant nothing to them, and now I discovered the team didn't even have its most dominant performer. I bet $5,000 on the Spurs and won easily, as the Lakers were beaten 122–108. I was the first gambler in America who knew Abdul-Jabbar wouldn't be playing.

But then a couple weeks later, in the last game of the regular season that came on a Sunday, the Lakers were playing the Kansas City Kings at Kemper Arena in Kansas City. I now perceived myself as a real wise guy and found out from a writer covering the game that Pat Riley wasn't going to use his three best players: Kareem Abdul-Jabbar, Magic Johnson and James Worthy.

Once again, I had valuable inside information no one else was privy to, and I reacted accordingly. The Kings were playing their final game at Kemper Arena, since they were relocating to Sacramento, and they had a few good players on their team like Eddie Johnson, Reggie Theus, Larry Drew, Mike Woodson and Otis Thorpe. The Lakers were favored by four points, and I figured the Kings would be fired up and the shorthanded Lakers would snooze and lose as they had done for me against San Antonio.

Gambling is an insidious pursuit and grabs hold of you without you even realizing it. Call it innate greed, or whatever, but this time I upped my bet to $13,000, which in retrospect was a ridiculous amount. You always want to make more and delude yourself into thinking you always will. I went down to the Caesars Palace sports book with my ticket broker friend Doug Knittle. The game wasn't being shown on TV in Las Vegas, but we watched the score of it stream across a digital ticker in the sports book. And, with 3:22 to go, the Kings were up 115–106, which meant I was up by thirteen points in my bet. And I was feeling terrific, set to celebrate with a few drinks.

Doug poses with Donald Sterling, owner of the NBA's Los Angeles Clippers.

But then, a few minutes later, the next score that streamed across was 116–115 in favor of the Kings. I suddenly began feeling inexplicably uneasy and actually started to fidget. The wait for the next score was interminable, and I told Doug to call his ticket office in LA, where the game was being televised. He did, and I suddenly became downright queasy as I saw him shake his head sadly as he looked at me. "The game's over, and the Lakers won 122–116," he said.

It turned out the Lakers outscored the Kings down the stretch by a 16–1 margin. Pat Riley later told me that kind of game happens once a season with his team, and it had to happen when I bet $13,000 against the Lakers. I stupidly chased that bet with another $13,000 one the next night on Thomas Hearns against Marvin Hagler and lost that one, too. I sank to such depths losing $26,000 in twenty-four hours that when I got back to LA I was so much in a state of shock that I even asked my then girlfriend (Karen D.) to marry me, which she gladly agreed to do. But I never followed up on the promise, which eventually resulted in our breakup.

"It's just hard to believe that you were once so heavily hooked on gambling," was always Gillian's response when I discussed the subject.

"Gillian, you have no idea," I said. "I was so hooked on it at one time that I used to give the woman I was living with [Karen D.] money to go shopping

Doug and Karen D. share a moment with hotelier Baron Hilton.

while I watched a football or baseball game so I wouldn't be bothered by her presence. And she later told me she once tore up three $100 bills in bitter reaction to my indifference to her during that time."

What I also remember about that vacation was Gillian's reaction to the picturesque scenery we came across throughout it.

As we went through the Grand Tetons and Yellowstone National Park in Wyoming and Glacier National Park in Montana and Banff National Park in Alberta and then across the Canadian Rockies and then across Washington to the coasts of Oregon and Northern California, Gillian would gaze in wonder at the endless mountain ranges and the towering trees and the idyllic forests and the flowing rivers and the gorgeous lakes and the Pacific Ocean.

"I'm just so glad I got to see all of this," she would say every day.

"Oh, we're going to do this again," I always would respond.

And I figured we would.

But we never did. After that, the longest trip we took in the United States was to Fowler to visit my parents and a day visit to nearby Yosemite.

Chapter 31

I've always been an adventurous sort, going back to my early days in college when, on a whim, an old high school buddy named Lloyd Koski and I, one late June day in 1964, piled into my 1956 Volkswagen and departed for New Orleans without notifying our parents.

Actually, we had told them we were going to Los Angeles for a few days but, instead, decided on a destination that was more than two thousand miles away from Fresno.

We spent that summer in the Crescent City and both wound up working in a small tavern on Bourbon Street, serving beer and sandwiches and meeting a gaggle of weird people. We stayed in a small room at a run-down place on Dauphine Street called the Anchor Hotel, which catered to pensioners, midget wrestlers, ponces, spielers, prostitutes and alcoholics. The cost was a mere thirteen dollars a week, and the room didn't have air conditioning despite the ghastly New Orleans humidity. I averaged three showers a day.

Our parents were appalled when we phoned them the first time from New Orleans.

"You come home right now!" commanded my mother, to no avail. Koski's mother did the same.

Sure, we took a lengthy journey without our parents' consent, but we were young and restless and anxious to assert our independence.

And what a time we had! I turned twenty-one that August 12 and wound up celebrating it with an older lady—she must have been at least twenty-five!—I met at Lucky Pierre's, a Bourbon Street tavern brimming with women

of a certain occupation in revealing apparel. It was a landmark birthday I'll never forget. I had $165 on me when we left for New Orleans and returned more than two months later with a similar amount at a time when gasoline never exceeded twenty cents a gallon and meals seldom exceeded $1.

It was a coming-of-age experience for both of us during that long-ago summer in which the decision to go to New Orleans was an off-the-wall, spur-of-the-moment one inspired by nothing more than the thrilling prospect of going to a place that had a mystique to it. After all, we were two young guys who grew up in the dreary rural humdrum of the San Joaquin Valley, a sprawling expanse of grape vineyards and fruit trees that turned into a sweltering sauna during the summer months.

I suspect I must have had a similar adventurous feeling on the Sunday morning of November 7, 1999, after reading an article on Syria written by Douglas Jehl in the travel section of the *New York Times*. In it, Jehl, who had been a correspondent for the *Times* based in Cairo, stated he had found traveling to Syria "to be the single most pleasant experience" he had during his stay in the Middle East.

"It is a land of stunning variety—of geography, culture and, above all, of the relics left by those who over many centuries have battled for its control. Nowhere else in the region, perhaps nowhere else at all, can a visitor leap so effortlessly from one era to another—from Roman ruins to Crusader castles, from Mameluke mosques to Christian churches, from Ottoman caravanseries to primitive, creaking water wheels." Jehl also wrote, "Anyone with a taste for the exotic and the old-fashioned will find Syria a wonderful antidote to the monotony brought on by globalization."

I knew Syria had just been taken off the State Department's terrorism list after a long time on it and knew the country was a dictatorship under the iron-fisted rule of Hafez al-Assad. But I noticed that Jehl discussed the restaurants and thriving shops in the Armenian Quarter in what was then Syria's second-largest city, Aleppo, and that he also revealed that he and his wife never felt threatened in Syria. I suddenly found myself smitten by the idea of visiting the country.

I had Gillian read the story, and she, too, found it interesting.

"Why don't we go?" I said to her.

"Why not?" she replied.

It was a typical Gillian response. While she was strong-willed, she always was open-minded and almost always went along with my travel suggestions, although I would have understood had she not been keen about going to a repressive Middle Eastern country.

When I broached the subject to friends and my parents, there wasn't one who endorsed the idea.

"Why would you want to go to a country where they stage public hangings at dawn?" asked Melvin Durslag, my old *Herald Examiner* mentor, summing up the general sentiment. "There are a lot nicer, if not safer, places to visit in the world than Syria."

Maybe so, but I had become intrigued by the prospect of going to a country whose self-imposed isolation had kept it immersed in another epoch in which there were no ATMs, no cellphones, no Internet.

If Douglas Jehl, who worked for the almighty *New York Times*, found the place enchanting, why wouldn't Gillian and I find it the same way?

And so, after we obtained Syrian visas in Los Angeles, and after spending that Christmas with Gillian's family in Hartlepool, we took a British Airways flight from London to Damascus on December 27, which took five hours and resulted in what became our most memorable vacation.

Sadly, it also would be the final one, and I often have thought about such a development. Was it just a coincidence, or was it divine fate that our last foreign journey would become the most memorable one?

There wasn't a day that went by in Syria that wasn't eventful, including even the three days of inactivity from my illness.

Soon after we landed at the Damascus International Airport, I found out immediately that, indeed, we were in a country far different than I was accustomed to when a grim-faced soldier asked me what my profession was as he closely studied my passport.

"Journalist," I said.

You would have thought I had said I was a member of the Muslim Brotherhood—an organization that at the time had been banned in Syria since 1982—as he loudly summoned an array of other officials. They took Gillian and me into a private room.

It took more than a half hour of confused conversation, but I finally got through to a gentleman who spoke severely broken English that I was a journalist who wrote only about athletics and not about politics, which, obviously, had caused the initial alarm because we then were allowed to proceed hastily through customs.

After we checked into the five-star Le Meridian in downtown Damascus in the early evening, we walked around the area for about an hour and came across machine gun–toting soldiers standing guard at almost every street corner and bearded men behind small carts pulled by donkeys navigating the streets alongside smoke-belching old cars. There was an endless maze of

Gillian and Doug dining in a Damascus restaurant.

ancient stone buildings, as well as mosques and churches and courtyards and small, winding alleys. We felt that we had stepped into a time capsule that took us back two thousand years.

We also saw a lot of men standing idly around the streets, and I noticed a lot of them kept their gaze on Gillian

"Why are all those guys staring at me?" wondered Gillian. "They just won't stop."

"I guess because they've never seen anyone as attractive as you," I quipped. "Gillian, I really don't know. It's kind of strange."

We'd find out later from the female concierge at the Le Meridian that men in a Muslim country like Syria weren't accustomed to seeing women in jeans that highlighted their derrieres—at least they weren't in Damascus in December 1999.

The concierge directed us that evening to one of Damascus's top restaurants, Zeitouna, and we had a large meal that included a *mezze* (small dishes of food preceding the main course), a *muhammara* (hot pepper dip used on bread) and then a hearty plate of lamb kebobs, chicken and fish. Also included in the feast that stuffed us was a Lebanese bottle of red wine and a rich Syrian dessert called *kanafe*, made of ricotta and shredded filo dough and enhanced by fragrant syrup. Although neither of us smoked, we took a

few puffs from a water pipe—it's called a *narghile*—that was at every table in the restaurant.

While the dinner turned out to be a challenging gastronomical experience—it must have taken us nearly an hour and a half to consume our vast amount of food—the most startling development came when the waiter brought the check. The Syrian lira we were charged was equivalent to $35. Such a meal would have been over $200 at a similar restaurant in America.

The next morning, we took a cab up to the nearby Al-Qalmoun Mountains. Rising about 4,500 feet above sea level, nestled in a quiet highland lap, is a hamlet called Maalula in which stone houses tower above one another like a series of terraces, with their rooftops serving as corridors and causeways for foot movement around the area. Most of the buildings have been chiseled out of the rock of the mountainous façade, and there is an unreal quality to the entire setting. It is a historic place dating back more than 2,500 years and the only surviving one where Jesus's dialect, Aramaic, still is spoken.

That afternoon, we visited the famous Al Hamidiyah Souq, a covered bazaar filled with customers that extends for almost a quarter of a mile. It was like an ancient Walmart—some shoppers rode donkeys—and every product imaginable was available. The prices were incredibly cheap, although one must be adept at bartering.

The exit is at the historic Umayyad Mosque, one of the largest and oldest mosques in the world and considered one of the four holiest places in Islam. It also is the place were many religious historians believe the head of John the Baptist is buried, and the tomb of Saladin stands in a small garden adjoining the north wall of the mosque. In order to tour it, Gillian had to wear a *hijab* that covered her head.

I've often told people it's indescribable what we experienced daily on that Syrian vacation, during which we did not once come across an American.

After a couple days in Damascus, we hired a driver to take us to Aleppo, which had a sizable Armenian colony. We took our time during the 223-mile trip, stopping on several occasions on the Damascus–Aleppo highway.

Once we pulled over on a desolate stretch of the journey when we came across a Bedouin herding his sheep on the side of the road in a scene that I'm sure had been going on in the country since biblical times. The Bedouin, his head covered by a red *keffiyeh*, was quite friendly and allowed both Gillian and me to pick up one of the lambs.

We stopped at one small village, and many of its inhabitants—including a lot of children—trailed us around. A few of its elders took us up a steep hill that overlooked a vast valley, and I remember thinking idly to myself as

we stood there near the edge that we easily could have been pushed over the precipice or even been kidnapped.

Of course, our driver was with us, and Syria, at that time, was still under the firm control of Hafez al-Assad; it was not the turbulent, bloody, strife-ridden country it has become in recent times.

One of the elders even invited us into his hut with his family, where Gillian and I sat on a mat and were served cups of tea. We were having a wonderful time, until the patriarch brought out a bunch of worthless jewelry and tried vainly to persuade me to purchase some of it.

Finally, after about ten minutes, I angrily got up and informed our driver, who had accompanied us, that it was time to go. We did, but that didn't exactly deter the guy from continuing to try to beseech me to buy his ersatz items. In fact, as our cabbie drove us out of the village, that patriarch and three of his pals got on motor scooters and sped alongside us, motioning wildly for us to pull over.

"Let's get the hell out of here!" I shrieked at our driver, whose driving I thought suddenly had become too timorous.

The scene was downright comical—those of a certain age might compare it to a chase in the old Keystone Kops silent films—although I reacted strongly when I noticed that Gillian had become wary.

Chapter 32

We made it safely out of there—I doubt we were in serious danger—and soon went through two cities, Homs and Hama, that have been at the forefront of the uprising against the Bashar al-Assad regime.

We took a detour near Homs to one of the country's most famous sites, the Cras de Chevaliers, a Crusader castle of medieval engineering mastery set among rolling green hills.

And when we drove through Hama, I noticed a lot of the structures still were pockmarked by bullet holes, a leftover from 1982, when Hafez al-Assad brutally suppressed a Muslim Brotherhood uprising in which it's been estimated that as many as twenty thousand people were killed.

We finally arrived in Aleppo at about 5:00 p.m., checked into our hotel, the Beit Wakil, and began prowling the streets, which were clogged with cars, all of which seemed to be honking. I'd have to say Aleppo was the loudest city I've ever visited—New York is a funeral parlor in comparison!—and maybe the busiest, as its sidewalks also were jammed with people.

We had a tasty dinner that evening at a place called the Sissi House and the next day walked into an auditorium adjoining an Armenian church down the street from our hotel where a young troupe of dancers was practicing its routines.

One of the dancers, a slim, pretty nineteen-year-old lady whose first name was Litty, came over during a break and spoke to us in halting English.

When she discovered my father was Armenian, she became extraordinarily excited and immediately invited Gillian and me to have dinner at her parents' home the following night and also said that she'd show us around Aleppo.

And that's what Litty did the next day as she escorted us up to the Citadel, a huge ancient fortress perched on a massif overlooking the city, and also took us to the stone-covered souk that was jammed with people and through a maze of alleys brimming with various merchants and craftsmen.

That evening, we had an exquisite Armenian meal of pilaf, lamb kebobs and kufta with Litty's parents and brother, and I remember asking her father how it was being a Christian family in a Muslim society.

"We have no problems with the Muslims because Hafez al-Assad won't tolerate any harassment of Christians," he said. "The word is that al-Assad's life was saved a long time ago by an Armenian doctor, and he always has treated Armenians well."

I also remember the fellow making a chilling revelation when I asked him if the large Armenian colony in Aleppo would feel threatened if the al-Assad regime was uprooted.

"The Armenians are well armed this time and won't be sacrificial lambs like they were in Turkey," he said, referring to the 1915 Armenian genocide in Eastern Turkey in which an estimated 1.5 Armenians were murdered.

I think back to that statement now in light of the turbulence that has raged in Syria in recent times and wonder how the Armenians and other Christian minorities will fare in its aftermath amid all the violent chaos.

After dinner, Litty's brother drove us back to the Beit Wakil, and as we had a nightcap in the hotel's bar, I suddenly felt faint and weak and began perspiring.

"I think I'm getting a temperature," I told Gillian.

Within a short time, I was sprawled out in my hotel bed and was burning up. We had a thermometer, and when Gillian took my temperature, the reading on it was a frightening 105.

"Food poisoning," I muttered. "I read in the brochures about Syria that foreigners have to be very careful what they eat."

"We've got to get you to a hospital," said Gillian.

"No," I said.

I don't recall much after that. The raging fever put me in a state of delirium, although I do remember having awful nausea and hallucinatory dreams. In fact, as I compose these words, I've become slightly nauseous remembering that scary night. Gillian later told me she kept my face swathed in cold cloths and that I refused her persistent attempts to call a doctor. Blessedly, the fever went down by the next morning—it had dropped to one hundred—but we decided to curtail our stay in Aleppo and return to Damascus. We once again hired a taxicab driver at the usual fee—$100—and I slept in the backseat

of his car during the journey, which was interrupted every sixty miles by military roadblocks.

I recuperated at the Meridian and never left the hotel the next couple of days, as I either was in my room sleeping or watching TV or checking out the goings-on down in the lobby that always had the same five or six guys in suits seated on the chairs and couches (I later found out from the friendly concierge that they were members of Haffez al-Assad's intelligence apparatus).

I did find it irritating to be awakened prematurely early in the mornings by a loud chanting that was broadcast over loudspeakers that could be heard throughout Damascus. It was the Islamic call to prayer—it's called the *adhan*—by the muezzin, and it kept reverberating in my head long after I had departed the city.

Gillian and I were in our hotel room when the new millennium arrived, and we opened the window and looked out at the city, which surprised me by its relative quietness. Oh, I heard some shouting and cheering, but this wasn't like those raucous other New Year's celebrations we had experienced in Berlin and Cannes and New York. Quite subdued.

I felt strong enough on January 2 to be on the move again, and we hired a cabbie to drive us to Beirut, the capital of Lebanon, which was only fifty miles from Damascus.

At the border, when the Lebanese custom officials noticed on my Syrian papers that I was a journalist and broadcaster, there once again was a volatile commotion, as there had been at the Syrian airport.

Our driver, an amiable, talkative chap named Muhammad, patiently explained that I reported on sports, not politics. But it didn't seem to make an impact, as the guy in charge kept shaking his head vehemently as both Gillian and I stood there in frustration, not knowing quite what to do.

Finally, Muhammad whispered in my ear, "Give me forty dollars in American money, and you'll get through."

Soon, we were on our way to Beirut, although we did stop an hour in Anjar, a small town settled by Armenian refugees in 1939. They hailed from the eastern Turkey area of Musa Dagh, which became internationally famous after Franz Werfel's 1933 bestseller, *Forty Days of Musa Dagh*, told of the heroic survival of a small group of Armenians in that mountainous enclave during the Armenian genocide in 1915.

As we drove up the hillside through the villages leading into Beirut, I couldn't help but notice that every mosque and church still bore the ugly scars from the Lebanese Civil War that raged for fifteen years and had been over for almost a decade.

And once we made it into downtown Beirut, it seemed as though every building also still displayed the ravages of that terrible conflict in which there were more than 1 million casualties—an estimated 200,000 deaths—and another 350,000 people who were permanently displaced.

While I never feared for my safety in Syria, I didn't feel the same way during my brief visit to Beirut, perhaps because the city was swarming with rifle-toting soldiers in the wake of a morning assassination of a Russian envoy by a pair of Chechen terrorists. On a couple of tense occasions, as we drove slowly through the battered city, soldiers ordered our driver to stop the car. They checked our travel documents with grim-faced vigilance, and I noticed their guns always seemed to be aimed in our direction.

"Douglas, I don't like it here," said Gillian after the final time we were pulled over.

"I don't either," I said as we drove past the battered remains of the old Holiday Inn.

We stayed in Beirut for about five hours, and our driver took us by the Shatila Palestinian refugee camp that was notorious for a massacre that took place there in 1982, as well as in the nearby Sabra. The place was a ghetto teeming with people, and a large regiment of soldiers surrounded it.

On the way back to Damascus, we stopped at a small café off the highway for tea, and Gillian and I quickly noticed that the other customers in the place—all males—were regarding us with unnerving scowls.

"I think we should go," I said to Muhammad.

He nodded.

In the car later, he said, "I'm glad we got out of there. I think those guys staring at us belong to Hezbollah. They don't like Americans because of your country's relationship with Israel."

Hezbollah is a Muslim militant group with strong political ties in Lebanon.

When we arrived back at the Meridian in Damascus in the early evening, I paid Muhammad, and he whispered in my ear, "Please don't repeat anything I've said today."

Muhammad hadn't said anything of a controversial nature, although he did concede that there were a lot of people in Syria who weren't strong advocates of Hafez al-Assad and that he, a devout Sunni Muslim, was one of them.

He had told us that Hafez al-Assad was an Alawite, a minority sect of Shi'ites that made up less than 10 percent of the Syrian population.

"Hafez al-Assad is not popular with us [Sunnis]," he said. "But please, don't tell anyone I said that, or I'll be thrown into prison, or even worse…"

I assured Muhammad that we wouldn't say anything—who were we going to tell, anyway?—but just the fact that he was so paranoid about an innocuous conversation was a reflection of the widespread fear Syrians had of Hafez al-Assad's regime.

And so I wasn't that surprised in the spring of 2011 when a Sunni-led uprising commenced in Syria against Bashar al-Assad, who took control of the country after his father's death in June 2000.

When we departed Damascus, I'll never forget Gillian turning to me, as our plane zoomed down the tarmac, and saying, "What an incredible experience this has been. I'll never forget it. I'm just glad I got to experience the Middle East."

"We'll be back again," I said.

"No, I don't think so," she said.

She said it in the same tone of wistful sadness she had the previous summer when she made a similar type of remark at Lake Louise.

I found her response strange, and I recall saying, "Honey, why do you say that?"

She remained silent, and I let the subject drop.

Who knew at this time that in less than four months her life would become a cruel struggle for survival?

Chapter 33

In March 2000, my old radio partner, Joe McDonnell, called me one afternoon and said, "We have a chance to get back on the radio together." I immediately demurred.

My last experience in the industry wasn't exactly an uplifting one, as I got stiffed for almost a month's pay in a brief tenure at that FM station in Sierra Madre. That had happened in the summer of 1995, and since then I had become quite content writing four days a week for the *Long Beach Press-Telegram*, maintaining a rigorous workout program and spending a lot of time with my young wife.

We traveled extensively, and I still had retained enthusiasm for my job. I still was covering the big events and commenting on all the important sporting issues of the day.

"I don't know, Joe. I'm married now, and I'm enjoying life," I told McDonnell. "I don't need the extra pressure and headaches."

But Joe, whom I had dubbed the "Big Nasty" for his bombastic style and harsh abrasiveness, can be an intractable fellow with a persuasive side to him that can be intimidating.

"You have to do this," he said sternly. "It will be just once a week on KABC. It'll be on Sunday evenings between nine o'clock and midnight. It could lead to something bigger, a lot bigger."

There was a part of me that missed radio—the repartee with listeners, the spontaneity of discourse, even the vitriolic arguments with McDonnell. And, of course, the extra income.

But there was another part that didn't miss it—the lengthy freeway commutes, the intractable daily schedule and, well, the vitriolic arguments with McDonnell.

"I don't know, Joe," I said.

And before I could continue, he replied, with his voice becoming angered, "You have to do it. We're getting another chance. This might lead to something *really* big. ESPN Radio is starting a station out here next January. And we have a chance to be its afternoon drive-time show."

"Let me talk it over with Gillian," I said reluctantly.

At the time, Gillian was taking her final class—physics—at Long Beach State, and she characteristically was making sure she'd get another top grade in it. She was spending at least eight hours a day studying such thrilling stuff as matter and energy and the interaction between them.

When I told her about the opportunity to go back to radio, she was enthusiastic about it.

"Certainly, Douglas, do it," she said. "You always told me you had fun in it."

"Yes, I did, but it also took up a lot of my time, and I had to be at work at the same time every day," I retorted. "I've always pretty much had my own hours as a sportswriter, except when I have to cover an event."

"Definitely, I think you should do it," she persisted. "It's only one day a week."

"But it could lead to five days a week," I said.

So, with a strong push from Gillian, I reluctantly agreed to go back to radio.

A lot would happen before our first show on the evening of June 4 as we went on a little over an hour after the Los Angeles Lakers had dispensed a heroic final-quarter comeback against the Portland Trail Blazers at the Staples Center, wiping out a thirteen-point fourth-quarter deficit to win the Western Conference championship to qualify for the NBA finals against the Indianapolis Pacers.

Of course, Gillian would be diagnosed with cancer in April and would undergo major surgery and would now be spending a lot of her time receiving treatment at the UCLA Medical Center.

As that summer wore on and the Sydney Olympics loomed in September, I became increasingly uncomfortable about leaving Gillian when I knew my presence, obviously, was important to her.

I think it was in the middle of August when I had a candid conversation with her about it, informing her I had decided not to go to the Games.

"Our newspaper group has two other very good journalists who also will be covering it," I said, referring to Karen Crouse and Paul Oberjuerge. "They don't need me. I'm going to stay here where I belong."

She would have none of it.

"Douglas, you have to go to Sydney," she said in her soft voice. "I'll be fine. My parents are coming over to be here with me. The Olympics is the biggest sports event in the world, and you can't miss it."

Reluctantly, I went, and it wasn't exactly the happiest three weeks of my life, considering Gillian's illness and the heavy workload.

I stayed in a small apartment in the sprawling media village that was a converted mental hospital and seldom went to sleep before midnight in what was a punishing grind softened slightly by the hundreds of Australian Olympic volunteers who were exceptionally helpful, friendly and supportive. Never did I come across an Aussie who wasn't incredibly nice during my stay in Sydney.

I spoke on a daily basis to Gillian by cellphone, and she always sounded upbeat.

"I'm just fine," she always would say, even though I'm sure there were occasions when she wasn't.

She was being driven to the UCLA Medical Center either by my neighbor, Esther Fawcett, always so caring, or my stepson-in-law, Tom Kelley, an affable Irishman with a thirst for liquor who, after Gillian's death, accompanied me on several European trips.

I returned on October 2, and Gillian greeted me at LAX in tears, which I matched.

"You look great," I said excitedly, and I did think so, even though she now wore a bandana to cover her hairless head instead of the wig she had purchased before I had left for Sydney.

"Thanks…I'm all right," she said, without a lot of conviction.

It still hadn't entered my mind that Gillian might be terminally ill, that the cancer had spread from her colon to her chest and might now be spreading to other parts of her body.

Gillian remained sternly resolute in making sure her illness wouldn't affect my work.

The World Series was coming up later in October, and when I told Gillian I planned to miss it, she gently shook her head in protest and implored me to attend it.

"Douglas, you must go to the World Series," she asserted strongly. "I'll be fine. I'll feel more miserable if you stay here and not go."

Typical Gillian. So thoughtful, so giving, more concerned about my needs and feelings than her own.

I did cover the World Series that year, spending a week in New York as the two hometown teams, the Yankees and Mets, played each other—the first

Subway Series the great metropolis had had since 1956, when the Yankees played the old Brooklyn Dodgers.

New York always is abuzz with passionate currents, but it reached staggering heights during that week of combat between the two local Major League Baseball teams, as the tabloids and the TV stations drooled over the proceedings, which turned out to be dominated by the lordly Yankees in a mere five games.

December 2000 [Family Illnesses]

Gillian's parents had returned for Christmas, and it would be the first one we had spent at home since we got married. We got a large, healthy evergreen conifer for the front room and decorated it lavishly with lights, bulbs, garlands and other ornaments. I even took out of storage my old Lionel electric train—I bought it in 1952 on the profits from selling Christmas cards—and got it running around the tree, but only after Gillian's father, Jim, and I located a new transformer at an electric train shop in Lakewood.

I still was doing the Sunday night radio with Joe McDonnell, but that would end at the end of the month when, as Joe had predicted would be the case, ESPN would launch a Los Angeles radio network with Joe and me hosting the featured afternoon show.

I still retained skeptical feelings about returning to radio full time because of the four-hour daily commitment and because of the annoying commute to Culver City and because of Gillian's precarious health.

But every time I would betray such thoughts to Gillian, she would say, "Douglas, you must do it. It's good for your career. And I know one of the reasons you don't want to do it is because of me. And that's simply not acceptable to me."

A few days before Christmas, Gillian's father felt severe pain in his chest and suddenly found it difficult to breathe.

We took Jim Howgego to the emergency room at Los Alamitos Medical Center, and he immediately was diagnosed with having suffered a major heart attack. Within a couple days, he underwent open-heart surgery at the Long Beach Memorial Medical Center.

"Thank God I had the heart attack in America rather than England," said Jim. "Because of my age [he was seventy-two], I probably would have had to wait awhile to have my operation in England and probably would have wound up dying."

It would be the second time that year that one of Gillian's parents wound up in a California hospital. In early August, I had driven Gillian and her parents up to Fowler for a weekend visit with my recently widowed mother. I also took Gillian and her parents on a day trip to Yosemite, the spectacular Sierra Nevada Mountains enclave internationally renowned for its towering granite cliffs, picturesque waterfalls, clear streams and sheer beauty.

We were waiting to have lunch in the lobby at the Ahwahnee Lodge when Gillian's mother, Mary, suddenly felt dizzy and momentarily lost consciousness, necessitating the summoning of paramedics, who took her to a local medical center.

From there, she was airlifted in a helicopter to Saint Agnes Medical Center in Fresno, where she would spend a couple days recovering with what was diagnosed as dehydration. Clearly, the native of Hartlepool, where it's routinely cold and rainy, wasn't accustomed to the sweltering weather—it had reached ninety-eight degrees on the afternoon she was at Yosemite.

"This has been one awful year for all of us," said Gillian. "I get sick, my mum gets sick and then my dad gets sick. Not a good time for the Howgego family."

This would turn out to be Gillian's final Christmas, and it was not one brimming with joy.

Her father was in the hospital in a weakened state convalescing from his heart surgery.

And Gillian herself wasn't feeling well.

She was complaining of headaches that, frighteningly, were becoming more frequent.

I remember one time we were in bed at night reading our books before sleep when she suddenly turned to me and said, "I can feel stuff changing in my body. I don't know what it is, but things are happening to my body, Douglas. And I don't think they're good."

She said it matter of factly, but her voice had a resigned wistfulness about it, and I could feel her frustration and anxiety.

"Let's talk to the doctors about what you're feeling," I said feebly.

"What can they do?" she said. "They're doing all they can, Douglas. I know that. I just wish I'd wake up one day and feel better. But it seems like every day I wake up, I feel worse."

Chapter 34

As I look back on those first nine months of 2001 when Gillian's condition slowly, implacably, precipitously declined week after depressing week, it's all now an agonized blur to me.

I know I kept myself frantically busy, as I was now doing weekday sports talk shows on ESPN with Joe McDonnell between 3:00 and 7:00 p.m., as well as my newspaper work.

I know I often would rise at 4:00 a.m. to write my column for the *Press-Telegram*, would be on the San Diego Freeway by 8:00 a.m. to drive Gillian to the UCLA Medical Center, would drive her back to Long Beach and then would get on the freeways again either to go to the KABC studio in Culver City or to the ESPN Zone in Anaheim.

I know it was a difficult schedule, but I also know I probably was able to retain my sanity because of it. I didn't have a lot of idle time to reflect on what was occurring, and what was occurring was that Gillian was dying.

During the four hours that I was on the air with McDonnell, we interviewed many well-known athletes during that period, and Shaquille O'Neal, Kareem Abdul-Jabbar, Bernard Hopkins, Hulk Hogan and others even came into our studio in Culver City. We also did the usual comical bits, like having a deft Muhammad Ali impersonator named Kevin Lamp doing such a masterful impression that the then sports editor of the *Los Angeles Times*, Bill Dwyre, who was in his car listening, was set to have a reporter do a story on it until he was informed the interview was fake.

I think the only laughter I managed during those nine months came on the *McDonnell-Douglas Show*, and for that I'll always have a deep fondness for Joe McDonnell, who was responsible for my presence.

Without his resolute insistence that he wanted me to be his partner again, even though there were those at ESPN's upper management in Bristol, Connecticut, who weren't in favor of it, I wouldn't have had another opportunity to be on the air.

While Joe McDonnell might not be at the top of the rogues' list of nonconformists and rebellious oddities who have inhabited my sphere over the decades, he certainly would pose a serious challenge to those who are.

When I used to say that Joe was the biggest journalist in America, I wasn't kidding. At 730 pounds, he certainly was.

And, as a sports talk host in those days, he was also the most irascible, outspoken, well-informed, if not most entertaining one in the business. He never pulled any punches in his caustic rhetoric, especially with me, whom he routinely pummeled with such flattering words as moron, stupid, idiot, imbecile, dumb, crazy, insane, harebrained—ad nauseam.

Joe had been a fixture on the LA sporting scene since he began his radio career in 1975. He first worked at KGIL in the San Fernando Valley and then began stringing for various national radio networks before landing a Sunday evening sports talk show on fifty-thousand-watt KFI in 1984, which gained him a cult following.

Like me, he attended all the Lakers games during the Kareem Abdul-Jabbar–Magic Johnson Showtime years and had a lot of inside knowledge of that memorable era.

Joe could have done standup because of his rapier-like wit, which he displayed notably one evening after a Lakers game in the team's locker room when he was assailed by Don Rickles, the famed insult comic.

"Did you ever meet a meal you didn't like?" cracked Rickles to McDonnell as he went around the room spewing his venom amid much laughter.

"At least I can lose weight, but you can't grow hair," retorted McDonnell, as the bald-pated Rickles nodded approvingly and howled at McDonnell's sharp retort.

There was no journalist in LA who knew more about the Dodgers during the twenty years Tommy Lasorda managed them than McDonnell, who became friends with many of the players and regularly had biting verbal sparring matches with them.

The loud exchanges between McDonnell and Kirk Gibson during the Dodgers' World Series–winning 1988 season became the stuff of legend.

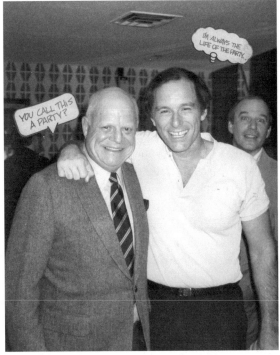

Above: Kathy Ireland joins radio partners Joe McDonnell and Doug.

Left: Doug with his longtime friend Don Rickles (left) after the comedian's performance at the Sahara in Las Vegas.

Joe's immense size became part of his persona, and he will admit today that he got that way by gorging himself with too much food and too many soft drinks. But before he underwent the gastric bypass surgery in October 2004 that he admits saved his life, one raised the question of weight with Joe at one's own peril.

I committed such an indiscretion one afternoon in August 1992 in our office at the old KMPC building on Sunset a few minutes before we were to go on air in the wake of what had just happened to the forty-one-year-old UCLA play-by-play football announcer at the station, John Rebenstorf, who had suffered a fatal heart attack.

"Joe, you have to start watching your weight," I said in a pleading voice.

"Don't you ever mention my weight again!" he responded crossly.

"Let's go and do our show," I said and never again brought up the sensitive subject with Joe.

Like all radio partners who spend so many hours together on a daily basis, Joe and I had our share of passionate dustups—he once angrily bolted out of the radio booth after a particularly savage disagreement, leaving me alone to do the show for a few tense minutes—but we always quickly apologized to each other and mended our differences.

But there was one instance when I wasn't so forgiving, and it happened on our show late on the afternoon of July 3, 2001, a couple hours before I was set to drive my ailing wife and my mother to La Jolla for the fireworks show the next day.

I don't recall to this day what Joe said about me, but I know it was something so demeaning that it enraged me, and I brooded about it the next couple of days in La Jolla.

When I returned to work the following Monday, I met with Joe in his office with the door closed, and I said in the sternest language I had ever used with him that I no longer was in a mood for his constant putdowns, which I had ignored for the most part in the past with a loud laugh and an "Oh, Joe" retort.

"As you know, Joe, my wife is very sick, but as you obviously don't know, I've become very fragile," I said. "If you disparage me again in your mean-spirited way, I'm out of here. I'm quitting the show immediately, on the spot. I'll walk and never come back. And I mean it."

While Joe McDonnell often came off as shrill and bombastic, and even boorish, on the air, there was another side of him away from the microphone when he could be warm, gentle, sentimental and quite charitable.

For years, he privately had lined up many famous athletes for the Make-a-Wish Foundation of Greater Los Angeles, an organization that grants wishes to children with life-threatening conditions.

As Joe listened to my rant, tears flowed from his eyes, and he kept shaking his head and saying, "Oh, I'm so sorry. I sometimes get carried away and should have shown greater respect for what you've been going through. I'm so sorry. It'll never happen again."

And, of course, it didn't, as Joe and I did shows without incident right up to the final week of Gillian's life.

March 2001 [Brain Surgery]

Gillian continued with chemotherapy, but it wasn't working, as we would find out in those depressing sit-downs we'd have with Dr. Peter Rosen and his staff. We always were informed that the cancer was spreading instead of abating, as there were now signs it had reached her liver and lymph nodes.

The funereal atmosphere of those consultations was daunting. In the early days, we actually went to them with high expectations, but that was no longer the case. Although neither of us would say anything, we had come to expect the worst—and not once were we pleasantly surprised.

In fact, in late February, Dr. Rosen even asked Gillian if she wanted to continue with the chemo treatments, which I guess in retrospect was the signal that her condition had become irreversible. She said she did.

An ominous development occurred during that time. Gillian had in previous months been experiencing occasional headaches, but she'd take a couple aspirins and they'd go away.

But suddenly, in recent weeks, they had become more frequent and more painful, and the aspirins no longer were providing relief.

Gillian awoke one morning and complained about a terrible pounding in her head.

"Douglas, it hurts so much," she said in a worried voice. "Something's wrong."

I contacted Dr. Rosen, and he said to come to the UCLA Medical Center for a CT scan. When we got there at mid-morning, Gillian was in agony, but

the nurses wouldn't give her any high-powered pain medication until after the imaging test.

Unfortunately, she had to wait over two hours before a CT scan machine was available—and during that time she suffered horribly.

I remember her lying down in a room with her hands pressed against the sides of her head. I felt so helpless, unable to do anything other than to attempt to console her with banal words of encouragement.

"I just can't believe how much it hurts," she said on several occasions.

And Gillian was one who never complained.

And to listen to her muffled groans meant that what she now was experiencing had to be torturous.

The results of the CT scan weren't surprising. There was a cancerous tumor in her brain.

Fortunately, it was operable.

On the morning of the surgery a week later, on March 3, I drove her to the UCLA Medical Center, and Leigh Anne Kelley was with us.

In the pre-surgery room, Gillian was lying on a bed in a curtained cubicle about a half hour before her scheduled operation when she asked for a pen and paper.

"I want to write a will," she said.

And for a few minutes, in what was indescribably distressing, she scribbled down the names of those whom she wanted to inherit her flat in south London and her wedding ring and a few of her other possessions.

She was crying, and Leigh Anne and I also were crying.

"I know I might not make it this time," she said between sobs.

"Oh yes you will," I managed to say.

The withering sadness of that scene still inspires tears. Wills normally are carefully drawn up in the quiet sanctuary of an attorney's office. Not in a hospital room. Not by a young lady knowing she might not wake up from the anesthesia and that death might be moments away.

Gillian drew her hands to mine as a nurse parted the curtain and said, "We're ready to go."

"Douglas, I love you so much," she said. "I'm so sorry I've put you through this. I just wish it didn't have to finish this way."

"It won't be finished," I said. "You're going to be fine. This is just a bump in the road."

She closed her eyes, which continued to leak tears.

I softly kissed her, and Leigh Anne and I left to wait in the downstairs lobby.

Four hours later, she was out of surgery, and the doctor told us, "She's doing fine. We got the whole tumor out."

After that, Gillian no longer had headaches.

Unfortunately, as Dr. Peter Rosen informed me, she had a particularly virulent form of colon cancer that treatments weren't impeding.

Chapter 35

As Gillian's health worsened even though she had recovered nicely from brain surgery, we decided in desperation to switch to another oncologist on the strong recommendation of Joe McDonnell. His name was Lee Rosen, no relation to Peter Rosen.

This Rosen was the son-in-law of one of McDonnell's first cousins. Not that we thought Peter Rosen had mishandled Gillian. There is nothing he did that we questioned, and we both felt he had done everything he could under the circumstances. An aggressive cancer that has metastasized in a person long has defied medical remedies no matter how wealthy the person is or how renowned the person's physician is.

We felt a change was needed, if for nothing else then for the sheer sake of change. Lee Rosen was much younger than Peter Rosen and flush with energetic optimism. His bright personality made Gillian feel more comfortable and contrasted dramatically with that of the more taciturn Peter Rosen.

But Gillian had had Stage 4 cancer ever since a lesion was detected in her lung shortly after her colon surgery the previous spring, and no amount of chemotherapy and radiation, which she underwent after her brain surgery, could dramatically change her status.

She began taking a heavy dosage of steroids to make her feel better, and it slowly began changing the contours of her face; her cheeks broadened, and her face suddenly had a swollen appearance, a different appearance.

When you're with someone on a daily basis, you seldom notice physical changes, and I didn't notice the changes in Gillian until one Saturday morning during breakfast at a place called Kinda Lahaina in Seal Beach.

She was wearing a bandana around her head that day, and she was in an uncommonly hyper mood. She spoke rapidly, even frenetically, in making a case for me to buy a condominium in Sun Valley as an investment.

When we had visited the Ketchum resort area in Idaho in August 1999, my sister Ginny had her real estate lady show us just such a piece of property, which we both found interesting but not interesting enough to buy.

But now, suddenly, out of nowhere, Gillian was imploring me to make a real estate purchase, which was so out of character for her since she never before had discussed such matters with me.

"That'll be a great summer place for us to live after you retire," she said. "You should do it, Douglas. It'll be something for both of us to look forward to."

I guess I regarded her with a scrutinizing look because she paused and then quickly added, "Why are you staring at me that way?"

I momentarily remained silent and said, "Oh, no, no, I'm just thinking of what you've been saying."

"No you weren't," she said. "You're looking at me funny."

And Gillian was right; she was quite perceptive.

I probably regarded her with that scrutinizing look—stare?—because, for the first time, I noticed how much Gillian's appearance had changed. It was as though a different woman now sat across from me.

Gillian no longer faintly resembled that youthful, smooth-featured, angelic person I remembered emerging with such princess-like majesty from that plane in Nice in late December 1995.

"Why're you looking at me like that?" she repeated.

"Oh, no…I'm just thinking it's probably a little late to buy a condo in Ketchum now," I said, trying vainly to deflect her perception.

She began crying, and I felt awful because I should have been more careful in the way I deported myself.

"Oh, Douglas, look at me. I know I don't look like myself any longer," she said. "I can't bear to look at myself in the mirror any longer. I guess I'm talking about Sun Valley because I need something to look forward to. I need something to think about positively, to hang on to, to…"

I wanted to say that she'd be fine, but I knew it would sound too contrived, and I just sat there gloomily and said nothing.

We finished breakfast in silence and strolled slowly over to the Seal Beach pier, where we so often in the past had walked the quarter mile

to its end at a brisk pace while gazing at the surfers and fishermen and sun-worshipers.

This time we advanced down it perhaps fifty yards when Gillian turned to me and said, "Douglas, let's go home. I'm not feeling well."

When we made it home, Gillian went straight to bed, where she remained for the remainder of the day.

Chapter 36

Because a growing number of the *McDonnell-Douglas Shows* were originating from the small studio at the ESPN Zone near Disneyland—the bosses at our Disney-owned station understandably wanted us to have a greater presence there—I wound up hiring a retired Long Beach elementary school principal, Ray Adams, to begin driving Gillian to the UCLA Medical Center for her treatments.

Gillian was the one who encouraged me to do it, as she was concerned about the toll my daily schedule was having on me, which, believe me, was trivial and manageable compared to what she was enduring.

Ray Adams turned out to be a savior who routinely engaged Gillian in long conversations and always managed to boost her spirits. He became close to her and her mother, Mary, who accompanied her husband back to Hartlepool in late January when he became well enough to travel after his heart surgery.

But Mary didn't remain in England long, as she soon returned to be with her daughter. She was a matriarchal bellwether during Gillian's illness, spending more than a year at our home helping out—cooking meals, washing clothes, cleaning, dusting, sweeping, etc.—in any way she could.

Mary displayed the traits that had attracted me to Gillian. She returned to Long Beach in late April alone—long plane flights were now out of the question for her husband—and would be a vital contributor until the end.

Incidentally, despite her condition, Gillian never stopped doting on me or being the good, caring wife.

She continued to encourage me to go out at night with friends, which I refused to do because I wanted to be with her as much as possible.

When she noticed I began fixing myself a few too many screwdrivers when I came home from work, she told me one evening, "Douglas, I think you've started to drink a little too much. That's not good for you."

She did it in a typically gentle manner, although she was slightly more assertive during the previous winter when I informed her one evening that I had been invited by Dominick "Donnie Shacks" Montemarano, a former capo in the Colombo crime family in New York, to watch a Monday Night Football game at his high-rise dwelling in a Westwood condominium complex.

I had met Montemarano at Phil Trani's restaurant, which at the time was one of his hangouts because he was dating one of the Trani waitresses, an astonishingly beautiful lady who was at least thirty-five years younger than him.

I found Montemarano to be a friendly, charming guy, and so did others who befriended him, like actress Elizabeth Hurley and producer Stephen Bing and the one-time UCLA All-American quarterback Cade McNown.

Gillian and I actually had dinner with Montemarano one night at Trani's, and naturally, I asked him about his Mafia background, which he spoke about in vague generalities, albeit he did discuss his relationship with John Gotti.

"Knew John well from the early days," I recall Montemarano saying. "Not surprised one bit he became the big boss. Smart, ruthless guy."

"I don't want you to go to that man's place and have dinner with him," said Gillian, and I think that was the only time in our marriage when she proscribed me from doing something.

I informed Montemarano, who had relocated to Southern California a few years earlier after spending more than eleven years in prison, that I couldn't make it. I think he got the hint. He never tendered such an invitation to me again, thank goodness.

As the spring and summer months of 2001 elapsed, Gillian continued to deteriorate. I became numb with frustration, disappointment and hopelessness. I saw what was unfolding up close but continued to push the reality out of my mind. It was as though I were seated in the front row of a movie theater observing a film of tragedy—only this wasn't a rehearsed drama orchestrated by actors, directors, producers, cameramen and cinematographers.

Up to that time, my life had been remarkably untouched by traumatic events. Both sets of my grandparents lived into their eighties. My father died a month before his ninetieth birthday. My mother turned ninety that summer and still drove everywhere. Irrespective of the food poisoning I

suffered in Syria and its Hepatitis A aftermath, I long had splendid health. And I doubt there was a sportswriter in America who had savored his job more and had more enjoyment than I had since coming into the Los Angeles market, if you add up all the incredible sporting events I covered with all the incredible nocturnal escapades and foreign expeditions I had experienced.

Certainly, there were the usual disappointments—the folding of the *Herald Examiner* when I was set to replace Melvin Durslag as its lead sports columnist was disheartening, as was the fate of my unpublished novel—but for the most part, I had lived a charmed life free of catastrophic developments like child-support payments, disfiguring car accidents, vengeful ex-boyfriends, enraged creditors and vengeful ex-girlfriends.

I've always considered the hoary saying "Things will work themselves out" to be one of the most vacuous on the planet earth, with no basis in fact, but indeed, I must concede that things always seemed to work themselves out in my life until the pendulum of fate swung to the dark side during my marriage to Gillian.

I think the way I coped with what was happening around me was to both accept it and to ignore it, a juggling act that I suspect I did to retain a sense of mental equilibrium. How else could I have continued to go on the air with Joe McDonnell cracking jokes and erupting in laughter and speaking light-heartedly to listeners?

Gillian was still ambulatory during that time, taking daily walks with her mother around the neighborhood. She also would accompany me to El Dorado Park when I went jogging; she either would sit on a bench and wait for me—oftentimes her mother would come along—or go on a short stroll herself.

Her willpower and determination were astounding. She refused to surrender to her illness and even kept exercising. She also was cautious about what she ate, as her diet consisted of a lot of fresh vegetables and fresh fruit. But most impressively, this lovely lady never complained about her plight, as I'm certain I would have done.

July 2001 [The Spiritual Supporter]

As we had done every year since she arrived in America, I took Gillian to La Jolla for the July 4 holiday, but this time I brought along Gillian's mother and mine. This would be Gillian's final trip outside Long Beach, and obviously, it was a bittersweet experience for all of us.

On the one hand, it was nice to be back in the picturesque resort hamlet near San Diego. But on the other, it was a struggle for Gillian to walk, as her rapidly spreading cancer was sapping her strength and causing her great pain, which she would counteract with the powerful pain medication oxycodone.

But she still hadn't lost her resolve, and she actually even mentioned an upcoming trip she planned to take to England. We ate the first evening at the Manhattan Restaurant at the Empress Hotel, where, as usual, we stayed. On the second night before we walked down to the La Jolla Village to watch the fireworks, we had dinner at the Marine Room, a venerable local beachfront restaurant.

I do remember Gillian saying to me as we drove back to Long Beach the next day, "I've always enjoyed so much the drive to La Jolla. We get such a beautiful view of the Pacific Ocean. I'm going to miss it."

I didn't respond, acting as though I didn't hear it.

She had said a day earlier how she had planned to return to England and now was intimating how she never would be returning to La Jolla. A hospice nurse later told me that such contradictions are frequent in those who are terminally ill, as they often alternate between fantasy and reality. "It's their way of dealing with what's happening to them," she said.

Later in the month, Gillian would have a chance meeting one afternoon at the Vons Pavilion supermarket near our home with a lady who would have a dramatic impact in the final seven weeks of Gillian's life. Her name was Sunni Webber, and how they met only reinforced Webber's passionate belief in religion.

"I saw Gillian in the milk department and noticed she had a scarf covering her head," relates Webber. "You could tell she had lost her hair, and I knew it was either caused by cancer or alopecia. My husband John had recently had chemotherapy for bladder cancer and had lost his hair. But I was a little wary about saying something to Gillian and embarrassing her. So I went to the other side of the store.

"But I just kept running into her. I think it was four times. After the last time, I went into the restroom and began praying. I'm a strong follower of the Christian faith and walk with the Lord every day. I long had served as a volunteer at the Women's Shelter in Long Beach, as well as the Rape Hotline. The Lord had brought me so many people to help over the years, and I remember asking Him, 'If you want me to minister to this woman, I will.' And I quickly walked out of the restroom and started looking for Gillian but couldn't find her.

"She would later tell me she had left the store because she didn't have any reason to be there in the first place. She told me she just wanted to get away from the house and walk around a little. But when she was out in the parking lot and set to get in her car, she decided to go back in the store and buy some crackers.

"After looking for her for about ten minutes, I spotted her in the deli section. I went up to her and said, 'My name is Sunni Webber, and I want to get to know you because the Lord has a message for you. He loves you so much, and He knows you're hurting and suffering. But He has a plan for you.' Gillian started crying right there in the store, and I spoke to her almost every day after that for the next seven weeks."

As a fellow who as an adult had stayed detached from organized religion—my father belonged to the Holy Trinity Armenian Apostolic Church in Fresno and my mother was a Catholic—I didn't know what to make of Webber at the beginning.

I had never spent any time around faith-based people and, frankly, was skeptical about such types. I guess, as I reflect on Sunni Webber suddenly coming into Gillian's life, I felt the same way toward her. Did she have an ulterior motive suddenly forming a friendship with Gillian? I soon would find out there wasn't one. Her only motive, it turned out, was to enhance Gillian's

spiritual awareness in her final days, which Sunni helped accomplish in so many compelling ways.

On the morning of July 28, the day after she met Webber, Gillian and I went to El Dorado Park, as we did every Saturday morning. I was planning to run my usual four miles, while Gillian might walk a few minutes or sit on a bench and read the *LA Times* while waiting for me.

That evening we were going to celebrate my mother's ninetieth birthday at 21 Oceanfront Restaurant in Newport Beach with my sister and her family and a few of her friends from Tucson.

As I began my run on the cement pathway that cuts through the park, Gillian, shockingly, began running alongside me.

And just as I slowed down and started saying, "Stop! What are you doing?" she stumbled and fell forward, slamming face first into the cement surface.

This was a harrowing microcosm of the constant evil occurrences that had stalked Gillian for almost a year and a half.

She lay there helplessly on her stomach, grimacing in pain, unable to rise and crying hysterically.

"I'll call 911," I said.

"No, no, no…please don't," she said in a whisper.

"I'm calling 911," I repeated.

"I'll be all right," she said between sobs, as I helped her up to a sitting position.

"You sure?" I asked.

"Yes, yes," she said.

And she kept crying.

And I put my arms around her and held her as tenderly as I could.

A few concerned people stopped and offered assistance, but we declined.

After fifteen minutes, she finally arose, and I noticed her right cheek was swollen.

"You go do your running," she said. "I'm now all right. I'm going to walk a little."

"I'm not going running, and you're not going to walk anywhere," I said.

But Gillian shook her head with surprising vigor.

"I'm all right. Please, Douglas, go do your running," she said. "I wanna walk. I need to walk. Oh, Douglas, please, please, go jog. Don't worry about me."

I shrugged and with reluctance took off on my run.

I would return forty-five minutes later.

And Gillian and I would arrive at the starting point, which was near the Spring Street entrance, at about the same time.

She told me she had been walking for the past forty-five minutes.

I don't know how she managed it in light of her condition, which had been exacerbated by that terrible fall, but I wasn't too surprised. Gillian had almost an inhuman inner strength. That evening she attended my mother's dinner party, and the bruise on her face had turned reddish blue, a discoloration that would remain until her death. She had a good time, managed an occasional smile and participated even in the toasting of my mother's milestone birthday.

August 2001 [The City of Hope]

After Gillian's latest bleak meeting with the medical personnel at the UCLA Medical Center, I decided in desperation to call an old friend, David Marmel, who was the executive producer of the Victor Awards, which preceded ESPN's ESPYS by several decades and had been the longest-running sports awards special in TV history. Marmel also was the creator and executive producer of both the Mrs. America and Mrs. World Pageants and was an influential fellow with a lot of strong contacts and a longtime member of the board of directors of the City of Hope, the renowned cancer facility.

When I apprised Marmel of Gillian's critical situation, he immediately went into action and set up an interview with a City of Hope physician who was overseeing a colon cancer clinical trials program.

As we drove to City of Hope in Duarte, a tiny city located at the foot of the San Gabriel Mountains, Gillian was hopeful that she could be enrolled in it and that her worsening condition could be reversed.

She had read extensively about the City of Hope and knew about its innovative treatment remedies for seriously ill cancer patients.

"I feel good about this place," she said shortly after we had arrived.

I did, too. I had read the stories of how those on the verge of death had found stunning success in clinical trials, as their disease miraculously went into remission from the experimental remedy.

Why couldn't Gillian be one of those fortunate people?

But within an hour, we were given the worst news possible.

The doctor had studied Gillian's records, which had been forwarded to him from Dr. Lee Rosen, and concluded that her cancer had spread too extensively for her to be a participant.

"I'm so sorry," he said with empathy.

Gillian burst into tears.

"Oh, no," is all she said softly. "Oh, no."

The ride back to Long Beach was like so many of the ones from Westwood, in total taut, solemn silence.

What could one say that wouldn't sound like a pathetic contrivance? Hang in there? You're going to beat it with God's help? Everything will turn out all right?

According to Sunni Webber, an occurrence happened later that day to Gillian that would set in motion factors that had a transformative spiritual effect on her in her final weeks.

"I remember Gillian calling me that afternoon, and her crying over the phone about what happened at the City of Hope," said Webber. "Her heart was totally broken. I had just known her for a few days, but it was as though I had known her for years. She confided how she had gone to a church near her home after she had returned from the City of Hope and how she was the only person seated at the pews. She said a couple of priests had seen her and walked right past her. She felt they had ignored her on purpose, and she told me how she felt unwanted and how hurtful she found their behavior toward her. I asked her if there was anything I could do for her and she replied, 'Please, Sunni, find me a church.' And I did: the Life Assembly of God in Lakewood. I took her there, and she sat down an hour with a couple of the pastors and a few church members. There was a lot of praying, and Gillian cried a lot and everybody embraced her with such love. When she emerged from that room, she was a different person. Something clicked in her mind. She suddenly had a plan, and that plan was to walk with God and be focused on where she was going to spend eternity."

Webber later also told me that she took Gillian one evening to listen to Joyce Meyer, a nationally known Christian author and speaker, at the Long Beach Arena.

"That night, Gillian was in a lot of pain, but she was captivated by the speech given by Meyer, who's very charismatic, and also was captivated by the music. She loved it, and we bought some tapes after the show."

While I knew Gillian spoke on the phone a lot with Sunni and would go out on occasion with her at night, I didn't realize the extent to which Gillian had turned to religion in those final weeks until Sunni later informed me.

Gillian never discussed in detail her activities with Sunni with me, even though we never had kept anything from each other during our marriage. I'm not really surprised. Actually, it was typical Gillian. She knew I was a secular person and figured her sudden passionate devotion to Christianity—as it was, she long had been a member of the Anglican Church—would on some level be disconcerting to me. It wouldn't have been, but her silence on the matter was understandable.

On the Tuesday morning of August 21, Gillian accompanied me to El Dorado Park, where I ran for about an hour. When we returned to our home on Huntdale Street, there were police cars parked in front of it and yellow crime scene tape draped in front of the home of my neighbor, Bob Getman.

"Omigod, what's going on?" wondered Gillian.

After parking the car across the street, I noticed a white sheet covered a body in Getman's driveway.

It turned out to be the eighty-two-year-old Getman, a friend who had been my next-door neighbor since I bought my house in 1975 and who had done so many handyman chores for me during that time. I was informed by a policeman that Bob had suffered a fatal heart attack.

He and his late wife, June, an Australian native, adored Gillian, and Gillian had similar feelings for them, as she did for Esther Fawcett, another neighbor who had been so helpful during Gillian's sickness.

Gillian was visibly shaken by Bob Getman's death.

"He and June were so kind toward me," she said between sobs. "I'm going to miss him so much, but maybe I'll see him soon."

Despite her rapidly declining health, Gillian insisted on attending Getman's funeral services three days later at the nearby St. Cornelius Catholic Church and even went to his burial at the military cemetery in Riverside, sixty miles from Long Beach.

Despite weakening legs, Gillian still was walking, albeit haltingly. Despite it becoming increasingly more difficult, Gillian still managed to get herself out of bed every morning, driven perhaps by the remembrance of what her first oncologist, Dr. Peter Rosen, had once told her about how the end would be near when she no longer could do so.

Chapter 37

Ibecame in awe of Gillian for the brave dignity she displayed as her hours ticked ominously to a conclusion. Actually, I was reacting to her deteriorating condition a lot worse than she was, as I got involved in some incidents in which I momentarily lost control of my senses. I'm sure I was close to having a nervous breakdown.

The first came at a restaurant on Bellflower Boulevard called Tiny Naylor's, which is no longer in existence but was a place I ate at on occasion in those days. I had stopped there one evening in early August after finishing my radio show when my waitress started whining about her cheating boyfriend and undependable car and her financial woes.

I had known her for a couple of years—her name was Joanne—and she was an attractive single mother of a three-year-old girl whom I had always gotten along with well, but I suddenly exploded at her when she brayed, "Life just sucks!"

"You have no idea how fortunate you are!" I shrieked, loud enough for other customers to hear. "You have your health, don't you? You have your future, don't you? Go up and spend a day at the chemotherapy ward at UCLA. You'll find out what real misery is like. You'll find out when life *really* sucks!"

I remember heaving a twenty-dollar bill to the table and hurriedly departing before my order had even arrived.

I returned later that evening to apologize and was embarrassed by my eruption.

But a couple weeks later, I lost my temper again at the ESPN Zone. After I had finished the *McDonnell-Douglas Show*, I had a few drinks with our

producer, David Vassegh, and then went back to the radio booth to retrieve my briefcase. But the door to the room was locked, and there was a well-dressed gentleman seated in one of the chairs talking on the phone.

I tapped softly on the front window a couple times to get his attention to open it, but he ignored me and blithely kept chatting away with his back to me. I then started knocking loudly, prompting him to slam the phone down, whirl around and get up to quickly open the door.

"Don't you ever do that again!" he said in a threatening voice.

Now, in my younger, intemperate days, I would have reacted with a stream of obscenities and perhaps even a volley of punches. But I had mellowed significantly and hadn't been in any sort of street encounter since November 1971, when I decked a drunken miscreant outside Spires Restaurant in Downey for pulling off the radio antenna on my beloved 1966 Volkswagen.

But uncharacteristically, I immediately fired back at the guy, saying, "Hey, motherfucker, don't be wolf talking me!"

And as I said that, I actually found myself getting set to launch a left hook at his right temple, which Evander Holyfield had told me long ago was the most vulnerable spot on a person's face. It was the punch I had learned from a great trainer, Noe Cruz, when I was sparring regularly at the Westminster Boxing Gym in the late 1970s.

But just as I was set to unleash it, I was grabbed from behind by Vassegh, who doubtless saved my job since my antagonist turned out to be a Disneyland executive. The guy complained about my behavior to ESPN management, which sternly admonished me for it and ordered me to apologize to the guy, which I did.

The final brouhaha I got myself involved in that late summer was the scariest since it could have resulted in my winding up in a hospital or even worse.

I had gone to a nearby Italian restaurant called Ferraro's to pick up some takeout and almost struck a car that was backing up as I pulled into the parking space.

The ridiculous way I overreacted indicates to me now that I was unraveling mentally. I started screaming at the driver and motioned for him to get out of his car so I could give him a fistic lesson.

Unfortunately for me, the guy did.

And as I swaggered toward him, I suddenly noticed his immense size. He was at least six-foot-five, he was at least 230 pounds, he was at least thirty years old and, blessedly for me, he at least turned out to be a pleasant fellow not given to beating up older guys half his size and age.

"You don't want to do it, buddy," he said, as I got closer to him. "You're going to get hurt."

I looked at this hulking guy and figured there was a lot of truth in what he was saying.

I also suddenly felt like a fool for my intemperate conduct, bowed my head, turned and walked away.

What a class act that hulking gentleman was.

I figured I would be bombarded with a lot of nasty, demeaning words, but he remained silent, not emboldened to express his disdain at my meek departure.

Chapter 38

The daily sadness and helplessness I had felt since Easter Sunday 2000, when the colonoscopy doctor gave me the dark news about Gillian, grew stronger as my wife grew weaker. I had suffered through numerous romantic breakups across the years and the lingering torment that went with them. But nothing was comparable to what I was feeling as I saw this woman I loved so much enter the climactic stage of her terrible disease.

Every day she walked a little slower. Every day she experienced greater pain. Every day her struggle to survive became more difficult. Every day the sorrow in my soul became deeper.

The *Press-Telegram*'s executive editor, Rich Archbold, told me to take time off, but I continued to write my columns. The ESPN program director, Erik Braverman, told me to take time off from the *McDonnell-Douglas Show*, as did Joe McDonnell himself, but I continued to do my radio work.

I actually continued working both jobs into the final week because I found staying busy helped me retain my sanity. For a few hours each tense day, my mind momentarily was diverted from Gillian's terrible struggle.

At least Gillian had a terrific support system. Her mother proved to be a steady, comforting presence, as was Esther Fawcett, who was constantly running errands and assisting in various household chores. Katharine Elliott twice flew over from Hartlepool—she brought her two young children the first time—and Gillian's spirits were brightened considerably by the presence of her beloved older sister, as well as her niece and nephew.

To list all the people who provided succor, in one way or another, would be an impossibility. But there are a few who deserve special mention.

The then president of Long Beach State, Dr. Robert Maxson, whom I kiddingly referred to as "Fightin' Bob" in the newspaper, and his wife, Sylvia, would stop by the home at least three times a week and drop off a tureen of taco vegetable soup and chicken and rice.

The repast was specially prepared by Sylvia Maxson, a gourmet cook, and Bob Maxson wasn't kidding when he said, "There's no one in the world who cooks better taco vegetable soup than my wife."

Her chicken and rice meal was top notch, too, and Gillian and I were heartened by this nice couple who would interrupt their busy schedule—Sylvia taught several English courses at Long Beach State—to dispense such acts of kindness.

Another person who turned out to be a godsend was Elizabeth Milligan, wife of my pal Stu Milligan. Liz then was a first-grade teacher in Santa Ana and made it a point after school during Gillian's final months to come to our home to comfort Gillian, who dearly enjoyed her company.

When Liz failed to show for a couple days one week, much to Gillian's disappointment, I called up Stu and told him how much Gillian missed his wife's company.

"I thought I was being a nuisance coming over all the time, and I felt horrible when I heard that Gillian got upset by my absence," Liz later related. "After that, I don't think I missed a day. Gillian and I had some great conversations. She was just a wonderful, wonderful person.

"Despite what was happening to her, she remained remarkably upbeat. I remember us laughing a lot, especially once when she told me a funny story about what happened at the 24-Hour Fitness one day when you and her were working out and one of the female trainers you knew said to you, 'Is this your daughter?' And you said, 'No, this is my wife.' And I guess that woman's face turned crimson in embarrassment. Gillian got the biggest kick out of that."

On the final day of June, the Milligans staged their wedding party—they had exchanged vows a couple months earlier—at Sam's Seafood Restaurant in Sunset Beach, and Gillian insisted on attending the event even though she wasn't feeling well that Saturday afternoon.

We went but remained for less than an hour.

Gillian, typically, expressed her apologies to both Stu and Liz for her brief stay.

"I'm so sorry, Liz, but I think it's better that I go home," she said to the new bride. "Please, don't be mad at me."

"Mad at you?" replied Liz incredulously. "I'm just so happy you came. I love you, Gillian."

Liz Milligan would be there in our home during Gillian's final minutes of life and played a vital role that day and many of the ones leading up to it.

So, also, did Sunni Webber.

She had become a confidante of Gillian, and she would take her to early evening gatherings at the Life Center Assembly of God Church and routinely engaged her in lengthy conversations about various faith-related subjects.

"I remember several nights when we'd sit in my car together in the driveway in front of your home and talk about the hereafter and heaven and God and Jesus Christ, Our Lord," said Webber. "Gillian always would cry a lot but never expressed any sorrow for herself. She had accepted her destiny. But she also was very human. She admitted she was frightened. 'You know you're going somewhere,' she would tell me. 'But you wonder where. This is not like a planned trip. This is a trip of eternity.' But in those final weeks, she always was in so much pain. She was such a courageous person."

September 2001 [Hospice Care]

I remember waking up with a sorrowful emptiness and knew it wouldn't be a pleasant day.

It was a Tuesday morning, a week away from the worst terrorist attack in American history. We were set to have a meeting at the UCLA Medical Center with our oncologist, Dr. Lee Rosen, and his staff.

As we drove to Westwood—Gillian's mother came along—there was a tense silence in the car, the chilling kind of silence that always pervaded when we returned to Long Beach after one of these consultations that always ended darkly.

After the City of Hope disappointment, I, finally, had come to accept the inevitable, and I knew that the words we would hear today from the medical people wouldn't be soothing.

And they weren't.

I noted the grim-faced visage of Lee Rosen as I escorted Gillian into his office in which a couple of his nurses also were present.

After Gillian sat down, she addressed her oncologist.

"What do you think we should do next?" she asked softly.

Rosen didn't hesitate in his reply.

"I think the best alternative now is hospice care," he said.

I felt that familiar shock of adrenalin cut through my body and sighed audibly. Gillian nodded and didn't speak. Neither did her mother. Neither did I.

I cast a quick glance at Gillian, and her eyes had moistened.

A blur of images permeated my thought process—my meeting Gillian in the Crystal Palace train station; my holding the five-month-old fetus of our son in the hospital room; our ducking out of the way of New Year's fireworks (falling rockets) at the Brandenburg Gate in Berlin; our sitting in a crowded beer garden at Englischer Park in Munich savoring the beer, bratwurst and ambiance; our South of France forays; our poignant visit to Renoir's mansion in Cagnes-sur-Mer; our Middle East adventure; our laughter; our tender, devoted love for each other.

She got up and said, "Thank you, doctor."

Rosen, still grim-faced, warmly embraced her.

The forty-five-minute trip back to Long Beach took an eternity. The car reverberated with the eeriness of silence.

Gillian was a mere thirty-five and knew it was now certain she wouldn't be celebrating thirty-six, knew she wouldn't be celebrating another holiday season, knew it was now a certainty that her time in this world soon would be at an end.

I wrote and spoke for a living, but I was at a loss for words that morning. Maybe I should have consoled Gillian in some way, but I didn't. I remained mute. I later spoke to Gillian's mother about it. "There's nothing you could have said that would have helped," said Mary. "Gillian knows your feelings on the matter. You don't have to express them."

I didn't, but to this day, I find myself cursing my silence. Maybe I should have told Gillian how much I loved her, how much she had enhanced my life and how much she had been an inspiration to me in so many ways. Maybe I should have told her that until she had come along I was a chaotic mess without any moral compass.

I didn't do the radio show that afternoon, and Gillian, as well as her mother, accompanied me to El Dorado Park, where I went on a run. And incredibly, during it, Gillian and her mom walked awhile.

Even after being informed by her doctor that the only viable alternative for her now was hospice care, she still chose to exercise, which she continued to do until her final week.

During that time, she never spoke about her imminent date with mortality, although she did lapse into the past tense on occasion during conversation.

"Oh, Douglas, I'm going to miss going to see the big fights in Las Vegas and going to World Series games," she said. "But most of all, I'm going to miss being on our European vacations and just being with you."

I remember we were seated together on a sofa in the front room of our home when she said that, and I turned my head away from her so she would not see my tears.

That weekend we remained home, and for the first time, Gillian was unable to accompany me to El Dorado Park. But she still was taking short walks around the neighborhood with her mother, although it was becoming progressively more difficult.

The sadness inside became more intense. To see someone you have cherished so passionately in such a debilitated state is unbearably hard. I was engulfed in an emotional gamut of helplessness, bitterness, emptiness, regretfulness and, perhaps most of all, sorrowfulness.

Such feelings manifested themselves in different ways. I no longer had an appetite and began skipping meals. My weight, usually around 165, dropped to 155. Sleep became almost impossible as I lay in bed at night next to Gillian, whose breathing had become increasingly labored and whose pain threshold had reached its limits despite her regular intake of oxycodone. I'm sure my insomnia only deepened my depression.

But worst of all was watching Gillian's precipitous descent. It was like a ghoulish dream sequence of watching in vain a person being inexorably pulled under by quicksand—and yet this wasn't a dream. It was real, too real for my distressed senses.

I kept thinking about the doctor's statement to Gillian about the end being near when she couldn't get out of bed.

She still was managing that feat, with great effort, and that Saturday night she even insisted on attending a Long Beach State women's volleyball match at the Pyramid. She had come to enjoy the sport and had become friends with the 49ers' nationally renowned coach, Brian Gimmillaro, and his wife, Dania.

I helped her into the arena, and she quietly watched Gimmillaro's ladies easily emerge victorious from the top row of the arena, even though there were times during the match when she was grimacing in pain.

That Sunday, her final Sunday, she even asked me to take her to a vegetarian Indian restaurant in Artesia called the Woodlands. Indian food had always been Gillian's favorite.

We went there that evening—her mother came, too—and Gillian ordered a plate of okra, which she picked at sparingly. It would be the last restaurant Gillian would visit, and Gillian barely could make it to the car, as both her mother and I assisted her in the difficult journey.

The next day, I got up early, wrote a column for the *Press Telegram*, spent a few hours with Gillian and then went to the ESPN Zone to do the *McDonnell-Douglas Show*. It would be the final one I'd do that week and actually would be the final one I would do until I came back from bereavement leave in the first week of October.

That Monday evening, as I watched the football game between the Denver Broncos and New York Giants in the front room, Gillian was in the kitchen helping her mother prepare dinner. I remember walking in and seeing Gillian slicing up some vegetables.

Her mother had informed me that her daughter had walked around the neighborhood that afternoon, which amazed me.

The hospice nurse had been making regular visits and informed me privately that those young people like Gillian with terminal illnesses had a fanatical desire to live and often did so much longer than expected because of it.

"They don't want to let go, and who can blame them?" she said. "But at the end, they must let go."

I didn't realize during that Monday night of September 10 that this would be the last evening I would be able to engage Gillian in a normal conversation.

And, tellingly, Gillian that night was unusually talkative after I turned the lights off in our bedroom.

As we laid next to each other in the darkness, Gillian, without any prompting, began speaking feelingly about life and its glad offerings.

She reflected about friendships, vacations, resorts, museums, rivers, lakes, work, family, books, paintings, films, traveling and, of course, love.

"Oh, Douglas, I'm just so fortunate to have been given the chance to do and to see so many great things in my life," she said. "I think we all tend to take life for granted until you know the end is near. Then you realize you were so fortunate to have been a part of it."

I listened to her soliloquy, and I was moved by it, as I marveled at the admirable grace she continued to display under circumstances that defied comprehension. Not once during it did she mention her fatal condition, which had caused her so much pain and grief. Not once did she deviate from her stream of consciousness about the virtues of life.

Eventually, she grew quiet and lapsed into sleep, but I remember myself that night alternating between a restless wakefulness and a restless slumber. And then, at 4:00 a.m., I could hear Gillian's soft voice beckoning me to call the hospice nurse for pain relief. I momentarily thought I was in the midst of a dream until she gently tugged at my right arm.

And then later would come the phone call from my friend Mark Emerzian about passenger planes crashing into the World Trade Center's Twin Towers and the Pentagon.

Tragic, unexpected deaths were occurring in New York and Washington, D.C.

And death, not unexpected but to me just as tragic, was happening in my own household.

For the next few days, with morphine coursing through her veins, Gillian remained bedridden, opening her eyes on rare occasions and speaking in whispered, barely audible tones. No longer could she walk on her own.

Our Calico cat, which Gillian had picked out of a pet store's adoption section three years earlier, lay loyally next to her during that time, departing only for the litter box and for food. Named Orphie—as in orphan—she had always been partial to Gillian and innately seemed to know the severity of her condition.

Gillian constantly had people near her. Her mother was a regular presence, as was my mother, a retired registered nurse who had come down from Fowler alone in her car despite being ninety. Liz Milligan showed up every afternoon. Esther Fawcett always was around. The hospice nurse came twice a day to perform her duties.

I often sat in a chair next to the bed and held Gillian's hand while either reading Auden poems to her or relating to her the day's events, which that week were of a historical nature.

She sometimes would utter a whispered response not quite decipherable or would manage a slight nod, although Sunni Webber later would tell me that Gillian reacted in a spiritual manner when she and Gillian's mother one afternoon spent a couple hours reading scriptures from the Bible.

"Gillian would nuzzle her head into her pillow, and a beautiful smile would cover her face during our readings," said Webber. "It was as though she was having a very contented dream. She just seemed so peaceful during that time."

My insomnia took hold of me that week; my periods of sleep became more infrequent as Gillian's condition worsened.

I had slept next to Gillian in our bed until Friday, when Gillian, no longer able to walk on her own, was moved into a hospital bed that had been ordered by the hospice nurse for safety reasons.

"Sometimes Gillian might be squirming around, and we definitely don't want her falling out of bed," the hospice nurse said, in explaining her decision.

The hospital bed was placed in the front room, and that Friday evening, the final one in Gillian's life, sleep totally eluded me as I laid on a nearby couch listening to Gillian's ominously labored breathing and feeling an aching desolation that didn't go away for a long time.

I arose several times to check on her—as did her mother—but she didn't respond to our queries. Her eyes remained closed, and she continued to struggle mightily and loudly with her breathing.

The Final Day

Icalled the hospice nurse that morning at seven o'clock. She came over promptly and told Mary, my mother and me that Gillian's blood pressure was decreasing rapidly and that she had only a few hours to live.

We all sat in the front room and waited as Gillian squirmed in her bed and continued to gasp for breath.

I kept asking the hospice nurse if Gillian was suffering, and she kept patiently assuring me she wasn't.

"This is just the normal reaction of a person when the system begins shutting down," she said. "And because of her age, she also is instinctively fighting to live. You can do her a favor if you tell her it's time to let go."

I turned and ran into the den and erupted in tears. I felt I was coming apart emotionally.

How do you tell someone who had brought such joy and comfort and stability into your life to give up her own?

It took me awhile to regain my composure, and I'm not sure I did. But I finally returned to the front room and stood over Gillian, who continued to squirm and gasp for air.

I leaned over and whispered into her ear, "Honey, it's time to let go."

I was stunned by Gillian's response.

"Let go of what?" she whispered back.

I turned to the hospice nurse, and tears once again were trickling down my cheeks.

But I remained standing over the bed as Gillian continued to squirm and to struggle to breathe.

The three older women—Gillian's mother, my mother and Esther—remained seated on the sofa. Liz Milligan, who was Gillian's age, had arrived and stood close watch over Gillian.

The hospice nurse told me Gillian's vital signs had become almost nonexistent—her blood pressure had dipped to zero—and that she had been called to another residence.

"I'll try to be back as soon as I can," she said.

"Are you sure Gillian's not suffering?" I asked again.

"Absolutely," she said. "She doesn't feel any pain."

About an hour later, I leaned down to Gillian and once again whispered in her ear, "Honey, it's time to let go."

Her hooded eyes gazed up at me for the final time, and she whispered in response, "I understand."

Gillian Mary Howgego Krikorian would take her final breath moments later, at 2:35 p.m., as her mother, my mother, Esther Fawcett, Liz Milligan and myself were gathered around the bed. I would kiss her gently as Liz closed her eyelids. I stared at her a few minutes and then repaired to my backyard, where I sat on a lounge chair in front of the swimming pool weeping uncontrollably, lost in the solitude of my grief.

The Aftermath

Later that afternoon, a stream of friends came by to offer condolences. One of them, Rich Archbold, the executive editor of the *Press-Telegram*, urged me to write a column on Gillian. Although I wasn't exactly in a creative mood, I'm certainly glad Archbold gently prodded me into doing so.

I did it for Gillian, who deserved a better fate in life, as so many ill-starred people born into this world do. The response to my piece that appeared in the September 17 edition of the *Press-Telegram* was astounding. I received more than one thousand letters and probably a like number of e-mails from people expressing their sympathies. T.J. Simers, the acerbic sports columnist for the *Los Angeles Times*, dropped an item in his column about how moved he was by my article. The fight announcer Michael Buffer mentioned Gillian's name on an HBO fight telecast a week later from Las Vegas before a show featuring Fernando Vargas.

A memorial service was held on September 19 at the Life Center Assembly of God Church in Lakewood. A crowd of more than five hundred came, and there was standing room only in the balcony. Those present included the Hall of Fame basketball player Jerry West, the one-time Los Angeles Dodger general manager Fred Claire, the longtime publicity director of the Los Angeles Angels Tim Meade, the high-powered Los Angeles public relations mogul Steve Brener, the Toyota Grand Prix of Long Beach executives Chris Pook and Jim Michaelian, several well-known area sportswriters and many local dignitaries and politicians.

I sat between my mother and Gillian's mother and wept as the somber sounds of Pachelbel's Canon in D played before the church's pastor, Tom Brown, gave his sermon. I was unable to stifle my tears during the proceedings in which the eulogies were delivered by my sister, Ginny Clements, the Long Beach State president Dr. Robert Maxson, my longtime sportswriting pal dating back to Fresno State Larry Stewart, the colorful boxing publicist Bill "Bozo" Caplan, the legendary voluptuary and boxing personality Johnny Ortiz and my radio partner, Joe McDonnell.

They all gave moving tributes to Gillian, and all related the dramatic impact she had made on my life, bringing a stability and happiness to it that had been missing when I was a single guy pursuing the dark temptations.

With Pachelbel's classic and then Gillian's favorite song—the French version of "La Mer" by Charles Trenet—playing in the background, many of the attendees afterward filed past me offering their solemn sympathies. I was in such a disoriented, tearful state during this ritual that I have no recollection of the identities of those dozens of people with whom I shook hands and warmly embraced. It wasn't until ten years later when I finally read the funeral register that I discovered the names of countless people whom I didn't realize were in attendance.

Gillian was cremated, and her remains were put in two urns—one that I would possess and the other that her mother would take back to England. Her ashes in her homeland later were spread in the Lake District, where Gillian and her family often vacationed.

I kept the urn in the bedroom that Gillian had converted into her office. After accompanying Gillian's mother to Hartlepool, where I remained for a few days, I flew back to Los Angeles and remained away from my two jobs for another week.

A strange development occurred early one evening a couple days after I had returned while I was lying in my bed reading a book. I heard heavy breathing coming out of the guest bedroom where I kept Gillian's urn and where Gillian had her office. I listened for a few minutes, and it seemed to get louder. The door to the room was shut, and I quietly walked up to it and pressed my ear against it to listen.

Now, I'm not a guy who ever has believed in ghosts, UFOs, astrology, chiromancy, sorcery, mesmerism or any kind of mystical hocus-pocus. But that noise in that room was coming from someone, so I gingerly walked back into my bedroom and called up one of my neighbors, Mike Davis, a big, strong guy inclined to settle disputes with his fists. I told him I thought someone was in my guest bedroom—that perhaps a homeless person had snuck into my home.

"I think there's someone sleeping in there," I told him.

Davis immediately came over with another neighbor, Doug Cook, and we quickly opened the door. The room was empty, and the sound of heavy breathing had suddenly disappeared.

To this day, I have no idea what created that noise, but I know I wasn't imagining it.

There was a distinct sound emanating from that room where Gillian spent so much time studying.

Sunni Webber believes it was a spiritual miracle of faith meant for my ears.

"That was the Lord's way through Gillian to let you know that she was very much alive and that everything was good," she explained.

I have no idea what it was, just that I know what I heard remains mystical to me, much like it's all mystical to me how Gillian came out of nowhere to make such a staggering imprint on my life, an archangel coming down from the firmament to bring a divine period of ecstasy and serenity into it.

Epilogue

I look back now, and it's all like a grainy film with infinite vignettes. I no longer write sports after forty-six years of doing so. Death has silenced so many of the people I chronicled. Others are quietly living out their lives in the oblivion of retirement. Others are stalked by infirmities. Others still are on the sporting stage.

Gillian's mother now lives in a retirement home in Hartlepool. Her father passed away in 2004. Her sister and brother-in-law still work as radiologists. Her niece and nephew are both attending English university medical schools to become doctors.

The *McDonnell-Douglas Show*, which came to an end in June 2005 when it was broken up by my latest firing, had yet another incarnation in March 2012, this time on the Internet out of a famous sports tavern in the Belmont Shore district of Long Beach called Legends. Joe and I did it a mere two hours a day—2:00 to 4:00 p.m.—and there was no pressure, no censors, no meddlesome program directors, no large audience, no big paychecks, no PR firms angling to get clients on the show. It was a lot of fun, but alas, the plug was pulled after four months for financial reasons.

It's all now so different for me, but I don't miss the tumult and the shouting and the commotion and the stress of dealing with athletes and attending games and worrying about deadlines. The newspaper business I left wasn't what it was when I started, and when I started there was no Internet around mocking its antiquity; there were no layoffs, no widespread speculation about its imminent demise, no accountants

disguised as publishers rendering mindless decisions that will only hasten such a dark destiny.

I can live nicely with the memories that often flow through me as I lie awake in bed during the darkness of night, when all the yesterdays come alive before sleep overtakes me.

I can think of that little boy growing up in the tiny farming community of Fowler in the middle of California's fertile and bleak San Joaquin Valley and dreaming about becoming a Major League Baseball player and then dreaming about becoming a sportswriter for a metropolitan newspaper traveling around the country with athletic teams and covering all the major events of the day, which, incredibly, I wound up doing beyond my wildest imaginings.

I can think of Chick Hearn, the most entertaining play-by-play announcer I've ever heard, dispensing his comical asides and critical insights during his descriptive narrations of Lakers games, and recall with fondness those times after games at The Forum when I'd join him in the privacy of his closed-door office for a few shots of vodka before he'd venture out into the nearby press lounge to hold court with his fawning admirers.

I can think of all those seasons throughout the 1970s of my chronicling the Los Angeles Rams, and how their owner, Carroll Rosenbloom, once sent me a pair of Gucci blue suede shoes when I told him how much I liked the ones he wore, and how he later got so mad at me for my persistent criticism of him in the *Herald Examiner* for his firing a great coach, George Allen, after two exhibition games in the summer of 1978 that he came down to the *Herald Examiner* building with his son Steve and met with the newspaper's editor, James Bellows, and publisher, Francis Dale, and Melvin Durslag and me in a vain attempt to muzzle Durslag and me.

I can think of Rosenbloom's widow—she remarried and became known as Georgia Frontiere—having me up to her Bel Air mansion one afternoon and relating to me during an interview how she had a nightly séance with her late husband and how she later shifted the Rams to St. Louis for financial enhancement in a move that made her easily the most despised figure in Los Angeles sports history.

I can think of my first wife, M, a decent woman despite her zealous possessiveness, losing her temper so often with me for breaking curfew in a marriage that was destined to fail from the start because of my rascality and restlessness.

I can think of the obstreperous sportscaster Howard Cosell once phoning the *Herald Examiner* taking loud umbrage about something I had written about him and then many years later screaming over the phone at me when

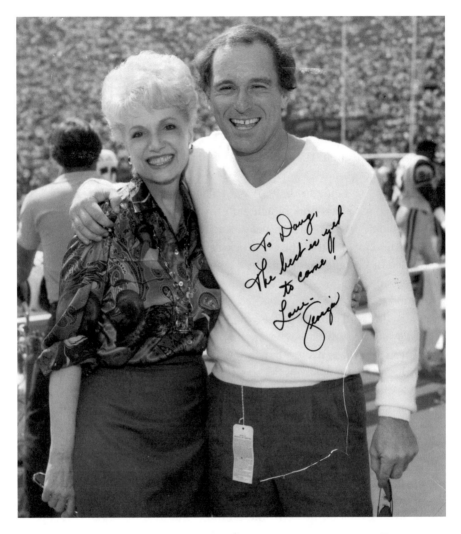

Los Angeles Rams owner Georgia Frontiere and Doug enjoy a moment prior to a Rams game.

I sought to have him come on the *McDonnell-Douglas Show*, saying, "Don't you realize, I'm dying!"

I can think of my mom and how she lovingly tended to her mother and then my father's mother when they were in their dotages and lived in our home throughout my childhood, and how she would routinely make the 460-mile round-trip drive to Long Beach when I needed assistance and how she doted on me to the end of her ninety-eight years.

I can think of my father, who went to work six days a week into his mid-eighties, imparting wise counsel and emphasizing the importance of my having a family—and, oh, why didn't I listen to this honest, hardworking man instead of blithely ignoring him all those years.

I can think of all the fights I saw in person, more than five thousand, and never will forget the ones in which four ill-starred men—Jimmy Garcia, Cleveland Denny, Johnny Owen and Kiko Bejines—wound up losing their lives from the beatings they endured in a sport of sanctioned violence that I no longer enjoy.

I can think of being in that Crystal Palace train station in South London on a rainy day, seated on a bench with this unknown young woman next to me who would become an eternal part of my soul.

I can think of being in the Hancock Park home of Muhammad Ali when he resided in LA, and his cracking jokes and doing magic tricks and evincing the charisma that was a vibrant part of his persona before Parkinson's Syndrome took it all away.

I can think of the doyenne of Los Angeles boxing, Aileen Eaton, enlisting her private hairstylist to shape up my then lengthy locks, which Ms. Eaton found too disheveled, and who was further ahead of the feminist curve than this small, strong, smart, dynamic lady who promoted so many fistic classics at the Olympic Auditorium at Eighteenth and Grand near downtown LA?

I can think of that time I came across Mike Tyson and his bodyguard, the late James Anderson, in a hallway at the Las Vegas Hilton, and I went into a shadow boxing pose and unfurled a left hook in the direction of Tyson, who shook his head in mock contempt and said, "I'd knock your fucking head off."

I can think of Johnny Ortiz and all the ladies melting in the presence of his light-hearted banter, his inexhaustible supply of titillating tales and all the drinks that flowed strongly when he was mixing them at the Stardust Lounge and Lancer Lounge in Downey and the Casting Office in North Hollywood and the Oyster House in Studio City and the City Slicker in West Los Angeles.

I can think of the great coach John Wooden angrily referring to me at a basketball media luncheon as "being an embarrassment to the Grantland Rice school of sportswriting" for mocking his UCLA team's early season non-conference schedule at the start of the 1971–72 season and his reaching me at the *Herald Examiner* the next day on the phone and offering an apology, much to my sheepishness.

Hector "Macho" Camacho offers a pose to illustrate his nickname between Doug (left) and trainer Jimmy Montoya (right) at a gym in the city of Bell.

I can think of having dinner one evening at the Redwood Inn in downtown Los Angeles with the fight promoter Don Fraser and the legendary mobster Mickey Cohen—he was portrayed graphically by Harvey Keitel in *Bugsy*—and recall Cohen discussing his brief incarceration at Alcatraz and the bookmaking operation he once had in Fresno.

I can think of all the characters I've met across the years, and I'm not sure anyone picks up more tabs than bookmakers, or has more fun while working than ticket scalpers, or scores on more ladies than bartenders, or comes up with more exotic excuses for not paying their debts than degenerate gamblers or turns on their coaches and managers faster during bad times than athletes.

I can think of brazenly challenging an eighteen-year-old political refugee from Czechoslovakia named Martina Navratilova to a game of ping-pong at the Beverly Hills home of her then agent, Fred Barman, in 1975, and how she displayed the skills that would result in her becoming a nine-time Wimbledon tennis champion by humiliating me so thoroughly—I didn't score a point in three games—that the mauling was the theme of the *Herald Examiner* story I wrote on her.

I can think of being in the Executive Lounge of the Berlin Hilton with Tom Kelley one evening a couple years after Gillian's death when a nice couple told me they were from Lisbon, Portugal, and my immediately bursting out of the room in tears in a reaction I had often in those days when grief overcame me when reminded of places where Gillian and I had memorable times together.

I can think of those chilling moments I avoided death and cringe at the thought of drag-racing my father's 1959 Bonneville Pontiac 125 miles an hour in the Fowler countryside when I had no idea about mortality at age sixteen, or zipping down the 605 Freeway at 135 miles an hour one late evening in a lady friend's Porsche when I was drunk and old enough to know I was daring death or incarceration.

I can think of the Hilton Hotel security personnel coming up to my booth in the hotel's main ballroom at the Victor Awards proceedings and threatening to boot me and my three guests, fight promoter Don King, tennis hustler Bobby Riggs and PR guy Bill "Bozo" Caplan, from the premises for the loud commotion we were creating (actually, King and Riggs were the miscreants in that embarrassing situation).

I can think of my pal Van Barbieri, a chivalrous man of honor with whom I had lunch that fateful day when I decided to fly to London and had so much fun with across the years, dying too young and too quickly in the summer of 2012 from pancreatic cancer.

I can think of my dear sister, Ginny Clements, who knows personal tragedy, always being there for me and for her own family, for our parents and for her large group of friends, in periods of need and distress.

I can think of the melancholic times I've gone out to Forest Lawn Cemetery in Cypress where I had Gillian's urn buried near a beautiful oak

tree and how serene the setting is for "My Loving Brit Wife," the epitaph inscribed on her bronze gravestone that reflects my feelings for a person who brought so much joy to all of us whose glad destiny it was to have crossed her sacred path.

About the Author

A former sportswriter and columnist for the *Los Angeles Herald Examiner* from 1968 until its demise in 1989, Doug Krikorian became the sports columnist for the *Long Beach Press-Telegram* for two more decades. He has been a sports radio talk show host for Los Angeles radio stations and ESPN Radio and a sports commentator on LA television.

Visit us at
www.historypress.net

This title is also available as an e-book